More Praise for *Veterans Voices*

"Another gripping reminder of our enormous debt of gratitude to our front line, in every respect.
Freedom is not free, and they have borne the cost. God blesses them, and God blesses America."
—*Stephanie Zimbalist, actress and daughter of the late Efrem Zimbalist, Jr., actor and WWII veteran*

★★★

"*Veterans Voices* is a compelling compilation of inspiring stories detailing the breadth of military service and experience.
It should be seen as an instrument for sparking a broader conversation in our communities
about the value of service in uniform and the sacrifices made by the few for the many."
—*Jake Wood, co-founder and CEO of Team Rubicon*

★★★

"As a documentary filmmaker, I know the power of the true stories of veterans.
The eloquent storytelling and memorable photography of *Veterans Voices* provides a vivid, moving, and much needed window into the
human side of the military experience—an experience whose impact cascades over time upon the lives of the veterans themselves,
but also their families, those with whom they served, and those against whom they fought."
—*Joe Fab, director, writer, and producer of* **Paper Clips** *and* **Bedford: The Town They Left Behind**

★★★

"What a tremendous book! It details the humanity of war, exchanging the theoretical for the personal.
The veterans profiled are engaging. Their stories are riveting. Their pictures are powerful and poignant.
Overall, this book shows how both tragedy and heroics exist on both sides of any war.
It's an exhortation in empathy we can all take to heart."
—*Marcus Brotherton, bestselling author of* **Shifty's War**

★★★

"*Veterans Voices* is a page-turner that is a gripping read and inspiring tribute to some of the finest men and women
our country has produced. I can think of no better gift for the next generations and their progeny."
—*John Lehman, former secretary of the Navy*

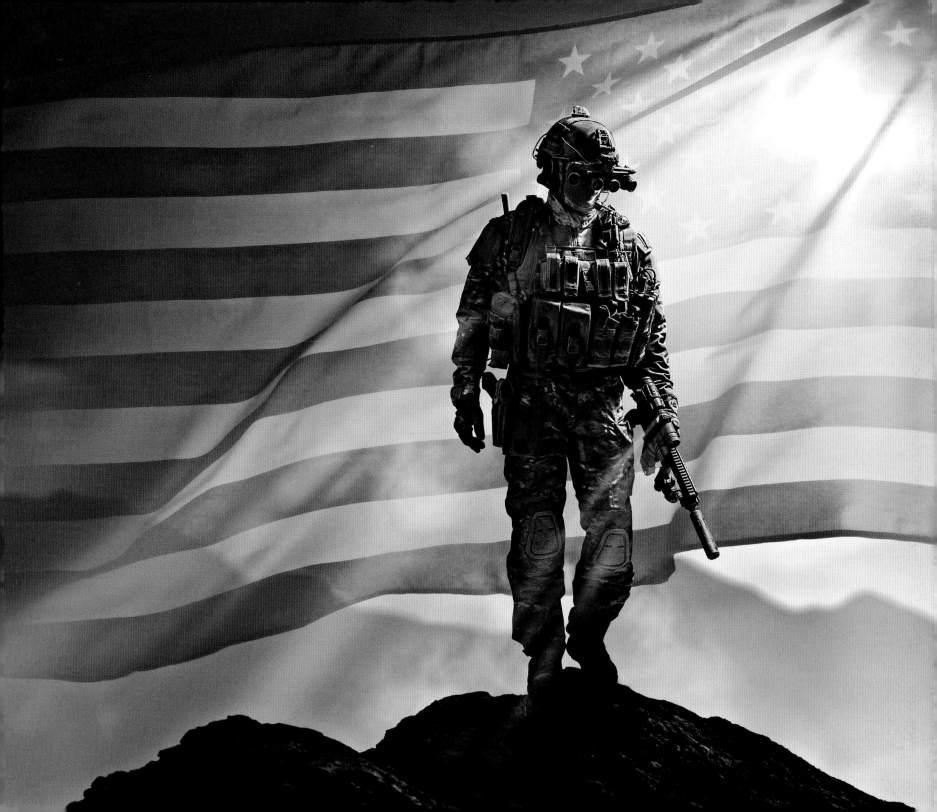

VETERANS VOICES

★★★★★

Remarkable Stories of Heroism, Sacrifice, and Honor

ROBERT H. MILLER AND ANDREW WAKEFORD

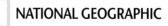 NATIONAL GEOGRAPHIC

WASHINGTON, D.C.

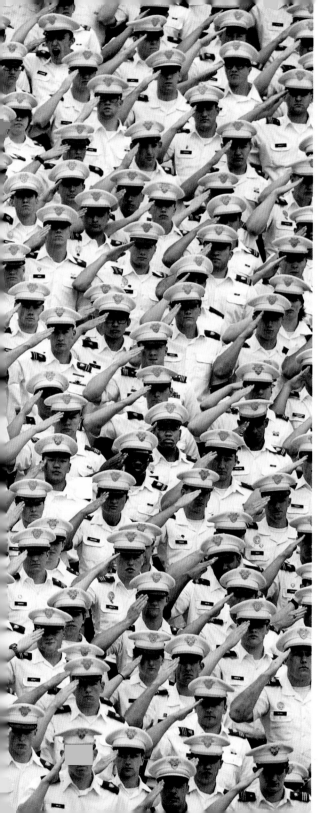

CONTENTS

★ ★ ★ ★ ★ ★ ★ ★ ★ ★ ★ ★ ★ ★ ★ ★ ★ ★ ★

ABOVE: *The Iwo Jima Monument against the dusky Washington, D.C., skyline*
PAGES 4–5: *West Point graduation, May 28, 2014*

*To veterans and their families,
whose heroism and sacrifice
inspire us all.*

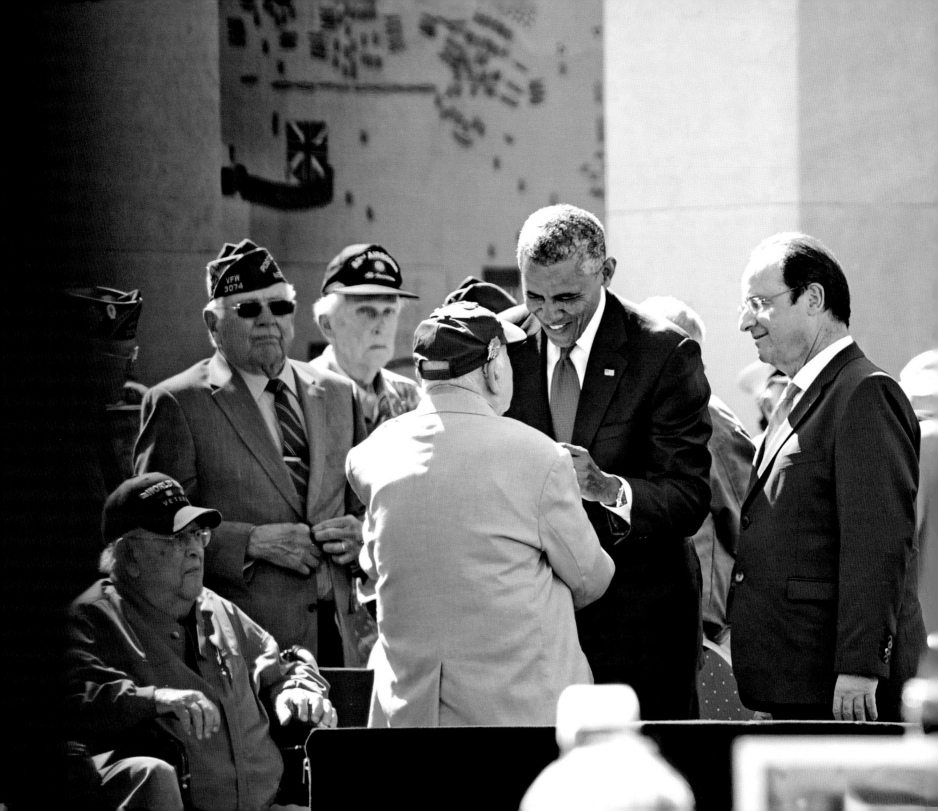

FOREWORD

★ ★ ★ ★ ★

Part of my wanderlust and insatiable desire to see the world can be blamed squarely on our family's subscription to *National Geographic* when I was a boy. And I can still recall the feeling of anticipation when it arrived in our suburban Detroit mailbox. I couldn't wait to see what was on the cover and once I opened the pages, I was transported to parts of the globe I hoped one day to see firsthand.

It was a given that the reporting was in-depth and educational. These were all journalists at the top of their game. But it was the photographs that held my attention. I remember studying the portraits of people, especially, marveling at the way the lens could capture the exact emotional moment of expression on a face.

Each of those images, especially the ones that captured extreme emotions, triumph, agony, joy, and pride, was a window into another world, a chance to stand in someone else's shoes and imagine their life experience.

Fast-forward to adulthood, and perhaps it is no surprise that I chose a career as a broadcast journalist and ultimately became a foreign correspondent. I loved the idea of telling stories with words and moving pictures. Over time, as a reporter for ABC News, I found myself on the road for longer stretches. I began covering conflicts and wars around the world. This is where the extremes of human nature converge; the absolute best in human nature meets the absolute worst. Turning a camera on a war and its participants is a glimpse into the human soul, into sacrifice and patriotism, into service and brotherhood.

The terrorist acts of September 11 forever changed how we Americans viewed our sense of self and security. For the next three years after the attacks, I spent long tracts of time embedded with the American military in both Iraq and Afghanistan, covering what is now the longest running war in which our country has been involved. Prior to that, my only real contact with the military culture had been as a journalist, although I was always proud that my father and grandfather had served in the Army.

In 2006, covering the war as the newly placed anchor for ABC News, I was hit by a roadside bomb, along with my cameraman, Doug Vogt. The force of the blast shattered my skull and left me with a traumatic brain injury, the signature injury of the wars in Iraq and Afghanistan. I spent 36 days in a coma at the National Naval Medical Center in Bethesda, Maryland, under the incredible and state-of-the-art care of the staff there. They attended to every single military member and their family as if they were their own.

But it was the months and years following my injury that forged a bond between myself and my family and the incredible men and women who volunteer to serve their country. They are the ones who raise their hands to go into areas of conflict.

Watching our nation's service members and their families handle the strains of multiple deployments, dealing with injuries both hidden and obvious, working to transition back to the home front after serving, has only raised the esteem in which I hold this small segment of our nation's population.

And if photographs can help us stand in someone else's shoes and bring their world to our living room, then this book will give you a glimpse of American life that all of us need to respect, no matter what our political leanings. ∎

BOB WOODRUFF
ABC News correspondent & Bob Woodruff Foundation

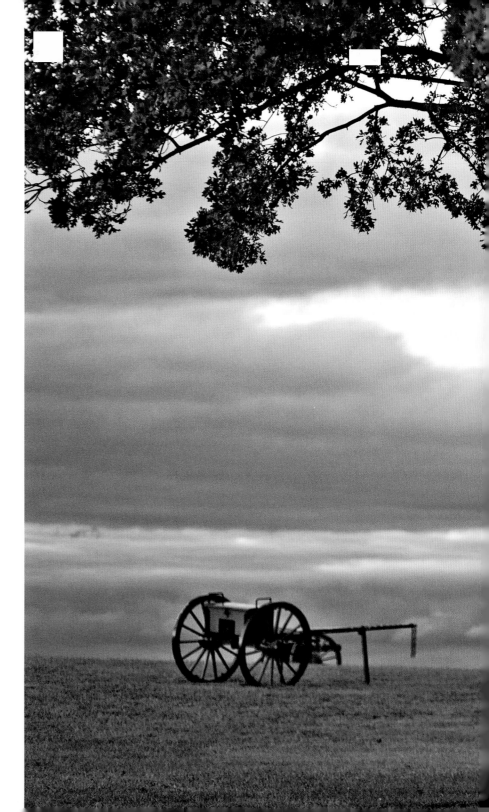

Three Civil War–era cannons sit at the top of a hill at dusk in Manassas, Virginia.

PAGE 8: *President Obama and President Hollande of France thank veterans at Omaha Beach on the 70th anniversary of D-Day.*

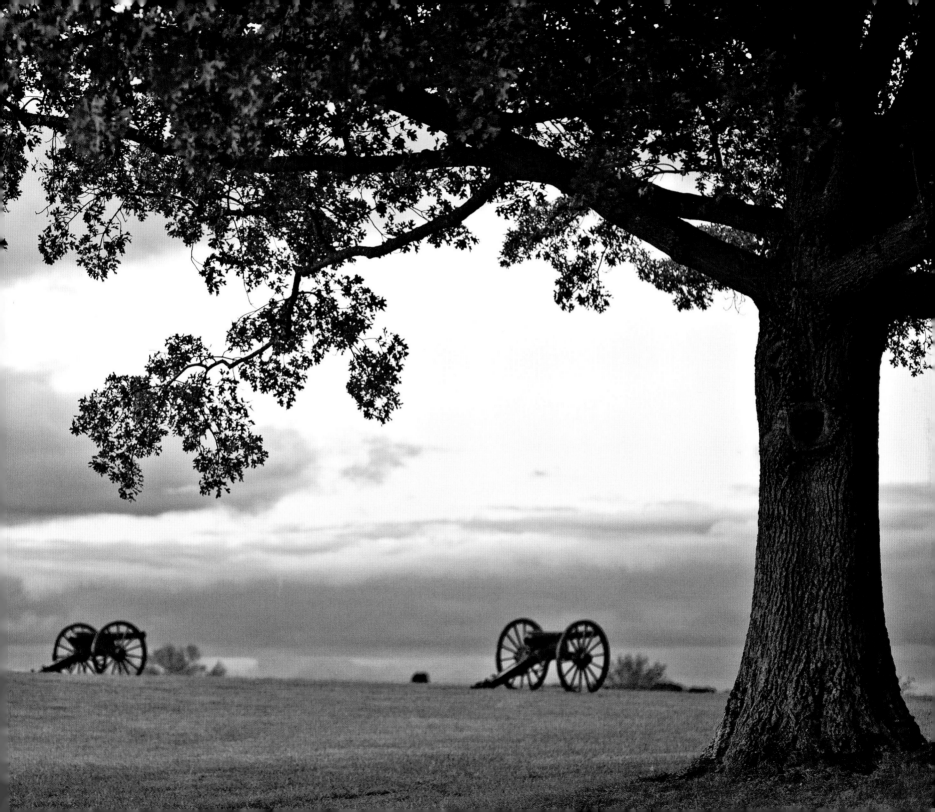

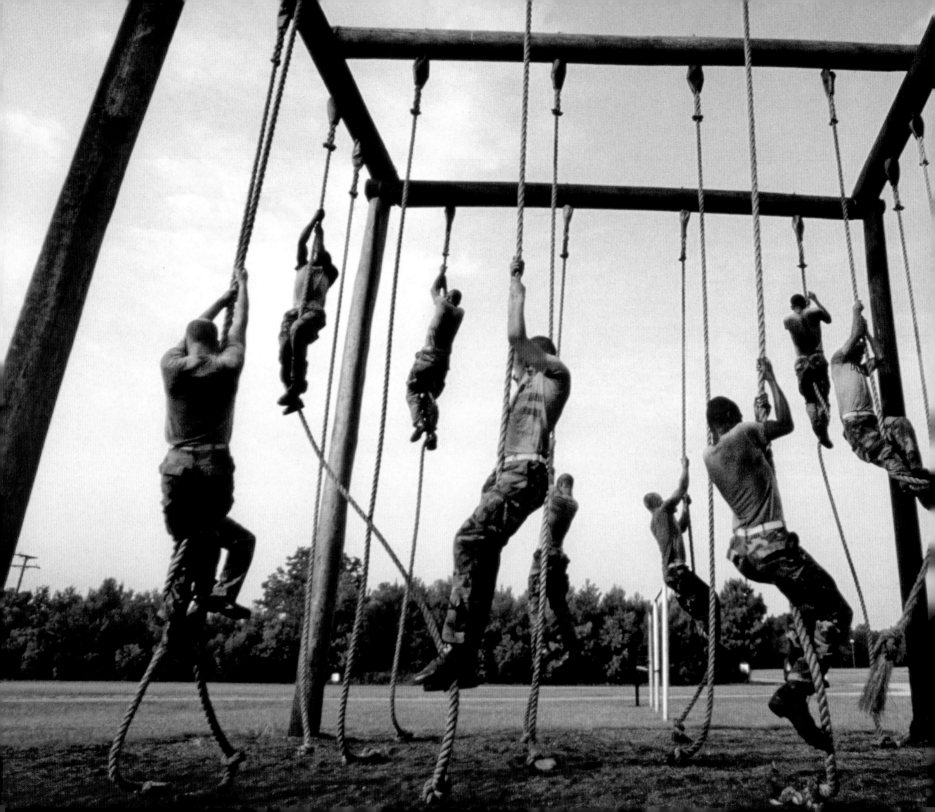

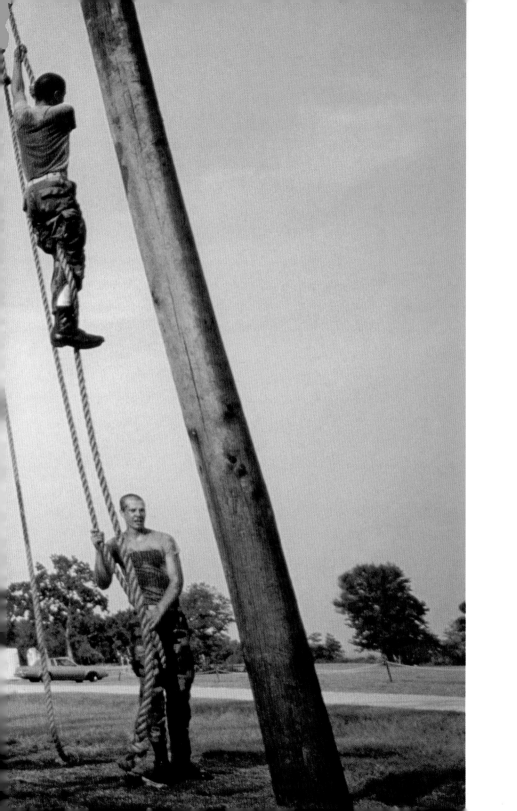

Marine recruits climb ropes during boot camp at Parris Island, South Carolina.

The sun sets over a pair of aircraft carriers in Norfolk, Virginia.

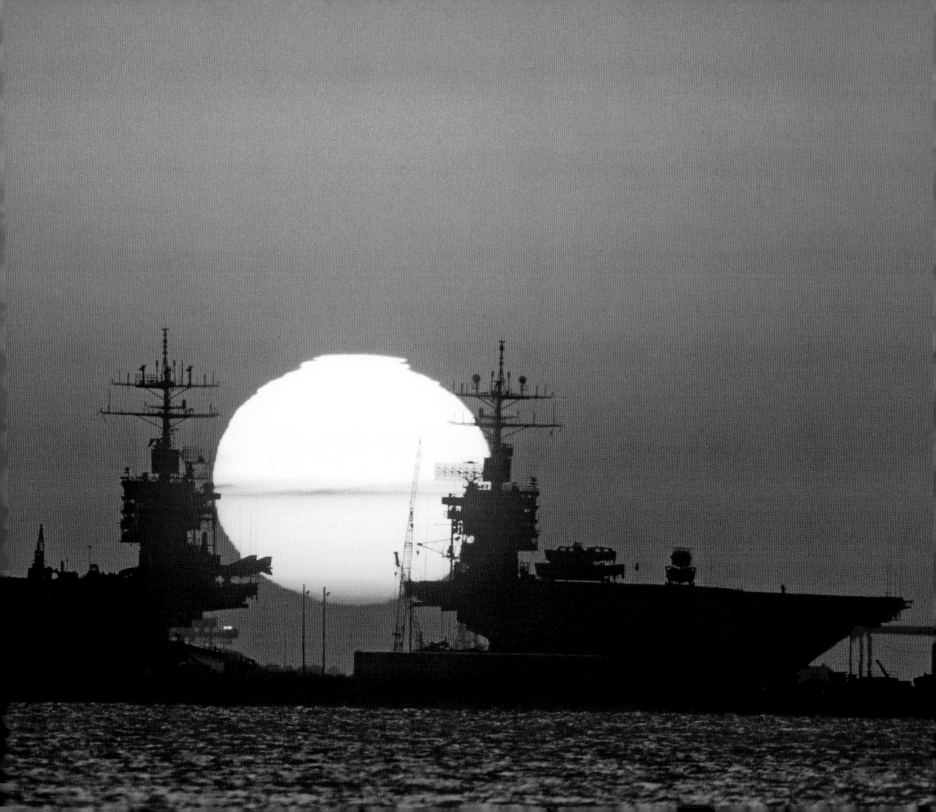

AT · JAMES L ~ ~ ~ NE Jr · LAWRE~CE D GR~ ~

W~LLI~ ~N · RICHAR~ T H~MES · ~LEV ~N

~ON · TODD R JACKSON · LOUIS C GROVE · ~LIFF

~NS · JAMES M LA ROUCHE · ROBERT E LOCH~ ~

~IE · JOHN E MANNING · ROBERT J MARIZ · J~ ~

~N L MARTZ · PET~ ~ ~NICK · LARRY D MILL~~D

McREYNOLDS · W~ ~ ~D E NELSON · TIMOTHY ~

~RUE · ROBER~ ~ ~RS · DELL C ODEGAR~ · ~

~ITNER · STEVE~ ~OWERS · WILLIAM J POW~ ~

~ TONY RIJOS · GE~ ~A ROSS · WILLIAM R RO~ ~ Jr

~AR · KENNETH A SP~KER · ROBERT L STALEY Jr · ~

~ALL · THOMAS H S~ ~NEA · BRAD J SZUTZ · ~HA~

~T~NER · ~ ~ ~SQUE~ · TUIOALELE T SU~AU~

~E WHITBECK · ~H ~ ~TE · JOSEPH C ZA~ ~A~

~RUM · CARE~ C~ ~ONY · JAMES A BALLIN~ ~

~ARTLEY · WILLIA~C BEHRENS · RALPH T BER~Y

~ING · RANDOLP~ ~E BOONE · LASZLO BOROS ~

~RAGA Jr · ~YD~ ~B BRAU~ ~TO~ Jr · J~MES A ~

~ETTE Jr · WILLIAM~ ~ BUSBY · PETER M BUTLER · HO~

INSPIRATION

"*If you leave here with love of* COUNTRY *stamped on your heart,
then you will be a 21st-century leader worthy . . . of the great privilege
and honor . . . of leading . . . the sons and daughters of America.*"

GEN. H. NORMAN SCHWARZKOPF

REGINA AUNE

Deployment: Saigon 1975
Served: U.S. Air Force
Residence: Texas
Occupation: Retired dean of Galen College of Nursing

★★★★★

"Sir, I request being relieved of my duties
as my injuries prevent me from carrying on."

It was April 1975, and Saigon was on fire. The North Vietnamese soldiers were marching toward the city, bombs were exploding, people were fleeing in terror, and President Ford had ordered airlifts to evacuate key citizens—including 2,000 war orphan babies who otherwise would be left to the mercy of the Vietcong. Lt. Regina Aune, a career Air Force nurse from Lakewood, Ohio, was lead medical officer of the team organizing the first flight of Operation Babylift.

A huge effort was made to refit a C-5 Galaxy with baby transport facilities. An enormous aircraft designed to transport entire helicopters and large numbers of troops, it had to be creatively adapted to its new use. On April 4 it was ready, and the crew, including Master Sgt. Ray Snedegar, was busy preparing for the flight while the medical team loaded the babies on board. Aune stood at the entrance door of the craft inspecting the orphans one by one before handing them over to the next crew member, who secured them for the flight. A number of adults were also being evacuated from Saigon: civilian employees of the Department of Defense, many of whom helped to care for the 270 babies boarding the plane.

Once airborne at 23,000 feet, a woman in the downstairs bay became very sick, repeatedly vomiting. Aune climbed the steep ladder to the next deck to find some water and medicine. At that point, there was an enormous blast caused by one of the cargo seals breaking. The craft filled with smoke and flying particles. There was a sudden loss of compression, and the crew had to make a rapid decision: Return to the airport or land the plane immediately.

There was complete chaos on the troop deck and Aune remembers seeing the South China Sea below her through the now open cargo doors, as the pilot accelerated upward in an effort to regain control. Although the pilot managed to turn the plane back toward the airport, they were still far from the runway and there was no way to make a proper landing. Two miles short of the runway, they crashed into paddy fields near the Saigon River, bouncing a number of times before skidding to a stop a quarter of a mile later. The engines and wings had fallen away from the rest of the airplane and burned without endangering the survivors.

From her position sitting on the floor of the troop compartment, Aune had been thrown the length of the compartment; she had felt bones in her foot break when she smashed into the wall. The lacerations in her foot were so painful that she didn't even notice that the impact had also broken a bone in her back. Despite her injuries, her adrenaline surged. When the plane came to a halt, she jumped into the mud and began to collect the surviving children as best she could. Helicopters soon landed to evacuate survivors, but their rotors caused debris from the broken

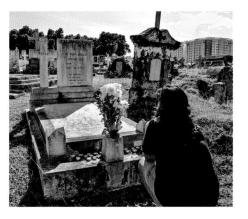

aircraft to fly everywhere. To protect her tiny charges, she held them close, her body hunched over theirs, and walked backward toward the helicopter. She repeated this operation again and again and again, in agony but as yet unaware of the extent of her own injuries.

After rescuing countless babies, she was finally overcome.

"Sir, I request being relieved of my duties as my injuries prevent me from carrying on," she said, according to crew members, just before she fainted.

Of those who were in the downstairs compartment, only two or three survived. All together, 133 of the 311 passengers were lost.

After a brief hospital stay to recover from her injuries from the horrific crash, Aune went back to work for the medical team to continue supporting air evacuations.

In 1997 she received a phone call from a woman named Aryn Lockhart, one of the surviving babies of Operation Babylift. Lockhart had heard the story of her rescue from the Vietcong and wanted to thank those who had sacrificed so much to save her. Aune was deeply touched and also introduced Lockhart to Snedegar, one of the crew with whom she'd stayed in touch. Through emails and phone calls, the trio became very good friends, and together they visited Vietnam in November 2014. It proved to be an emotional, cathartic journey for them all. They saw many of the historical sites and relived the memory of this humanitarian rescue mission. ■

JERRY LINENGER

Deployment: Around the world, including space, 1974–1998
Branch of Service: U.S. Navy
Residence: Michigan
Occupation: Retired astronaut, consultant, author

★★★★★

*"What I learned was to step back from life's problems,
and if I don't see the solution I try to step back even further."*

The pamphlet inside the counseling office advertised one of the finest military schools in the nation. In big, bold letters it read: "Are you good enough?"

And that's all high school student Jerry Linenger needed to focus in on his childhood dream.

"I decided I wanted to go to the Naval Academy, in part because more astronauts graduated from Annapolis than any other school."

Linenger was accepted by the U.S. Naval Academy in 1973. He was now on the path to becoming an astronaut. Then, after 12 years of college, medical school, and advanced studies—and a successful stint in the U.S. Navy as a naval flight surgeon—Linenger was ready for his next adventure: astronaut training.

In August 1992 Linenger walked through the doors of the Johnson Space Center. In two short years, he aced his training and soared into space on his first mission aboard the space shuttle *Discovery.* There, he honed his skills in space and completed a successful ten-day mission. It wasn't long before he began training in Russia with a team of cosmonauts in preparation for a long-duration stay aboard the space station Mir.

"Because of my experiences in space my perspective on life has greatly changed—for the better. I just don't worry about things as I did before."

Aboard the space shuttle *Atlantis,* Linenger lifted off into space on January 12, 1997, and united with the two Russian cosmonauts on space station Mir. Together for 132 days, in what Linenger calls "total isolation," they orbited Earth.

The aging Mir already had been in orbit for ten years before Linenger arrived. Unbeknownst to the men, there were a host of problems that would plague the mission. The most serious of these was a life-threatening, 15-minute-long fire that began with an onboard oxygen canister.

Linenger recalls, "The smoke was so black it looked like someone had switched the lights off. When I saw our cabin was full of smoke, my first reaction was I wanted to open a window—and that was impossible! I was truly afraid for the first time." Together, they eventually put out the fire.

Linenger can seemingly recount every detail about his time on Mir, his five-hour spacewalk, and his perspective of planet Earth. As he looked out Mir's window, Linenger saw the Hale-Bopp comet and the northern lights.

"I thought a lot about life, and I'm very fortunate I could see life from a perspective from space that most people will not ever see."

"What I learned was to step back from life's problems. And if I don't see the solution I try to step back even further. After all, I saw the entire world from a distance, not the nitty-gritty details that can cloud our vision and consume us all." ■

Drew Bartkiewicz

Deployment: Gulf War 1991
Branch of Service: U.S. Army
Residence: Connecticut
Occupation: Founder and CEO of lettrs

★★★★★

*"Letters for me in my toughest times
were some of my most prized possessions."*

It was late in 1989; tension in Iraq was escalating and quickly becoming America's concern. U.S. Military Academy graduate Drew Bartkiewicz never expected he would see active combat after graduation, but the troubling events in Iraq quickly led to his deployment in 1991—directly into the hotbed of the Middle East.

Bartkiewicz soon found himself in Iraq witnessing unspeakable human horrors, coming upon mass graves filled with remains of Kurdish people young and old.

He recalls, "I knew I was prepared academically for combat, but emotionally—no training in the world could prepare me to deal with the horrific atrocities I was now seeing every day."

Driven and optimistic by nature, Bartkiewicz was determined to make the best out of a tough situation. After several weeks in Iraq, he received his first letter from his grandmother. Soon they were frequently exchanging letters.

It wasn't long before Bartkiewicz realized this correspondence was lifting his spirits. Each letter became a legacy of value that could be called upon whenever he wanted. The act of trading letters became very important and helped him cope with the chaos and uncertainty. Unbeknownst to him, the precious letters from his grandmother he received during his military service were creating an indelible impression that would help create a future, life-changing opportunity. Bartkiewicz was eventually honorably discharged from the Army and returned to civilian life.

Bartkiewicz soon married, had kids, and moved along with a successful, post-military life. Then one day he realized he wanted something more. He was inspired by a conversation with his teenage sons and preteen daughter.

"I saw my kids and others didn't even know how to address or compose a letter, which was incredibly sad for me."

Then it dawned on Bartkiewicz how much his grandmother's letters had meant to him when he was in the midst of war. Soon he decided it was time to mix the old with the new. Despite the exploding number of social apps, he saw there was no platform to create meaningful, lasting letters that were treasured and saved. He moved swiftly to implement his idea.

In January 2013 he founded lettrs. In 2014 he and his team of passionate software experts released a highly successful iPhone and Android app. A year later, more than two million people had downloaded the app, which can be translated into more than 80 languages.

"Letters for me in my toughest times were some of my most prized possessions," Bartkiewicz says. "At the time I needed those words the most, they were there." ■

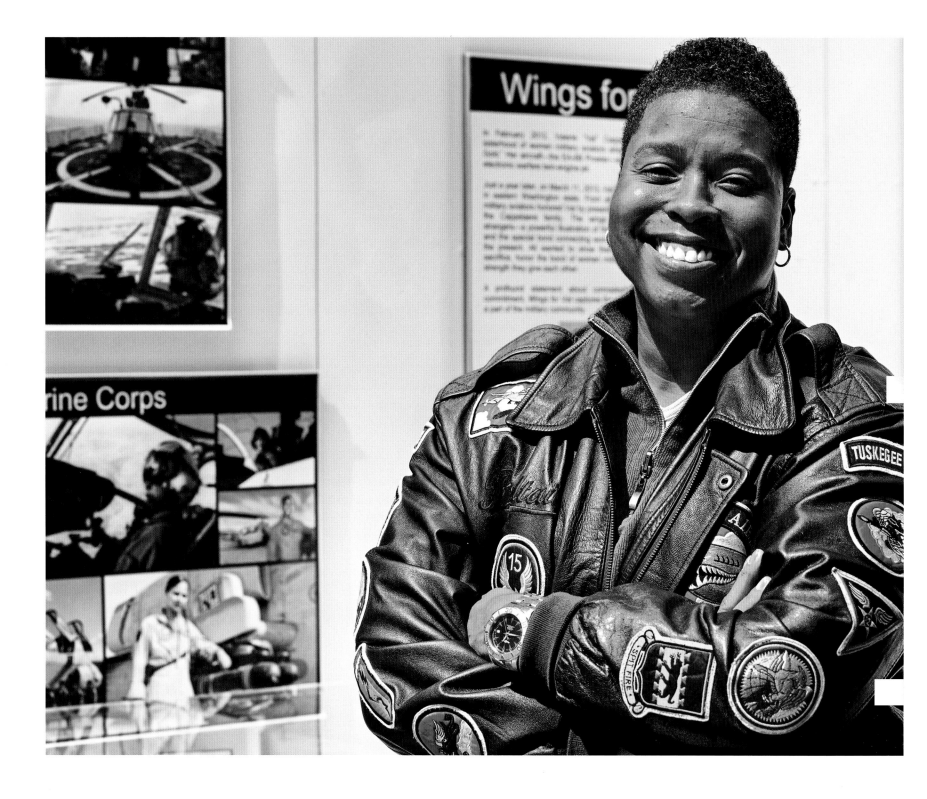

VERNICE ARMOUR

Deployment: Iraq 2004
Branch of Service: U.S. Marine Corps
Residence: Virginia
Occupation: Public speaker

★★★★★

"If we were to encapsulate my life and my philosophy,
I would say it's 'the gutsy move.' "

The possibilities for a prospective police officer seemed endless to Vernice Armour. It was career day at the ROTC advanced leadership training camp at Fort Bragg and the 20-year-old student planned to make the most of it.

She made it a point to stop at every tent of interest, including combat arms jobs restricted to women at that time. Reluctantly, she agreed to go with her battle buddy to the aviation tent.

A few moments later, Armour saw a woman who would change the course of her life. That woman represented a part of Armour she didn't realize existed until that moment: the part of her that had ambitions beyond her childhood dream. That woman inspired Armour to become the first African-American female combat pilot.

"I don't even know her name," Armour says. "[But] because of five minutes in that tent on that hot summer day in 1994, I'm here talking to you."

But that dream was still in the future. Armour had dreamed of being a police officer since she was four years old, so she withdrew from college after receiving an invitation to the police academy. After serving on the force for several years, she still hadn't forgotten that moment in 1994.

She had applied to become a marine while enrolled in school but was declined a slot. Shortly after she started her police job, she applied to Marine Corps Officer Candidates School. She was rejected again but refused to give up. Whenever Armour wanted something enough, she knew she would make it happen eventually.

"Delay is not denial," she has said many times.

In 1998 she was accepted into the program. After a year and a half of flight school, Armour graduated at the top of her class, earning her Pensacola wings of gold on July 21, 2001.

Her graduation happened to occur less than 60 days before September 11.

It wasn't long before FlyGirl made good on her nickname, deploying twice to Iraq. As America's first African-American female combat pilot, she protected the troops below from her AH-1W Super Cobra attack helicopter.

In August 2004 Armour was on a mission to take out a building containing materials that were used to create improvised explosive devices (IEDs) when her attack helicopter division received a new mission from the forward air ground controller.

They learned that the marines on the ground were out of ammunition, out of green signaling smoke, and pinned down by mortar fire. Armour was able to locate the ground troops after seeing their mirror signals.

Her helicopter had less than 20 minutes of fuel and only one missile left. Under fire, she circled around and took the shot. Nothing happened.

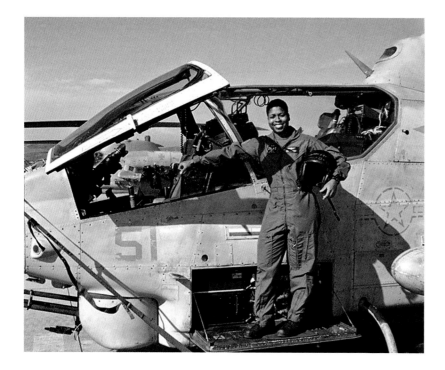

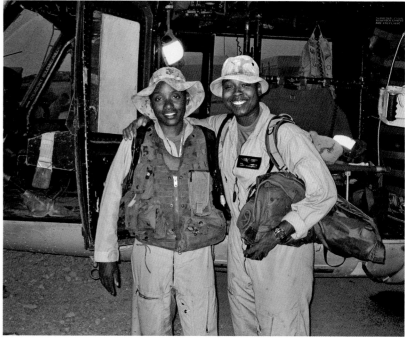

She reset switches and attempted to fire the missile again. It worked. Armour's division managed to make it back to base, and the marines made it home that night.

A few months later, she was at the military hospital for a routine checkup when she ran into one of the marines who had been on the ground that day.

"Ma'am, you saved my life," he told Armour.

"It was a very sobering moment—one I shall not forget," she recalls.

By November 2006 Armour had begun to speak for various organizations. It started as a way to give back to the community on a personal level. Then she wanted to do it full time. During one conference, she was approached by two women who were inspired to follow their dreams because of her speech.

Armour thought, Wow, I inspired them and I'm not even going for my plan A. It was at that conference that she made the decision to resign her commission from the Marine Corps to become a professional speaker. On August 7, 2007, Armour ended her tenure with the military. She didn't know much about turning professional speaking into a career, but she broke six figures within a year and seven figures within four years. Her latest dream had become a profitable reality.

She has achieved a personal dream as well. In September 2015, Armour welcomed her first child, a baby girl. "If we were to encapsulate my life and my philosophy, I would say it's 'the gutsy move.' It's not a haphazard move. In your gut you know it's right and it takes guts to do it," Armour says. "I help people and organizations make and take the gutsy move that leads to amazing, adventurous, juicy, epic outcomes." ■

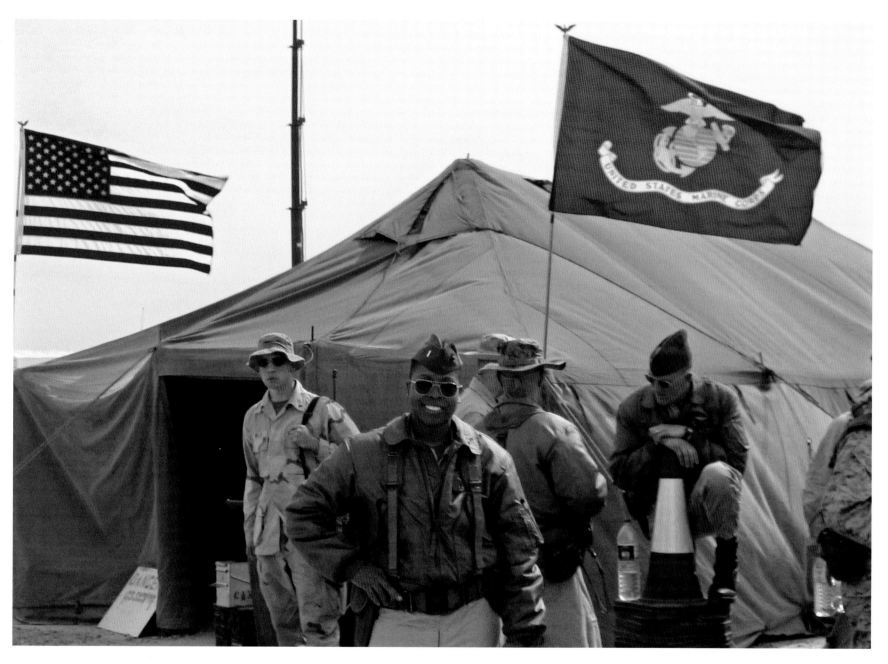

ABOVE: *Vernice Armour, boots on the ground, in Kuwait, 2003*

OPPOSITE: *(Left) Armour, the first female African-American combat pilot, prepares to preflight her Super Cobra helicopter in 2002. (Right) Misca Geter and Armour share a moment at Forward Operating Base Al Qaim in 2004.*

JIM FIORELLI

Deployment: Beirut 1983
Branch of Service: U.S. Navy
Residence: Virginia
Occupation: Assistant attorney general of the Commonwealth of Virginia

★★★★★

*"That's what kind of makes it really exciting.
Man is really at the edge of his capabilities in that environment."*

Jim Fiorelli hadn't really planned to follow in his father's footsteps. His father had been a merchant marine who had traveled the world. A young Fiorelli had often looked through his father's photos, coins, and mementos, but never imagined he'd do the same.

That's because, even at the age of 17, Fiorelli knew he was meant to be a lawyer. It was his father who reminded him that there was more than one path to achieve his goals. A liberal arts college would be traditional, but a military academy could provide him with financial assistance, adventure, experience, and a good education.

Fiorelli applied to both types of schools but, heeding his father's advice, chose the Naval Academy. Then he decided he wanted to fly, just like one of his role models, a famous trial lawyer who had written that his time as a Marine F-4 pilot had prepared him for any battle that arose in the courtroom.

Fiorelli would later agree, noting that to a young man in his early 20s, flying jets and landing them on naval carriers was the best feeling in the world.

"I think I've shaken two or three presidents' hands. Jimmy Carter gave me my diploma after I graduated. I went to law school and finished at the top of my class and all that," the 59-year-old Virginia man says. "None of that really compares to getting your wings, your naval aviator wings."

Landing jets on carriers could be difficult, especially at night. But Fiorelli loved the challenge.

"That's what kind of makes it really exciting. Man is really at the edge of his capabilities in that environment."

During his career, Fiorelli performed more than 400 carrier landings, 99 at night, and most during his three-year tour at sea. He flew missions in Beirut and surrounding areas in 1983, arriving shortly after the October bombing of the Marine barracks.

Fiorelli also engaged with the Russians during the peak of the Cold War. The Russians liked to show off that they knew where to find American warships and planes. As a pilot, Fiorelli would often intercept Russian bombers that had detected U.S. planes and cruisers with their radar.

"We knew they were coming."

Fiorelli and his fellow aviators would fly their planes at 500 miles an hour, get down to 200 feet, "and just go at them."

"You do things when you're younger not thinking about all the political implications," he admits.

After his tour, Fiorelli became a flight instructor and later joined the Navy Reserve. He retired from the Navy the day after he graduated from law school in his 40s. But flying is still one of the achievements of which he is most proud. ■

*Haziness over Bloody Lane, Antietam, Maryland—the
site of the bloodiest one-day battle in American history*

"I asked for a few Americans.
They brought with them the courage of a whole army."

GEN. ABDUL RASHID DOSTUM

RICK IANNUCCI

Deployment: South America 1982–1992
Branch of Service: U.S. Army
Residence: New Mexico
Occupation: Founder and director of Horses For Heroes

★★★★★

"For us, PTSD stands for post-traumatic spiritual dissonance.
We are here to recalibrate the soul."

Eric Yorty was a frustrated young man the day he arrived at Crossed Arrows Ranch. He had survived seven roadside bombs during his tour in Iraq, but the injuries had taken their toll. He had traumatic brain injury, damage to his back, and heart-wrenching memories that often took hold of him. Then he thought of the perfect job: a police officer, another role that would allow him to protect and serve. But his application was rejected. Opportunities were hard to find.

Yorty's mother worried as she watched her son struggle. Finally, she discovered Horses For Heroes, a nonprofit organization dedicated to helping wounded combat veterans through a unique program called Cowboy Up! She advised her son to look into the program.

Arriving at the ranch, located just outside Santa Fe, New Mexico, Yorty couldn't help but notice the rolling desert hills and sagebrush, the perfect setting for an old-fashioned Western.

Waiting for Yorty was the ranch's owner, Rick Iannucci, a retired U.S. marshal and former Green Beret who had commanded the Combined Country and Assessment and Training Team in Colombia. Iannucci had grown up in southeastern Pennsylvania, home to horse racing country. By age 12 he had trained and learned how to ride quarter horses, a passion he returned to once he left the service.

Iannucci first used his ranch to teach children leadership skills, but switched the focus in 2007, when he was asked to extend his services to wounded veterans.

Iannucci realized the ranching lifestyle itself would build camaraderie among the veterans as they completed routine chores. And working with the specially trained quarter horses could be a transformative experience, something he had witnessed many times.

"We saw these proud young men and women that were warriors, returning after multiple deployments with an amazing set of skills," Iannucci says. "These skills served them well in the military and got them home alive, but now they were being told, Forget about all that. But we said, Don't forget any of it. Tell us what it is that you know and we will show you how to rework it."

To do that, veterans must learn to be centered, says Nancy De Santis, Iannucci's wife and business partner, who administers Horses For Heroes. Drawing on years of experience, she adds, "A horse won't work with you if you are not calm and centered."

Contact with horses provides a perfect vehicle for reconnecting the spirit and the physical, adds Iannucci.

The program begins by teaching the veterans to groom and walk a horse. Later, they learn to ride and eventually work with cattle. By the second day, it is their job to teach the newcomers, Iannucci explains. "See one,

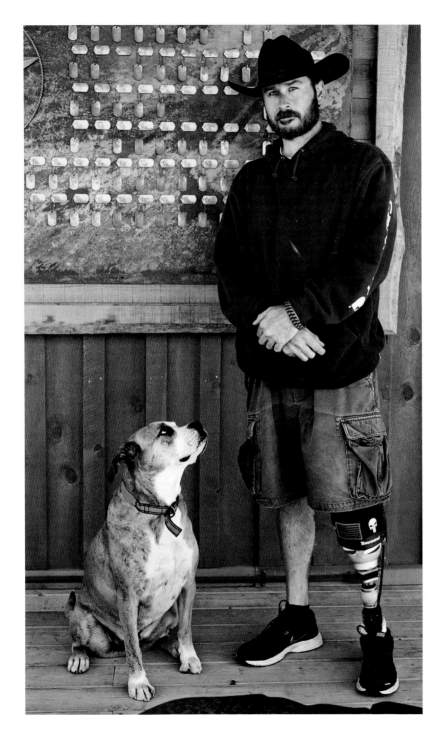

do one, teach one, true to the Special Forces concept," says Iannucci. "When they teach it back, that's when they own it. When they own it, that's when they are empowered with a renewed sense of self."

That was especially true for Chris Chaisson, who lost use of his left leg after a tour in Iraq. Eventually the leg was amputated and Chaisson had to learn how to function physically while also dealing with the mental scars of battle.

Because of his amputation, he has to mount a horse from the left side, which is unusual. However, because Chaisson was able to adopt the right attitude and patience, the horses learned to adapt to his rider's needs.

"Working with the horses does wonders for your self-esteem," Chaisson says.

It also did wonders for Yorty, who felt like a different person after the program. He chose to stay at the ranch as an instructor.

"It has given me a new avenue to excel at, similar to the things I excelled at in the military," Yorty says. "We have a primal connection to the animals, and the camaraderie we find with other combat guys redirects us to a better place."

That's the goal, and one Iannucci and De Santis continue to grow with the support of donations and endorsements.

Their message of empowerment and their ability to provide veterans with special skills has drawn veterans across the United States, and they have shared their expertise. Several of their students have gone on to work for other cattle ranches, which welcome them for their unique set of skills. ◼

"We have a primal connection to the animals, and the camaraderie we find with other combat guys redirects us to a better place," says Eric Yorty, instructor for Horses For Heroes.

BENJAMIN KING

Deployment: Iraq 2006–07
Branch of Service: U.S. Army
Residence: Maryland
Occupation: Mindful personal trainer

★★★★★

"You see what I look like right now on this table, Doc.
Wouldn't you be laughing?"

A feeling of euphoria swept over Sgt. Benjamin King as he touched American soil for the first time in nearly a year. After a tour in Iraq and recuperating from an IED wound, it was good to be home. But that feeling didn't last long. It was 2007, and like many other soldiers, King found himself filled with shame, rage, doubt, worry, and fear.

In Iraq, helping others understand each other was part of his job description. A psychological operations specialist who led a three-man operation, King worked with local authorities south of Baghdad. He generated positive relationships while gathering passive intelligence. He trained fellow soldiers on how to communicate with locals, understand the culture, and control crowds and defuse dangerous situations.

But he wasn't immune to dangerous situations himself. King was injured by an IED while in his Humvee on December 31, 2006. He was medevaced to a field hospital where doctors treated his groin injury.

"I couldn't help laughing at the situation I was in," King recalls. "And when a doctor probed my privates asking if it hurt, which it did, he asked me why I was laughing in that case."

"You see what I look like right now on this table, Doc. Wouldn't you be laughing?"

King began taking yoga and was encouraged to take meditation at the Veterans Affairs hospital.

As he did, he would often think about that Humvee. He thought about how a Humvee has heavy plates bolted onto it called "armor up" when it enters a dangerous zone. A soldier makes similar preparations. But unlike the Humvee, which is restored to normal once it is back on base, soldiers can't easily remove the mental armor that prepared them for battle. King and others needed to "armor down" in civilian life.

King realized he was only able to "armor down" when he started practicing meditation and mindfulness, as well as various other resiliency and transition practices.

That's how his organization, Armor Down, began. His website offered Quick Response codes for printing or smartphone scanning so soldiers could access the techniques on their own.

He also curated the "Mindful Memorial Day" exhibition of 6,821 yellow ribbons, one for each service member killed since 9/11, which hangs as a curtain at the Women's Memorial in Arlington National Cemetery, Virginia. Visitors are encouraged to honor a particular fallen soldier, so that, in time, each ribbon will have a name.

He also began a blog dedicated to veterans.

"The Army taught me how to armor up my mind and body for war," he states. "I taught myself how to armor down to thrive as a civilian." ■

MICHELE JONES

Deployment: Germany 1984, Honduras 1987, Afghanistan 2004
Branch of Service: U.S. Army
Residence: Maryland
Occupation: Retired special assistant to the secretary of defense as White House liaison

★★★★★

"It set me on a path of: I can control anything
[and] I can do anything. I felt unstoppable."

While celebratory gunfire was common in the mountains of Honduras, Michele Jones and her soldiers weren't taking any chances. They had arrived in the Central American nation in 1987 as part of a humanitarian mission. The mission wasn't without risks, however, as the region suffered from occasional outbursts of violence.

After gunfire erupted near her unit's encampment, Jones and her soldiers readied themselves to fend off a potential attack. That was when she realized her training as a paralegal had not prepared her for combat. In 1982, when Jones joined the service, military training focused on specific jobs, but lacked focus on fighting.

The gunfire faded and no attack transpired, but the moment had galvanized the young staff sergeant.

"I knew I was good at what I did, but I also knew I was not trained to be in the infantry," she says. "I did, as a soldier, need those types of skills . . . I wasn't prepared."

That was a problem she decided to remedy.

Determined to be the best leader she could be, Jones sought a reassignment that would allow her the training she needed. Within the year, she was sent to an airborne unit to train as a paratrooper. Her training forced her to tackle her fear of heights and falling. "It set me on a path of: I can control anything [and] I can do anything," says Jones. "I felt unstoppable."

Confident, Jones took on new challenges, mentoring others while tackling complex leadership issues. She later completed the U.S. Army Sergeants Major Academy, serving as class president, before becoming a division command sergeant major.

On October 28, 2002, Jones was selected to the Army Reserve's highest enlisted position of command sergeant major of the U.S. Army Reserve, where she served as the representative of all enlisted personnel and the adviser to the chief of the Army Reserve. She was also the first woman and first African American to hold this position.

Her new role provided her with an office inside the Pentagon; however, she spent much of her time in the field, traveling the world to visit enlisted soldiers. She made it a point to venture to desolate, forward-operating bases throughout Afghanistan and Iraq, sometimes surprising small contingents of soldiers when she arrived to explain that their needs were important. Back in Washington, D.C., she shared her findings with the military and Congress.

Jones retired after serving 25 years. Following her military career, she served as a special assistant to the secretary of defense as White House liaison. ■

DAN THOMPSON

Deployment: Iraq 2003–04
Branch of Service: U.S. Army
Residence: Washington, D.C.
Occupation: Foreign Service officer

★★★★★

*"I want to serve my country
and maintain my integrity."*

Dan Thompson joined the Army after ROTC in 1998. After serving in Kosovo in a peacekeeping role, he had serious reservations about the conflict in Iraq.

A religious man, Thompson wanted spiritual guidance before deploying to Iraq. On a whim he decided to fly to Rome and visit the Vatican.

While there, he followed a line of tourists approaching the confessional booths. Most priests appeared to be nodding off as the crowd made their way to the confessional screens. Once he took his turn, he realized his priest was dozing as well. He went ahead with his confession anyway.

"Father, I am due to go to Iraq in two weeks, and I don't know what to do."

That got the priest's attention. Putting his face close to the screen, the priest asked, "What are you doing here? Who are you?"

"I'm a soldier, a U.S. soldier stationed in Germany," Thompson replied. "I needed to come here to get clarity."

"Well, tell me more," the priest responded. "What do you want from me?"

"Well, I don't think I can kill a man. But I want to serve my country and maintain my integrity."

After deliberating, the priest said, "Listen, George Bush and Saddam Hussein will be judged not only by history but also by their Maker. But you pledged an oath to your government, to the U.S. government. It's a good government, so do your duty, protect your life and protect the lives of others, and you'll make it through."

Thompson left the confessional blessed with guidance.

Armed with the priest's advice, Thompson made it through 14 months in Iraq serving as a tactical operations specialist. During his deployment, he organized the initial rescue and evacuation of the United Nations building in Baghdad after the suicide bombing in September 2003 as well as coordinated complex live air-ground joint operations in combat.

He received two Army Commendation Medals for outstanding leadership and lifesaving coordination in Iraq. After his deployment, Thompson took on several leadership positions in communications and public relations for the U.S. Army.

Thompson wrote about his experiences in Iraq in order to make sense of what he had witnessed. He published his thoughts in a blog and later in a book called *American, Interrupted*.

In 2014 he became a Foreign Service officer at the U.S. State Department in Washington, D.C.

Thompson believes that his visit with the priest changed his outlook on life and his career. He took the priest's advice to heart, making it his own personal mantra, one that he continues to follow to this day.

"Protect your life and protect the lives of others." ∎

Robert "Rocky" Bleier

Deployment: Vietnam 1969
Branch of Service: U.S. Army
Residence: Pennsylvania
Occupation: Motivational speaker, retired NFL player

★★★★★

*"The one essence of all of our lives
is the creation of hope."*

Rocky Bleier sat up as the doctor examined his foot, knee, and thigh.

"You'll be fine. You'll be able to do normal things," he assured him. "I don't know if you'll be able to play football."

Bleier stared at the man in front of him, silently judging the doctor's competence.

Bleier thought, How did he know what it took?

Bleier had been in Vietnam less than five months when he was shot in the left leg and struck by a grenade in the right. Part of him recognized he was lucky to be alive, but the strongest part of him was more interested in what would happen next.

The 22-year-old Wisconsin native had been born to play football. There was no way he was going to give up now. He had already been placed on the Pittsburgh Steelers roster as one of their rookies. Of course, that was in 1968, before he had received his draft notice.

He was beginning to feel down about his prospects when a postcard from the Steelers' founder, Art Rooney, arrived. "Rock, the team's not doing well. We need you."

"That was just the inspiration I needed," Bleier would say later.

As infantrymen, the draftees' mission was to protect helicopter landing zones and guard necessary ammunition and artillery. Bleier quickly acclimated to his surroundings as he got in the routine of walking patrols and watching out for the North Vietnamese Army or Vietcong guerrillas. It became Bleier's job to carry the grenade launcher.

In August Bleier got his first real taste of combat. Bleier and his unit had been sent to the jungles of Vietnam in the dark of night to find any of the men in their sister company, Bravo, which had been attacked earlier in the day.

They found the remains of fallen soldiers, resolving to bring them back to camp, until they were fired upon.

A few days later, Bleier and a few members of his unit returned with reinforcements. The point man headed toward the left. When he saw the North Vietnamese soldiers, he shot in their direction.

Bleier and his group dropped to their knees in the rice paddies, trying to avoid enemy fire. Within moments, four of their guys were pinned down. Bleier could see the machine gun about 250 feet away.

He and his fellow soldiers worked to save the four men pinned down, while trying to maintain their cover. Bleier was one of a few to sustain injuries after a grenade landed next to him, leaving shrapnel in his right foot, knee, and thigh.

After his initial wounds were treated, Bleier went back to Pittsburgh, hoping to land his old job again. But it would take two years to get

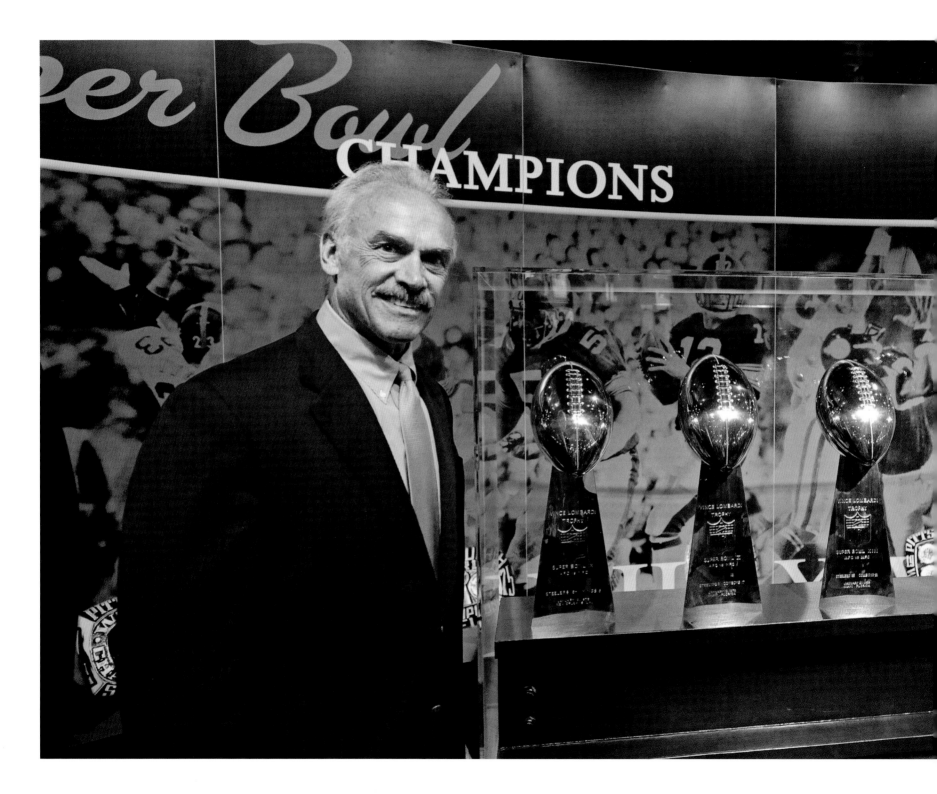

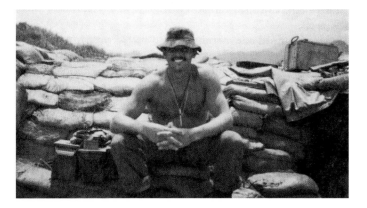

ABOVE: *Rocky Bleier takes a break from his infantry duties in Vietnam in 1969.*

LEFT: *Bleier recalls the four Pittsburgh Steelers Super Bowl Championship trophies he helped win.*

onto the team's active roster. He made it a point to head to the gym almost immediately, but he kept facing setbacks. He ran and limped on his injured legs, lifted weights, and tried his best to get into shape. Training camp was brutal.

Then he received the devastating news that he was going to be cut from the team. Instead of packing up his locker, Bleier insisted on staying to practice with them. The next day, Dan Rooney, Art's son, decided to put him on injured reserve, buying Bleier an extra year to recover.

Bleier made the most of it. He gained weight and became the leading ground gainer during the exhibition season in 1972, 1973, and 1974.

Bleier helped the Steelers win four Super Bowl championships. He also became known for his service to his country. Despite the negative press Vietnam veterans received, Bleier was heralded as a hero. "I became somewhat of the poster boy," he says.

After he retired from football, Bleier wrote a book and gave motivational speeches.

"The one essence of all of our lives is the creation of hope, of what we can do and what we can accomplish and having a support system to give you opportunities so you can do it," he says. "Having a sense of value of who you are as a person, of what you want to get accomplished, becomes important." ∎

COURAGE

"Courage is not having the strength to go on;
it is going on when you don't have the strength."

THEODORE ROOSEVELT

NICK DEMIRO

Deployment: Germany 1990–93
Branch of Service: U.S. Army
Residence: Michigan
Occupation: President of an automotive tier one supply company

★★★★★

*"After landing, I literally dropped to my knees and kissed
the ground. I had never been so scared in my life."*

Nick DeMiro scanned the horizon, searching for the lights that were supposed to illuminate the small island off the Danish coast. But only darkness surrounded the young Army lieutenant and his UH-1 Huey helicopter.

It was the early 1990s and DeMiro, who had been serving in Germany, had been sent to Denmark with a platoon of 30 soldiers to train with NATO forces. Still working to achieve his pilot-in-command status, DeMiro had been grateful for the opportunity to transport one of the military's high-ranking generals between islands. The unique landscape made landing a challenge, but one that was easily met by DeMiro and his pilot-in-command.

After consulting maps and checking fuel and weather, DeMiro and the rest of the crew felt certain their return to their home base would be easy. DeMiro took the controls.

Using dead reckoning, or time, distance, and heading as the main navigation method, DeMiro and crew estimated they would see lights from their small island destination about 30 minutes into the flight. Instead, they remained in darkness, the sun no longer lighting the horizon.

DeMiro began to feel disoriented as a wave of vertigo hit him.

"My internal senses were telling me one thing, and the instruments were telling me another," he says.

DeMiro handed the controls over to the pilot-in-command, but he began to experience the same phenomenon.

The situation grew worse when the fuel light came on, indicating they only had 20 minutes to land.

"I felt really sick but knew we needed to maintain control of our emotions, and make smart logical decisions," he recalls.

Instead of panicking, DeMiro and crew quickly made a call to Denmark Air Traffic Control and asked for vectors to their destination. They also called the crew at home base and asked them to set up a strobe light to help identify the landing zone. The pilot-in-command finally regained his orientation, and they turned the aircraft to the appropriate heading. Within several agonizing minutes (that seemed like hours) they saw the brightly flashing strobe light in the far distance.

"There was an amazing sense of relief that had overcome us all," remembers DeMiro. "After landing, I literally dropped to my knees and kissed the ground. I had never been so scared in my life," he recalls.

"There are so many lessons that I learned from that experience and the many more extreme challenges encountered during my Army career," said DeMiro. "The greatest characteristic that I developed throughout my career as an officer in the Army is the ability to understand how stress and crisis affect me and to separate emotion from logic." ■

GRETHE CAMMERMEYER

Deployment: Vietnam 1967
Branch of Service: U.S. Army
Residence: Washington State
Occupation: Sleep nurse specialist

★★★★★

*"The process of a personal journey of self-discovery was difficult and painful,
but necessary to find the real me."*

Margarethe Cammermeyer was born in Oslo, Norway, in 1942. Her parents were active in the Nazi-resistance movement. Her mother smuggled weapons under the mattress of the baby carriage where Grethe slept.

"As I grew up, my heroes were those resistance forces and my parents who stood up to the bad guys," she said.

In 1946 her father, a doctor, received a coveted Rockefeller Fellowship to further his studies in neuropathology. The Cammermeyer family eventually settled in the Washington, D.C., area in 1951.

In 1960 Cammermeyer became an American citizen. Longing to give something back to her adopted country, she joined the Army as a student nurse.

On active duty in 1963, she served in the United States and later in Germany, where she met and married her husband, a fellow soldier. Cammermeyer volunteered for Vietnam after her husband received his orders. His orders were canceled, but she left on her own, arriving in 1967. Six months later, Cammermeyer became head nurse of the neurosurgical unit. She had great admiration for "America's best crop of youth in dire circumstances."

After 14 months in Vietnam, Cammermeyer returned to the United States. Women in the Army were not permitted to have dependents, so she was forced to leave in 1968 when she became pregnant. After giving birth to four sons, Cammermeyer returned to the Army Reserve, since the rule had changed in 1972.

While she continued to excel professionally, her marriage ended in divorce. Cammermeyer later realized that she was a lesbian. Eventually she found happiness with her partner, Diane Divelbess.

She also found success in her military career, achieving the rank of colonel in 1987, and accepting the position of chief nurse of the Washington State National Guard in 1988. A year later, Cammermeyer interviewed for a top secret clearance position during which she had to reveal personal information, including that she was a lesbian.

As a result, she was dismissed—her life's work and accomplishments forgotten. Devastated, Cammermeyer took the issue to court in 1992. After 25 months, the judge ruled her discharge unconstitutional.

Reinstated in 1994, Cammermeyer was unhappy with a piece of legislation commonly called Don't Ask, Don't Tell that prohibited homosexuals from serving openly in the military. Her struggle for equality was publicized in her autobiography, *Serving in Silence,* and in the television adaptation starring Glenn Close and co-produced with Barbra Streisand.

In 2011 Don't Ask, Don't Tell was repealed. In an interview with ThinkProgress.org, Cammermeyer said, "Before the repeal, we in the service represented the flag. Now the flag represents us." ∎

J. Howard Shannon

Deployment: Afghanistan 2005, 2007
Branch of Service: U.S. Army
Residence: New Mexico
Occupation: Writer

★★★★★

*"I served all those years and never went to war. When the call came,
I was like, Yeah . . . Okay, I'm ready to go."*

"Joining the Army was the single smartest thing I ever did with my life," J. Howard Shannon affirms.

With a long family history of military service, Shannon joined the Army in 1983. Trained as a paratrooper and deployed to Italy, he joined the only airborne combat team in Europe.

"It was beautiful, it was a dream tour," Shannon recalled.

In Italy Shannon met his wife, and their first daughter was born. Later, in 1986, he went off active duty, took his family home to New York, and completed a bachelor's degree at Cornell University. Meanwhile, he joined the National Guard.

In the wake of September 11, Shannon's unit was called up. As a squad leader, he was charged with guarding part of LaGuardia Airport and, later, a nuclear power plant. By 2004 Shannon had received a direct commission as a lieutenant, and at age 40 he entered infantry officer school at Fort Benning.

"I served all those years and never went to war," said Shannon. "When the call came, I was like, Yeah . . . Okay, I'm ready to go."

In May 2005 Shannon deployed as an individual augmentee for the Third Special Forces Group. Stationed at Bagram Air Base in Afghanistan, Shannon worked as a battle captain in the Combined Joint Special Operations Task Force (CJSOTF) Joint Operations Center (JOC). He monitored special operations activity and coordinated medevacs, close air support, and supplies.

During Shannon's third week, U.S. Navy SEALs, who were part of the CJSOTF, initiated Operation Red Wings, hoping to disrupt anti-coalition militia activity in the Asadabad area. During reconnaissance, four SEALs unexpectedly encountered and detained three Afghan shepherds. Following the rules of engagement, the SEALs released the shepherds, who then alerted the Taliban. The team came under heavy fire. A quick reaction force sent to extract them was shot down as they neared the area. Sixteen men in that helicopter were killed, as were three of the SEALs.

"When we understood what had happened—that was a real shocking and painful moment," recalls Shannon.

The JOC team labored to coordinate the recovery of those killed and the subsequent rescue of Marcus Luttrell, the only SEAL to escape.

Later that year, Shannon himself came under fire during a mission to reengage local Afghans. "Everyone has the question: When I'm under fire, what am I going to do? I felt like I acquitted myself well."

Shannon deployed to Afghanistan again in 2007. Now a captain, he commanded 233 troops charged with protecting American soldiers training Afghan police and the Afghan National Army. All arrived safely home after their 12-month deployment. ■

PAUL GALANTI

Deployment: Vietnam 1965
Branch of Service: U.S. Navy
Residence: Virginia
Occupation: Retired director of a pharmaceutical association

★★★★★

"You can decide who you want to be and how you're going to feel.
If you act enthusiastic, you will feel enthusiastic."

"Most civilians don't understand the military or its humor," Paul Galanti begins. "A good Marine friend of mine put my POW experience this way. 'Galanti, you're the luckiest son of a gun alive. You were in the Navy for 20 years; you only had to make one cruise, and most of that cruise was overseas shore duty, living in a gated community.' "

That type of humor, what some might refer to as "gallows humor," has been an effective coping mechanism that has helped Galanti deal with the demons he has faced since the six excruciating years he spent as a prisoner of war in Vietnam. Galanti works to put his experiences in perspective and chooses to maintain a positive outlook on life.

Galanti remembered the first time he knew he wanted to be a pilot. As a child, he watched Chuck Yeager fly his jet past the crowd at a local air show. "That's all it took for me to get hooked," he recalls.

Galanti fostered his dream to fly jets by attending the Naval Academy in Annapolis, Maryland. In November 1964 he was assigned to the Navy Light Jet Attack Squadron 216, based aboard the carrier U.S.S. *Hancock*. It departed for Southeast Asia in November 1965.

Galanti flew 97 combat missions in his A-4C Skyhawk before being shot down and captured by the North Vietnamese on June 17, 1966. "I was nearly 27 years old when I was shot down and captured. I was 33

years old when I was released from captivity—that was the prime years of my youth that I spent as a POW in a foreign land."

The first three years were brutal for Galanti, who spent most his time in solitary confinement when he wasn't being tortured. But the first nine months were the worst.

"Solitary confinement tore me apart piece by piece. I was confined to a four-by-seven-foot cell alone with my thoughts. The window and door were boarded up and only a small amount of daylight would enter the cell through the cracks that were open," he recalls. "The Vietcong were experts at understanding how to maximize the discomfort of their prisoners. With temperatures soaring to the high 90s most of the time, the outside bricks of the building absorbed the heat and each cell became an oven, almost baking us alive. There was no room to walk or pace around in."

He was also subjected to routine torture sessions. The Vietcong wanted personal and military information from its American prisoners and would do almost anything to get it. In four of his torture sessions, the Vietcong tied tourniquets around his arms and pulled until his elbows touched each other. He lost all circulation in his arms, and they turned black.

They repeatedly questioned Galanti during the process, not letting up until they thought they had the information they needed.

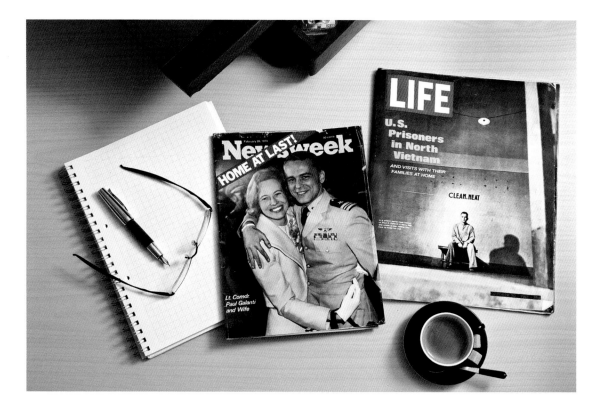

"I lost feeling in my hands and arms for almost six months before the feeling returned to them," says Galanti.

Despite his constant refusal to cooperate, the Vietcong chose Galanti as the prisoner they wanted to use as a tool in a propaganda campaign. Their goal? They wanted Americans to believe they treated their prisoners well. To achieve this illusion, they temporarily removed him from his atrocious surroundings, placing him in a much larger, cleaner cell, and took his photograph. The photo, with the words "clean" and "neat" stenciled above his head, was published on the front page of *Life* magazine on October 20, 1967.

Galanti never knew why the photograph was published. But he refused to smile and help the Vietcong share their message that American prisoners were treated well.

His situation began to improve around 1969, right about the same time Ho Chi Minh died. That's when the Vietcong started releasing some of the early American POWs.

Galanti was returned to U.S. custody in 1973, and he was transported back to the United States for debriefing and medical care.

"It took me a while to recover and regain my weight and strength back but I eventually did."

Galanti remained with the Navy until 1983, when he left to become the executive director of the Virginia Pharmaceutical Association. On alternating years he and more than 400 other ex-POWs have held reunions where no press or outsiders are allowed. Together, they are 400 extraordinary men who have turned a traumatic experience into a private triumph, Galanti says.

His optimism shines through when he reflects on the philosophy that enabled him to surmount such a devastating experience. "The proper attitude is don't get hung up on bad things. They are always around. You have to deal with things, but you don't get stuck on them," Galanti says. "You can decide who you want to be and how you're going to feel. If you act enthusiastic, you will feel enthusiastic." ■

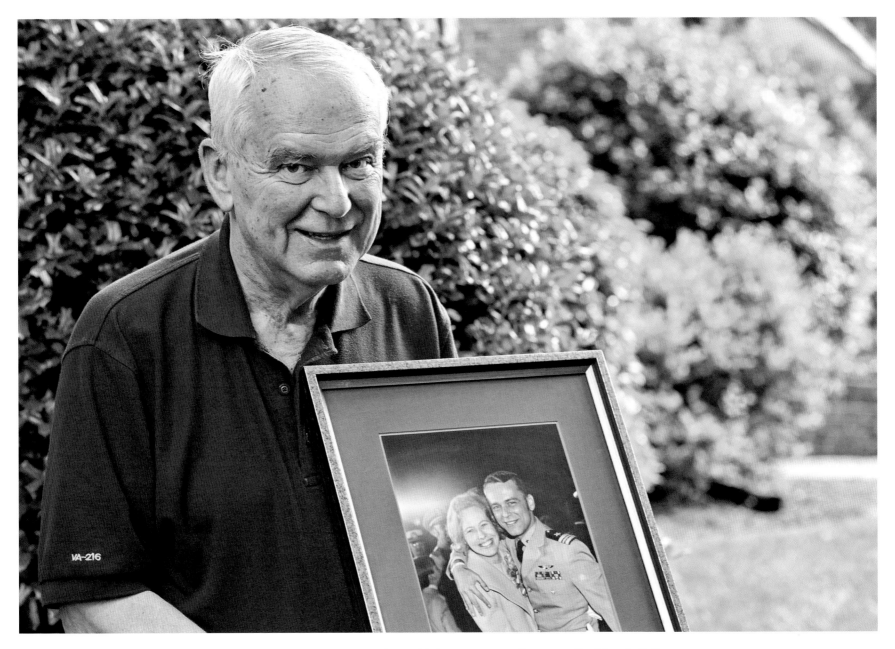

ABOVE: *Paul Galanti holds an original print of the homecoming image of his younger self with his wife, Phyllis.*

OPPOSITE: *Galanti, then a prisoner of war, appeared on the cover of* Life *magazine in 1967.*
He says the North Vietnamese used him for a propaganda campaign. He refused to smile.
Newsweek *later published a piece featuring Galanti's homecoming.*

MITCHELL ROWLEY

Deployment: Afghanistan 2009–2010, 2012
Branch of Service: U.S. Marine Corps
Residence: California
Occupation: Student

★★★★★

*"I will always remember how fortunate I was
to receive a second chance at life and a career."*

Mitchell Rowley enthusiastically joined the Marine Corps in 2002, at age 17. With his stoic face and inquiring personality he was the perfect candidate to work inside the intelligence branch of the Marines.

During his first deployment to Afghanistan in 2009, Rowley was involved in various intelligence-gathering activities, including the interrogation of suspects who posed a threat to the Afghan people or the U.S. military.

He also befriended several Afghans, making an effort to learn more about their culture and provide mentorship if desired. Told never to speak about politics and religion, he soon discovered that those were the subjects the Afghan people wanted to discuss with him the most.

In 2012 Rowley received orders to return to Afghanistan. He did not know that his second deployment would become a life-threatening event for him, one not caused by a cruel act of war.

"I had only been on the ground in Afghanistan for 45 days when my whole world started collapsing in on me," recalls Rowley. With each day his energy level decreased, and his flu-like symptoms grew steadily worse. Pushing himself to make it through patrols, Rowley was also experiencing excessive sleepiness and random blackouts. "It got so bad," he says, "I finally checked in with the military doctor at our camp."

Hospitalized immediately, Rowley underwent a battery of tests. The results revealed that he had been experiencing the early stages of a diabetic coma. Despite being treated quickly, he lapsed into a full diabetic coma and woke up in a British hospital in Afghanistan. Eventually he was stabilized and transferred to Germany, where he slowly recovered.

Rowley has little memory of that time. His doctors told him that he was lucky to have survived. He was diagnosed with type 1 diabetes, rarely found in adults. Had he delayed medical treatment, he would have certainly died. Deeply grateful for the expert care, Rowley now wears an insulin pump 24 hours a day; it will be with him for the rest of his life. He returned to his home in Oregon and received an honorable discharge with 100 percent disability.

After serving as a marine for more than ten years, he had been thinking about his next career move before he fell ill. He considered becoming a warrant officer, joining the Army or joining civilian life.

After receiving his discharge, he decided to go to college to pursue another one of his passions: marine biology.

Rowley flashes his winning smile and becomes philosophical. "There's a kind of poetic justice about the whole event," he says. "I'm glad to be able to keep the word 'marine' in my world as I go forward with my life. I will always remember how fortunate I was to receive a second chance at life and a career." ■

"We are determined that before the sun sets on this terrible struggle our flag will be recognized throughout the world as a symbol of freedom on the one hand and of overwhelming force on the other."

ARMY CHIEF OF STAFF GEORGE C. MARSHALL

Flags flap on a farmland fence in the early morning fog of the Pacific Northwest.

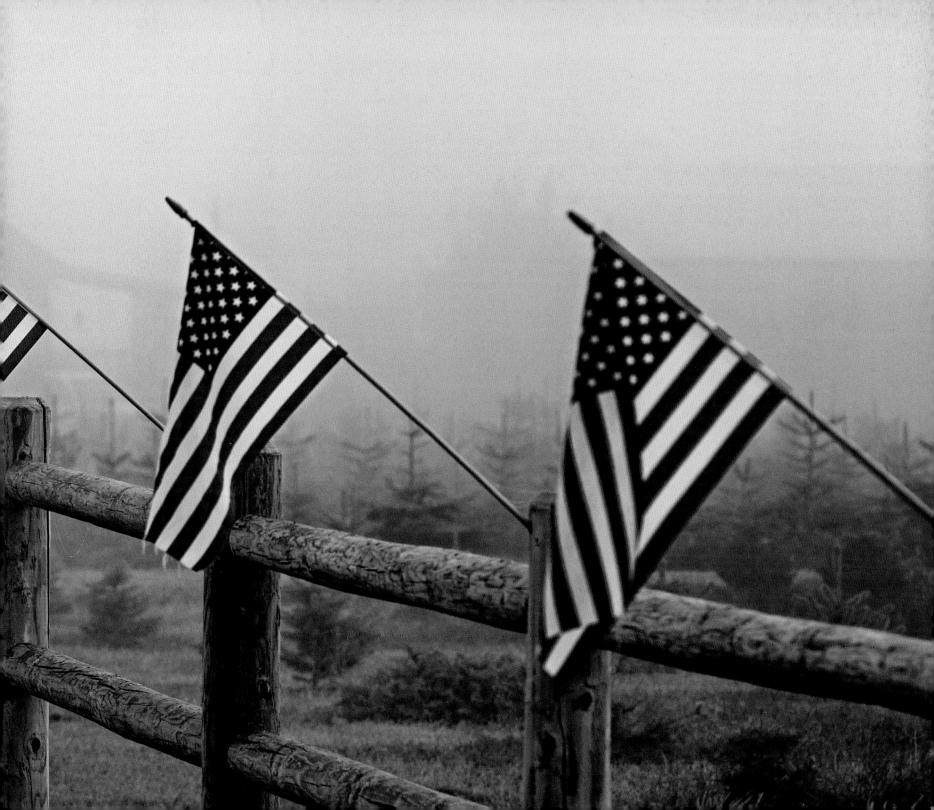

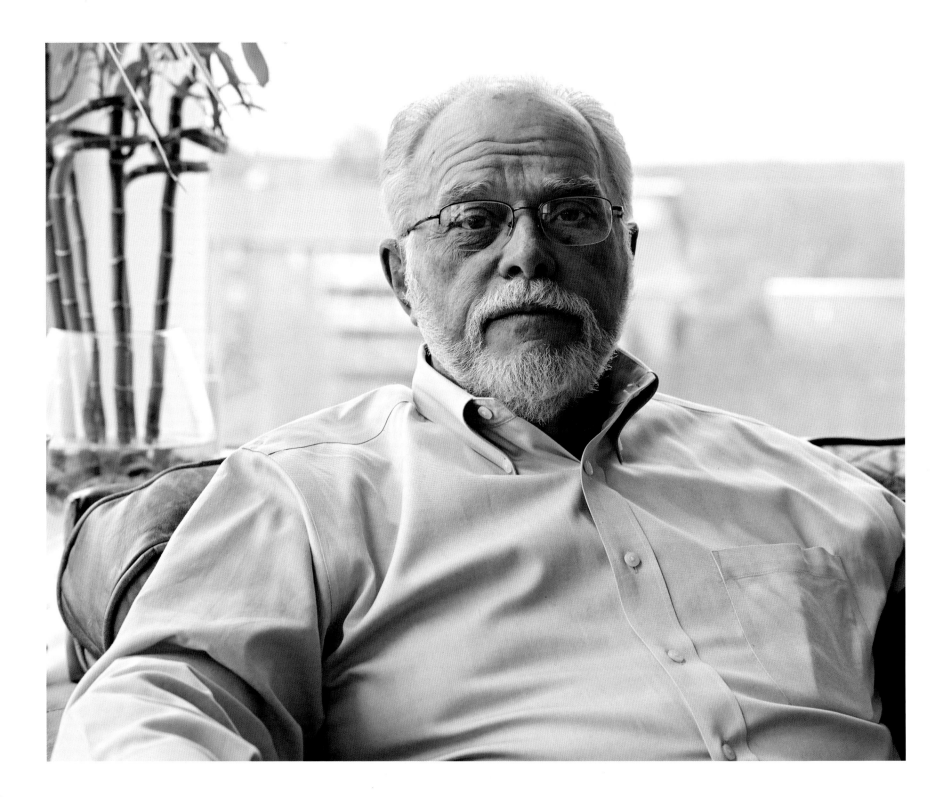

FRED THACHER

Deployment: Vietnam 1964–67
Branch of Service: U.S. Army
Residence: Massachusetts
Occupation: Semi-retired health care entrepreneur

★★★★★

*"Fred, you've gotta get fluids or
you're going to die!"*

Fred Thacher was barely lucid. The fever and chills racked his body until he slipped into unconsciousness, unaware of the battles going on around him.

After several days, he came out of the coma, but his mind remained elsewhere. With a single hallucination, the senior combat medic realized his situation was dire. He watched as a vision of himself called out, "Fred, you've gotta get fluids or you're going to die!"

After barely two years of retrieving wounded Vietnam GIs, he had collapsed because a tiny insect had given him malaria. Thacher checked into the local field hospital until he could return to the front lines.

He had arrived in Vietnam in August 1965, and he decided to remain for two tours without a break. Fascinated with science and how the body worked, Thacher knew his skills were needed.

An active combatant, he arrived with infantry on air assaults. He would use his medic skills to stop profuse bleeding before bringing the wounded to safety. He performed numerous rescues under fire, tending to more than 600 soldiers as well as hundreds of civilians, before he left the country in April 1967. He was later awarded a Purple Heart, a Bronze Star, a Combat Medical Badge, and an Air Medal.

When he wasn't tending to the wounded, he spent time with Vietnamese civilians, including many members of the ethnic minority known as the Montagnards. Thacher admired their culture, noting many of them had aspirations similar to his own.

From the Central Highlands, the Montagnards are a minority ethnic group known for their primitive lifestyle. They had sided with the Republic of Vietnam and the Americans, a choice that cost them greatly when the Vietcong slaughtered many of their people in 1967.

When he finally returned home, Thacher discovered a drastically different political climate. "The first days when I got out, I had nothing but military clothing," Thacher recalls. "People were yelling at you, swearing at you."

Able to understand the antiwar sentiments, he was frustrated by this reception, especially since he couldn't secure a civilian job.

"Every Vietnam veteran I think that I've ever met that had been in real combat went into business for themselves, something more self-employed as opposed to becoming more involved in corporate America," he says.

That's how Thacher found his own success. After receiving his military discharge, he studied medical sociology, which led to his own business in promoting the curative properties of blood.

Through his company, ZMBAT Medical Innovations, Thacher has become a leader in his field, aiding inventors and their research with the latest technologies used in hospitals. ∎

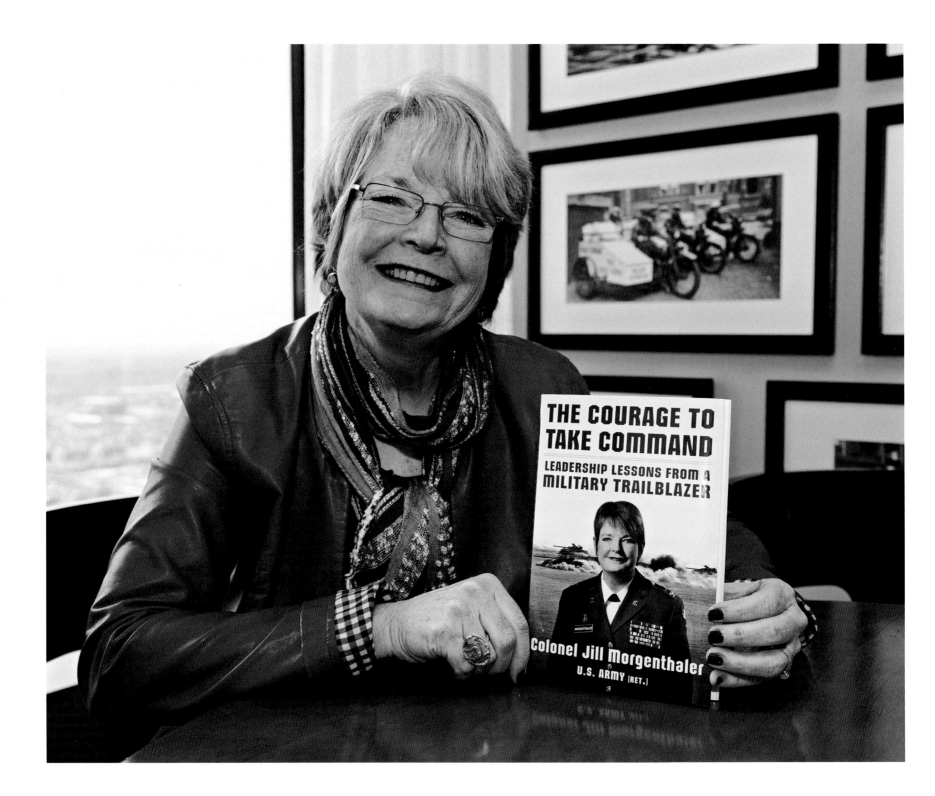

JILL MORGENTHALER

Deployment: Iraq 2003–04
Branch of Service: U.S. Army
Residence: Illinois
Occupation: Author, motivational speaker

★★★★★

"I wanted to meet Hussein—I wanted to see for myself what kind of person
could possibly commit the crimes he was being accused of."

"Fake it until you make it" was the motto Jill Morgenthaler's father instilled in his daughter before she left for ROTC boot camp in the mid-1970s. Morgenthaler soon found out that being a woman serving in the Army was going to be one of the toughest challenges of her young life.

Back then, many male soldiers were angry to see women coming in as equals and leaders. "Every step and turn was filled with obstacles—verbal challenges, meaningless work duties, and threats," she recalls. "The generally accepted goal at that time was to make women want to quit and leave the service." Morgenthaler's father (a former marine) and mother raised her to believe quitting was not an option.

"This helped me get through the military. Once I understood this and mastered my can-do attitude, two things happened," she says. "The Army slowly became more accepting of women, and their opinions and knowledge started to matter to our superiors. As I became successful with my expanding duties, it was soon clear to me I could make it for the long haul." Over her 30 years of military service, Morgenthaler rose through the ranks, eventually becoming a colonel before she retired in 2006.

In 2003 the entire world watched as U.S. armed forces hunted down and captured Saddam Hussein inside Iraq. Morgenthaler, by then an Army colonel and commanding an Army Reserve brigade, was sent to Baghdad to coordinate all the public affairs and media issues for the multinational forces under the command of Gen. Ricardo Sanchez. Hussein was scheduled for his first judicial hearing for crimes against humanity.

Morgenthaler decided to release her soldiers from their duty of escorting the media and did it herself. She explains, "I wanted to meet Hussein—I wanted to see for myself what kind of person could possibly commit the crimes he was being accused of."

Soon Morgenthaler was escorting American media anchors like Peter Jennings and Christiane Amanpour and reporters from Middle Eastern news agencies like Al Jazeera and others into a tiny courtroom in Baghdad. She was stationed outside the courtroom as she waited for events to unfold inside.

"Out of nowhere, a lone bus pulls up and the doors swing open, revealing a group of heavily armed guards surrounding Saddam Hussein," recalls Morgenthaler. "Dressed in a suit and restrained with wrist and leg shackles, Hussein clumsily stumbled out of the bus. He was looking down at the ground, and it was obvious to everyone present that Hussein was visibly shaking with fear."

Morgenthaler and others speculated that Hussein most likely thought he was going to be executed on the spot, not unlike the way he had carried out his brutal style of justice on the people of Iraq.

Once Hussein understood that he was not going to die immediately,

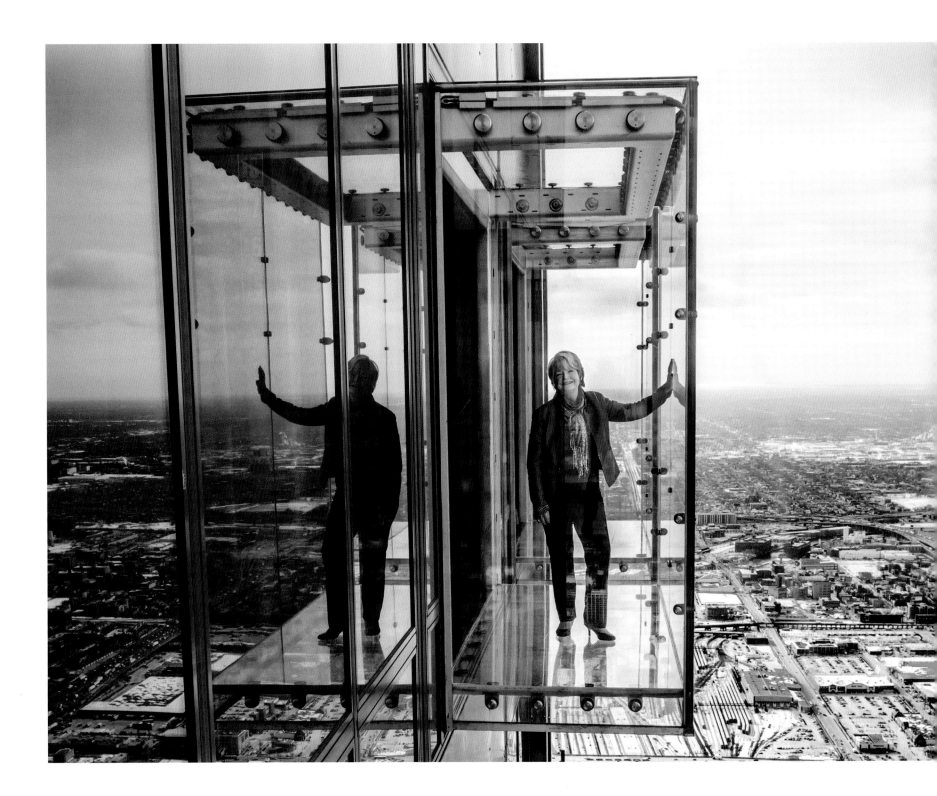

ABOVE: *Jill Morgenthaler wears her signature purple shoes above bustling Chicago.*

LEFT: *At the Willis Tower Skydeck, Morgenthaler recalls, "My father always told me 'Fake it until you make it,' and that is exactly what I do in a critical situation."*

Morgenthaler realized the day was going to become even more interesting. "He started threatening the judge and the people in the courtroom, announcing: 'Everyone is going to die when I regain my rightful power!' The transformation from coward to tyrant occurred in an instant. The arrogant and self-righteous Hussein had returned—he thought he was now on top of the world, and he would show them what his supreme power really meant!"

After the hearing, Hussein was escorted from the courtroom. He took notice of Morgenthaler standing against the wall. The American Army colonel and Saddam Hussein were less than three feet apart. "Hussein stopped and started to check me out from head to toe," recalls Morgenthaler. "I felt like I was being undressed by his eyes, like I was some blond bimbo waiting for him." Suddenly she heard her father's voice inside her head: "Fake it until you make it"—and that's exactly what she did. Morgenthaler thought, You don't stare at me that way. She started staring right back, using all her nonverbal skills to silently telegraph to him: Yes, you are a truly disgusting person.

As she continued to stare, Hussein yelled something in Arabic. His guards burst out laughing. As they led him away, she asked one of the guards what he had said. The translation was "Kill her!"

"It was the Hussein way. If anyone stared or looked at him inappropriately, he would have them instantly killed," says Morgenthaler.

She thought about it for a moment and concluded, Saddam Hussein, you truly have forgotten where you are. ∎

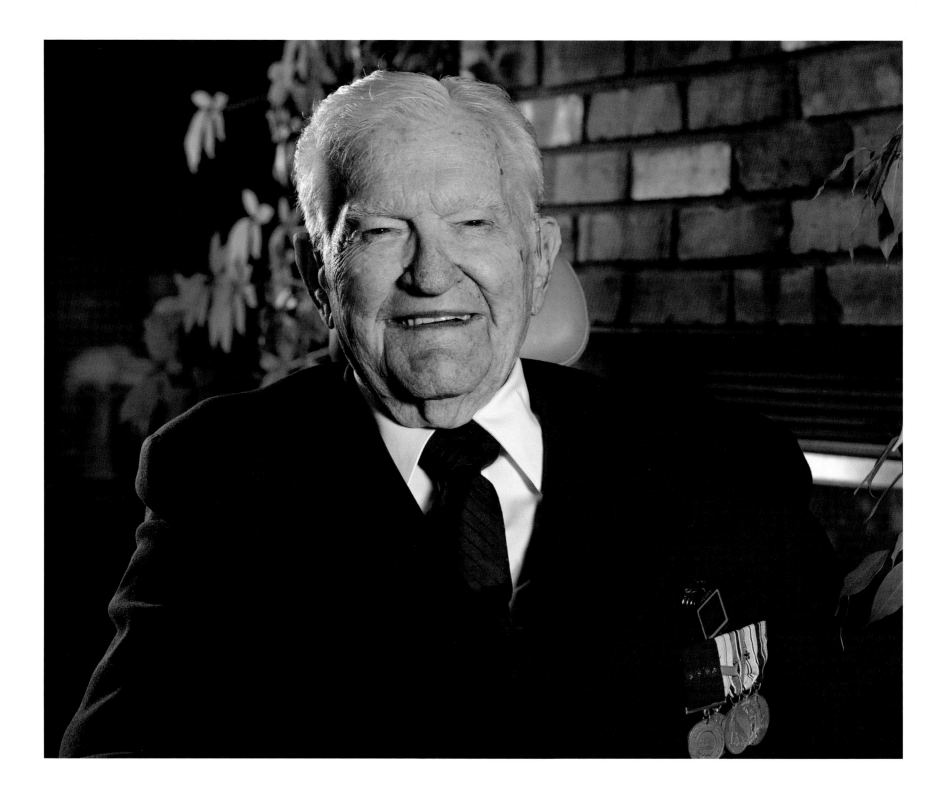

JIM DOWNING

Deployment: World War II, Pacific 1941–45
Branch of Service: U.S. Navy
Residence: Colorado
Occupation: Retired

★★★★★

*"We lost 107 naval officers and men. Seventy were belowdecks,
trapped or killed from the explosion."*

"Lord, I'll see you in a minute," said Lt. Jim Downing as shots rained down from the sky. The bullets from a Japanese machine gun had practically formed a trench near where he stood. Moving across the harbor was a tanker with a capacity of six million gallons of aviation gasoline. Downing expected the tanker to explode any minute. It never did.

Currently a resident of Colorado Springs, Colorado, this 102-year-old is one of the oldest surviving veterans of the December 7, 1941, attack on Pearl Harbor.

A newlywed, Downing was on the shore in Oahu when the attack started, but his home for more than ten years had been aboard the U.S.S. *West Virginia.* The U.S.S. *West Virginia* was moored alongside the battleship U.S.S. *Tennessee* to the quay wall in Pearl Harbor. In 1932, at age 19, Downing had left home to join the Navy. He had come from a house without electricity or indoor plumbing. To him, the battleship was an impressive upgrade.

On December 7, 1941, 40 Japanese Type 91 aerial torpedoes were launched on Pearl Harbor just after 0800. Nine struck the U.S.S. *West Virginia,* creating a watery grave. According to Downing, the battleship quickly sank, and everything above the waterline was on fire.

"We lost 107 naval officers and men. Seventy were belowdecks, trapped or killed from the explosion," says Downing.

When the first wave of the attack hit, Downing made his way to his battleship by sliding down a gun barrel of the U.S.S. *Tennessee* to get aboard the *West Virginia.* Downing fought fires, wondering if it would be the last day of his life.

Not being able to bear the thought of families never knowing the fate of their sons, Downing hurriedly memorized the dog tags of the dead and injured; his friends and comrades aboard the sinking ship. Later, he would go to the hospital where more than a hundred people were badly burned. The ones that could talk gave their names and dictated messages to their families via Downing.

"What amazed me was how optimistic they were," recalls Downing. "They said to their parents 'Don't worry, I'll get out of this.' And then most of them died that night."

The humiliation of watching ships and airplanes be destroyed and men die has stayed with him to this day. For a long time, Downing struggled with the shame of surprise and defeat he felt over what happened that December.

According to intelligence, Downing advises, there were at least 27 warnings and 164 ships in the port. Each day, the submarine net, closing the mouth of the harbor, would allow a tugboat in to take garbage from each ship out to sea. During this routine procedure, a Japanese submarine tried

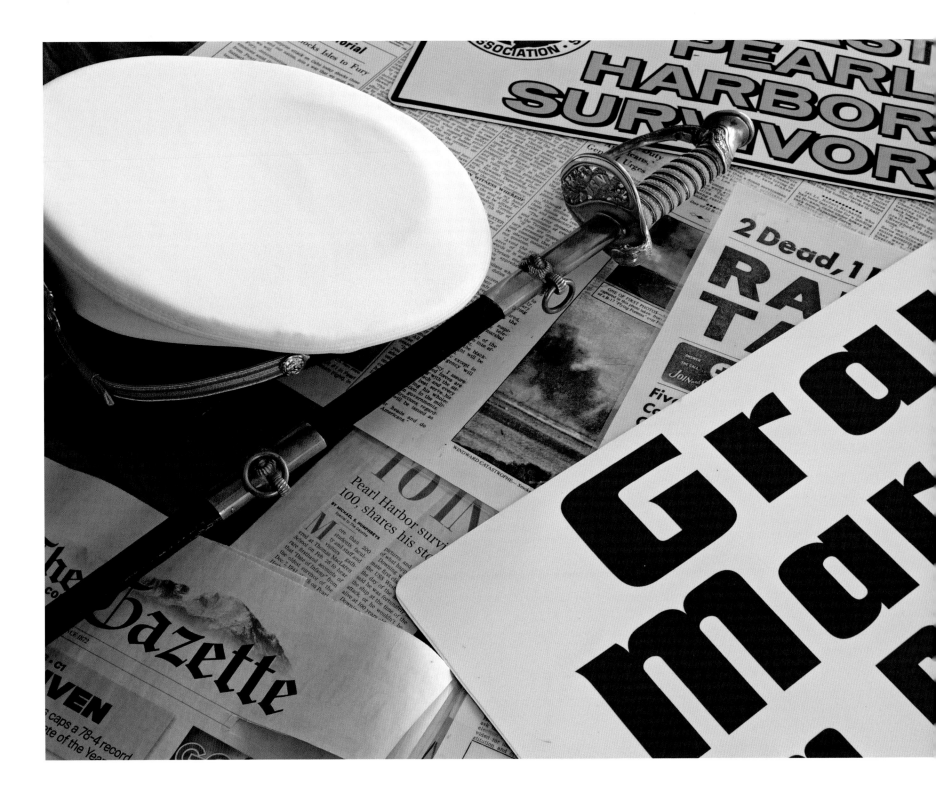

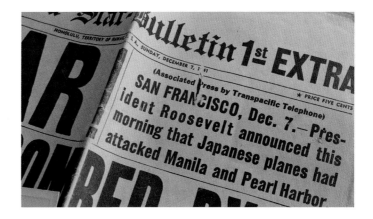

Above: *Newspaper headline following the bombing of Pearl Harbor on December 7, 1941*

Left: *Jim Downing saved the sword his crew presented him when he left the service. He has kept several souvenirs from that time.*

to sneak into the harbor in the morning before the attack. A destroyer picked up the submarine and sunk it just outside of the harbor. The information was confirmed, but the warning was not shared with the fleet of ships.

The Army had radar in operation, but due to the newness of the technology it wasn't utilized yet. All you knew was what you saw, he says. The Army recorded a fleet of planes coming in from the west. That day a fleet of B-17 planes were due in from the east. Someone assumed they must be the same planes and, again, no warnings were given.

Downing processed a number of emotions, starting with fear, when the first plane flew overhead. Later, he felt anger at those in leadership. Finally, he felt resolve. Downing swore that day that if he were ever in a position of authority, he would never be caught unprepared again.

During the Korean War, Downing was the commander of the Navy Aviation support ship U.S.S. *Patapsco*. One day there was a threat and it wasn't going away easily.

"I told my crew to man the guns. If they don't change course, shoot a warning shot."

Later, Downing got heat from his superiors. He stood firm, advising them that he had been at Pearl Harbor, and he knew better than most that "weakness invites aggression."

In 1956 Downing retired from the Navy and joined full-time ministry with the Navigators, a Colorado Springs–based Christian organization. ■

CHRIS MCKOWN

Deployment: Vietnam 1966–67
Branch of Service: U.S. Navy
Residence: Maryland
Occupation: Retired

★★★★★

*"It still haunts me, how close I came to being
tossed into the sea."*

Giant waves and gusts of wind tossed the ship as it tried to make its way across the South China Sea. The steel girders and plates began to groan and squeal as the U.S.S. *Repose* began a series of near-45-degree rolls.

The sick and wounded men aboard the U.S. Navy hospital ship lay helpless, many of them openly stating that they would rather be in Vietnam. Their chances of survival were greater in the field than on the ship as it tried unsuccessfully to steer clear of Typhoon Nancy.

In the midst of the storm, a young nurse tried to maintain some semblance of control. Frances "Chris" McKown had actively tended to the battle wounds of various marines and Army soldiers since her deployment.

McKown joined the Navy in 1964 believing that the military health care system operated more as a team than the civilian sector. Joining the Navy also felt right to her because her family members had served their country all the way back to the Revolutionary War.

Deploying to Vietnam in 1966 was important to her. She wanted to serve her country and take care of her fellow soldiers. The Nurse Corps itself was a source of pride, having a history of performing miracles under fire, such as during the Battle of Corregidor in World War II. Like the other doctors and nurses aboard her ship, McKown didn't give up hope as she tried to check in on her patients during a particularly savage November

storm. While they worked to ensure the safety of their patients, the storm had other ideas. McKown was thrown across the deck, slamming into the bulkhead, right beside an open door. Coming to her senses, she realized she had come within inches of being tossed into the unforgiving sea below.

After three days, the storm subsided and McKown and the rest of the Nurse Corps were able to gather the remaining hospital equipment. Everything was on the floor in a chaotic state of disarray: X-ray arms were broken, operating room tables had broken loose, and gurneys were upside down.

But they were alive.

McKown and the other nurses, doctors, and surgeons went back to caring for their nearly 500 patients. McKown tended to severe wounds, and assisted skillful surgeons as they worked to repair the damage war had done.

"It is a reality that wartime is a dynamic, dangerous environment and unexpected things happen," McKown says. "It still haunts me, how close I came to being tossed into the sea."

McKown drew on her experience to help institute new programs to teach health care professionals in the Nurse Corps how to respond to combat. She also collaborated on the development of field hospitals and hospital ships until her retirement in 1991. ∎

JACK PORT

Deployment: World War II, Europe 1944–45
Branch of Service: U.S. Army
Residence: California
Occupation: Retired businessman

★★★★★

*"We were just doing a job we didn't want
to do but that had to be done."*

Training for the D-Day invasion was in full swing when 21-year-old Jack Port arrived on the southwest coast of England. A California native, Port volunteered for the military thinking he would be sent to the Pacific theater. But he was assigned to the Fourth Infantry Division, bound for New York and then Europe.

Port was close to Operation Tiger, occurring near Slapton Sands off the coast of England. More than 30,000 troops were training there for the invasion of Normandy when they were discovered by the Germans.

German E-boats swiftly attacked the exercise, sinking several ships and leaving 900 servicemen dead in a single swoop. It would later be called the forgotten tragedy. To protect the fragile morale of the American troops, Port and others in his infantry were sworn to secrecy.

The secrecy surrounding the incident only increased Port's anxiety. The silent question everyone pondered was, Did the Germans have a real advantage over the Allies? No one knew the answer.

Soon the war turned in the Allies' favor. Early afternoon on June 6, 1944, Port landed at Utah Beach, and participated in the D-Day invasion.

After a three-week campaign, the Allies liberated the harbor city of Cherbourg and Port and his fellow troops made their way inland. They liberated Paris on August 25. Eventually Port arrived in a town outside of Paris called St. Quentin. He and another soldier arrived shortly after the Allies had conducted an air raid of the area in an attempt to drive any remaining Nazis out of France.

But there were other casualties. Crossing the countryside, Port met a French farmer carrying the body of a small child. In broken English, the man explained that his young son had been hit by exploding shrapnel from a bomb raid. Port watched the man weep as he lowered the boy's body into a wheelbarrow for transport to a grave. That was the image—more than all the battles that he'd been a part of—that left an indelible impression on him.

"These weren't the people who should have been suffering, they were the ones we were supposed to liberate," he says.

Port and his division moved from France through the Belgian Ardennes, where he fought Germans in freezing conditions. He was promoted to first sergeant, which Port believes was because there simply weren't many men left to choose from.

Port was sent home after the victory in Europe and spared redeployment when the Japanese surrendered. He has received a lot of praise due to his service in the war, but the 93-year-old retired businessman doesn't view his deeds as heroic.

"We were just doing a job we didn't want to do but that had to be done."

Others feel differently. France honored him with the Legion of Honor, the country's highest award given to a foreign national. ■

RESILIENCE

"What counts is not necessarily the size of the dog in the fight—it's the size of the fight in the dog."

GEN. DWIGHT D. EISENHOWER

Paul Duran

Deployment: Iraq 2005
Branch of Service: U.S. Marine Corps
Residence: New Mexico
Occupation: Student

★★★★★

*"You don't know it at the time,
but you're the only one that's different."*

Paul Duran knew he wanted to fight for his country. He joined the Marine Corps in December 2003. He looked forward to serving and having an adventure. He would do both, but he would suffer, too. In 2005 Duran was deployed to Ramadi, Al Anbar Province, Iraq. That April, Duran's squad was hit by multiple suicide bombers who drove two tanker trucks into his squad's machine gun–lined bunker.

"Some guys were riddled with shrapnel. Other guys were knocked out, and we were still taking fire," he recalls.

Down five men after the attack, Duran and his unit had to put their camp back together.

"A couple of us had to go out and start sandbagging, trying to fix our post, and while we were doing that we were picking up body parts from these suicide bombers. Picking up a foot or a hand; I will always remember that."

In July 2008 Duran was back in the United States and no longer serving in the military. "You don't know it at the time, but you're the only one that's different," he explains.

At 23, he was a lost soul. He drank copiously and wanted to fight all the time. "It's not that I wanted to be a bully, [I was] just hurting inside, alone and with no direction."

Duran continued his path of destruction, his pain manifesting as aggression. He believed, as many others do, that nothing could stop him,

that he was somehow invincible. After all, he had survived the mission when so many others hadn't.

There were many fights —often followed by nights spent in jail. It wasn't until he met a cowboy by the name of Sterling that Duran started to see his life come back together. Sterling shared his own story and pointed him toward Horses For Heroes, a nonprofit based in Santa Fe, New Mexico, and its unique horsemanship, wellness, and skill set–restructuring program, Cowboy Up!, for veterans and active military who have sustained physical injuries and/or post-traumatic stress disorder (PTSD). Veterans contribute to all aspects of ranch life, including working cattle with other veterans.

"We're all guided here to find nurturing and our way back on the right path," he says.

For Duran, that path has also included his passion for geoarchaeology. He began studying at Santa Fe Community College and continues to pursue field courses focusing on the ancestral Pueblo people in the Santa Fe basin.

While he had traumatic combat experiences, Duran is grateful that he was able to serve with the First Battalion Fifth Marines, noting that he had "a wide array of experiences." In addition to the Middle East, Duran visited the Philippines, Indonesia, and Japan, and he went to port in places such as Guam, the Maldives, Bahrain, Africa, Dubai, Australia, and Tasmania, "which was an amazing adventure." ∎

Fred Lash

Deployment: Vietnam 1967, Beirut 1983
Branch of Service: U.S. Marine Corps
Residence: Virginia
Occupation: Retired

★★★★★

*"We'd lost our neutrality and our
peacekeeping role that we'd had before."*

In 1967 platoon commander Fred C. Lash did a three-month tour in Vietnam. "They had a rule that you're required to leave after three Purple Hearts. You couldn't stay in the country. I was a human magnet," he said. "I couldn't stay away from the flying metal."

That didn't deter the young marine. Nearly 15 years later and now a major, Lash had a new assignment. He was to work in the Lebanese capital, Beirut, as part of a mobile public affairs detachment.

The United States' interest in Lebanon had grown considerably since U.S. troops had joined a multinational force from France, Italy, and the United Kingdom to assist the embattled Lebanese government in peacekeeping endeavors.

Lebanon had been torn apart by a brutal civil war that started in 1975. Things went from bad to worse when in 1982 Israel invaded the nation as a means to drive out the Palestine Liberation Organization, known for terrorist acts at the time.

Despite the threat of violence, the nation seemed peaceful to Lash when he arrived in March 1983. Shopkeepers were putting stock back in their stores, and glass was going up in shop windows.

Lash was to make a public affairs film. And he worked daily with the more than 150 registered press to answer questions and act as a liaison for the military. That is, until the bombing started.

On April 18, 1983, Lash was slated to hold a joint news briefing with the State Department at the U.S. Embassy. In a last-minute decision, the conference was moved to the airport. A few minutes after 1 p.m., an explosion erupted in the embassy killing 17 Americans, including the marine at Post One. Sixty-three people died, hundreds were wounded. A pro-Iranian group called the Islamic Jihad Organization took credit for the bombings.

"We'd lost our neutrality and our peacekeeping role that we'd had before," Lash says.

The terrorists weren't done yet. In October 1983 a suicide bomber in an explosive-laden truck drove into the Marine Corps barracks at the Beirut airport, killing 220 marines, 18 sailors, and 3 soldiers. Investigations into the attack revealed that it was the largest non-nuclear blast in recorded history.

Luckily, Lash had left Beirut two months before the bombing, having been promoted to media director at Marine headquarters. One of his job's many responsibilities was locating next of kin, a number that grew rapidly over the next several days. What started as "a few" lost lives quickly turned into more than 200. More than 25 marines and civilian volunteers were put under his command as he ran the media crisis center. Lash seldom left the office, sleeping on cots in between interviews and delegating calls.

He is now retired from his job as a public affairs officer in the U.S. State Department. ∎

CHIQUITA PEÑA

Deployment: Afghanistan 2005–06, 2013–14
Branch of Service: U.S. Army
Residence: Virginia
Occupation: Student

★★★★★

*"I am eternally grateful
for their kind generosity."*

Chiquita Peña knew she had lingered long enough. But she just had to hold her baby girl a little longer, kiss those adorable cheeks and forehead, grip those tiny hands, and murmur the promise that she'd be back as soon as she could.

She knew Nayeli would be safe in the arms of her mentor and friend, Jas Boothe, but Peña couldn't help but feel the agony of the coming separation. Feeling like a failure as a mother, she gathered her few belongings and left to serve her country in Afghanistan.

Deep down, Peña knew this deployment would help her young family. Her service as a financial management specialist was much needed by the Army. She could use her financial skills to help other soldiers cover their expenses at home.

Her husband, Karl, was also on his way to Afghanistan. Their family had fallen on hard times, and this was the much needed boost to bring them financial stability. Just before Thanksgiving 2013, they had explained to their two-and-a-half-year-old that they were going to be gone for a short time. Like a little trooper, she had said, "Bye, Mommy and Daddy. See you soon!"

It was too much for them, and Karl had pulled off the road breaking down in tears at the thought of leaving his little girl behind. Peña started crying, too. "We soon realized every minute that passed was one minute closer to seeing her again."

Being a good mother was important for Peña. She had grown up with a mother who struggled with drug and alcohol abuse. Her father, who never married Peña's mother, was a positive influence who encouraged her to move beyond the dysfunctional home she was brought up in. Peña made a promise to herself that she would rise above her situation.

After graduating from high school in May 2001, Peña entered East Carolina University. Working three jobs to fund her education, Peña struggled. Her school loans were piling up and the jobs were taking a physical toll on her. "Every day my financial situation just kept getting worse."

Out of the blue, an Army recruiter called to inquire if she would be interested in joining the Army Reserve. After listening carefully, she decided to commit. Two weeks later, on January 31, 2005, Peña reported for basic training to Fort Leonard Wood, Missouri. For Peña, this was the best of all worlds: a military career and the possibility of funding further education.

After basic training, Peña moved to Savannah, Georgia, and found work at a local bank. Her life became more complicated when one of her Army girlfriends learned she was going to be deployed. Peña spent several months taking care of her friend's eight-year-old child while her friend served on active duty.

Peña was next to receive the call for deployment. Her commander informed her that the Army needed a finance soldier with her banking

experience. Seizing the opportunity, she accepted and was sent to Afghanistan for 12 months.

"I met my future husband, Karl, while on that deployment, and we fell in love. He was also in the Army Reserve."

Still serving as an Army Reservist, Peña and her future husband secured good full-time jobs and were starting to build a life together. Things were going so well they decided to have a child. "Shortly after our first child was born, everything that could go wrong did go wrong. While I was on paid maternity leave, I found out a new supervisor who did not know me or understand I was on maternity leave, had decided to terminate me. She actually thought I went AWOL from my job."

Adding to this complication, her company had just completed a large corporate merger, and both layoffs and a hiring freeze were in effect. Peña protested until the company said they would hire her as an external contractor. Unfortunately, there were no positions available anywhere.

"It actually gets worse," says Peña. "At first, Karl was still employed and we had some savings. We were confident everything was going to be OK. Then one evening, Karl noticed a mosquito flying around in the room, and not wanting it to bite the baby or me, he decided to go after it. As he stepped up on the wood frame of the coffee table, he lost his footing and fell through the glass top, severing his leg tendon and muscle. It was the worst possible injury that had long-term consequences."

Karl's job did not provide short-term disability insurance and his recovery took almost six months. The family was heading for financial disaster. Neither of them had incomes, and their meager savings were quickly slipping away. Their rent was three months past due, and they could barely scrape enough money together for food. They were close to eviction.

In the fall of 2011 Peña received an email from another soldier about a female veterans' organization, Final Salute, run by Executive Director Jas Boothe. She was invited to a job fair at the Women's Memorial at Arlington National Cemetery.

"I put on my power suit—with my baby in tow, my résumés stacked on the bottom of the bassinet—and headed off to this job fair." Final Salute had already matched her with potential employers, guaranteeing several employer visits.

It was the first time she met Boothe. They bonded immediately. Getting right down to business, Boothe looked at her list and replied, "Oh, you have your first interview coming up soon, you need to prepare for it. Gimme that baby." Peña was surprised by how sincere and down-to-earth Boothe was. She was surprised to feel at ease enough with Boothe to hand over her daughter.

Peña walked away with some good job prospects. And the team from Final Salute clearly understood Peña's declining situation. Before Peña left the job fair, Boothe presented her with a new bassinet, a check to cover back rent, and enough funds for some extra food. "I am eternally grateful for their kind generosity," adds Peña.

Although these acts helped stabilized the situation, it was not enough to keep the struggling family afloat long term. Karl was still not back to work, and Peña was still job hunting. Peña and her now fiancé gave up their apartment. Peña and Nayeli moved in with friends but eventually ended up in one of the homes Final Salute operates for homeless female veterans. Karl was forced to move in with a local family (not his) to survive. They commuted to see each other every chance they could.

In February 2013 Peña learned she was going to be deployed again. Karl saw the opportunity that his skill set could be needed on that deployment and together they decided that it would be best for both of them to deploy in order to get them out of the financial hole they were in. Deploying together meant they could stash away even more money since neither would have living expenses. It could be a fresh start for their family.

Deciding to make it official just days before their deployment, Peña and her fiancé married on November 2, 2013. Both of them were very concerned about who would care for Nayeli. Neither had family or friends to support them. Boothe's previous military service and homelessness experience made her especially compassionate and caring toward the needs of female veterans. Understanding the situation, Boothe personally offered to take care of the couple's child while they were on deployment.

It was a long year, but Karl and Peña served their nation faithfully during their deployment, returning stateside in November 2014. Happily reunited with their daughter, they have since found good jobs and live in a nice apartment in Virginia. They are currently finishing up their degrees and still serve in the Army Reserve. ■

Chiquita Peña, her husband, Karl, and their daughter, Nayeli, share a special moment with close friend Jas Boothe after the couple's return from joint deployment in Afghanistan in 2014.

HERBERT SUERTH

Deployment: World War II, Europe 1944–45
Branch of Service: U.S. Army
Residence: Minnesota
Occupation: Retired marketing executive

★★★★★

"You never know what life has to offer you—
I'm just real glad to have my legs."

Herbert Suerth, 91, is one lucky man, and he's the first to admit it. Enlisting in the U.S. Army in December 1942, he was sent to Europe and fought in the Battle of the Bulge. He was such a memorable figure that he was later portrayed as "Junior," his own nickname, in the famous HBO miniseries *Band of Brothers.* The series is based on the book by historian Stephen Ambrose, and it is the story of Easy Company, part of the 101st Airborne Division.

The scars of his past are clearly present as Suerth limps across his living room and launches right into his amazing story.

"It was the coldest and snowiest December on record in Bastogne, Belgium, in 1944," recalls Suerth. "We almost froze to death."

Camped just outside the small town, Easy Company was taking direct fire from the Germans. Even under the cover of heavy snow, enormous holes from mortar attacks looked like craters on the moon's surface.

"The Germans were crafty," says Suerth. "They marked the position of every hole, so if we decided to make our way through them, they could instantly take aim and blow us to smithereens."

Suerth continues, "As we were laying low, a group of men and I were standing next to several tanks that were quietly idling in the darkness in order for us to use them as a warming station. These tanks and the men inside them were fresh replacements, and all of them were very naive about battle. Without

thinking, one of these men nervously lit a cigarette and proceeded to take a puff. Before anyone could react to tell the soldier to extinguish his cigarette, three explosions from large German artillery hit our area—instantly killing four of my buddies and almost fatally wounding me."

A shell fragment tore through both of Suerth's femur bones, causing him to fall into the deep snow. He remembered looking at his bloody legs bent in the wrong places and thinking they were gone. The extreme cold and fresh snow saved Suerth from bleeding to death before help arrived. Suerth recalls a medic pronouncing his buddies dead and then standing over him and shouting, "He's alive, he's alive!"

Stabilized and transported to an English army hospital, Suerth had many surgeries and was placed in traction for more than three months. After 18 months, he had recovered enough to leave the hospital. Therapy and his strong will to regain mobility resulted in his reclassification from 100 percent to 80 percent disabled. In May 1946 he returned to Minnesota.

Suerth's determination and can-do spirit have served him well. He married, raised a family, and had a successful career despite his war injuries. Though his character, Junior, was a small part in *Band of Brothers,* the real Suerth was proud to be depicted.

"I was called Junior throughout my entire war career," he says, "and it was great to hear it again—especially when I saw my character on the screen." ■

*A wall at the Korean War Veterans Memorial
in Washington, D.C.*

M IS NOT FREE

"The issue is not war and peace, rather,
how best to preserve our freedom."

GEN. RUSSELL E. DOUGHERTY

SCOTT ROBERTSON

Deployment: Iraq 2004–09
Branch of Service: U.S. Army
Residence: Louisiana
Occupation: Recruitment officer

★★★★★

"I'm thinking of growing my hair and a beard when I leave the Army.
Maybe not as long as the others . . ."

Scott Robertson was a real Army brat, growing up in Germany where his father was stationed in the 1980s. Being a soldier was an early career choice because he had always looked up to his father and listened to his words of wisdom. "My dad thought I wasn't paying attention, but I was. I just didn't want it to seem too obvious," he says.

Robertson enlisted in the Army in 1997, and from 2004 until 2008 he was deployed three times to Iraq. While overseas, he served as an aviation mechanic, mainly with Blackhawk helicopters and supporting convoys.

During his first deployment, he met several Iraqis. He was amazed at how happy many of them were despite living in what the West would call impoverished conditions. Their tables were always overflowing with food, and they were welcoming. On coming home after his first deployment in 2004, his appreciation for a hot shower or a flushing toilet seemed to know no bounds, and he would spend half an hour in fascination, just watching the steam from the shower head, a seemingly endless supply of what was so hard to come by in Iraq.

But the end of that year was filled with personal tragedy. His wife died of an accidental overdose of pain-killing drugs following back surgery; his grandfather died a few days later; and his father suffered heart attacks, for which he had bypass surgery. Robertson was still recovering from the effects of deployment and now he had all of this grief to process, too.

A few months later, he was deployed again to Iraq and sent back to a reality that had changed from his last visit. He observed a radicalization among the population that he hadn't experienced before.

Life had become harder both at home and abroad. Then, just before his last deployment, he met a young woman named Marsha, whom he married soon after his return to the States. They are now a happy family with four boys, and life has taken on a new dimension.

He began working as a recruiter, and when he isn't busy with his young family and job, he visits the family patriarch, Silas Robertson, who rose to fame through his reality show, *Duck Dynasty*. He and some other men in the family became known for sporting long hair and long beards. But he is also proud of his 24 years in the Army and his service in Vietnam. He is glad that his son, Scott, listened to what he was saying about military life.

"War should be the last option, because it's insanity. Human beings killing human beings. For whatever reason, it's still insanity. We are losing more now to suicide than we lost in war. We gotta do better than that!" Silas Robertson exclaims.

Robertson listens fondly to his father.

"I'm thinking of growing my hair and a beard when I leave the Army," he says. Looking at his father, he adds, "Maybe not as long as the others . . ." ∎

DOTTIE GUY

Deployment: Iraq 2003
Branch of Service: U.S. National Guard
Residence: California
Occupation: Outreach coordinator for veterans

★★★★★

*"Even if you've gone through something terrible,
you don't have to define your life by it. It's what comes after."*

An amateur photographer and people person, Dottie Guy works with veterans and connects them with services ranging from housing and utilities to mental health support through the Oakland Vet Center in the San Francisco area.

"People open up to me. It's like I'm Oprah—but poor," she laughs.

It may also be because she can understand where many of them are coming from.

Guy joined the National Guard as a high school student. The small-town Virginia girl never thought she would serve overseas. But in late 2003, her unit was sent to Iraq.

Nothing really prepared the then 21-year-old military policewoman for what she would experience. The heat was oppressive in Iraq, and when she reported for duty, she learned there was an armor shortage.

On one of her first days, she joined a convoy taking a detainee to the hospital. On her way, her platoon sergeant asked for her 9-mm service weapon. He unlocked it, loaded it, put it on "fire" and told her, "If he made one wrong move, I was to shoot him in the head."

She had always known that she might have to kill someone, but sitting three feet across from her potential assailant terrified her. Her detainee was also scared. A former Iraqi diplomat, he had lived in Virginia, eating at the same restaurants she had.

"I think that's when [the war] became real to me," she says. She spent most of her time tending to the needs of detainees and escorting them to interrogation.

She learned a lot about their lives. Some had been pawns for Saddam; others were known terrorists. "It was strange knowing I'm sitting face-to-face having a conversation with this man that murdered innocent people, but yet he's sitting here more concerned about me going home for Christmas than him praying for Ramadan," she recalls. "People tend to see things in black and white, so to me it was this huge gray area of morality and why people do the things they do. And I got to see this compassionate side of this person, who a large amount of people would have killed, if they had the same access I did."

Guy returned home a few days before Christmas. She didn't realize how much she had internalized until she went to the mall to purchase a pair of shoes. The sheer amount of choices overwhelmed her, and she burst into tears. "Obviously if I make the wrong choice with shoes, no one is going to die," she says. Even today, she finds it difficult to make choices.

Guy decided to move to San Francisco and became involved with a veterans organization called Swords to Plowshares. The organization introduced her to her current employers.

"I love my job," she says. "I get to see the results of what I do." ■

THOMAS HOUDEK

Deployment: World War II, Europe 1944–45
Branch of Service: U.S. Army
Residence: Michigan
Occupation: Retired automotive electrical systems rebuilder

★★★★★

*"I would never want to be a prisoner of war again.
It was an awful experience."*

Shortly after the Battle of the Bulge in January 1945, Thomas Houdek and several other GIs found themselves deep inside an abandoned German pillbox fighting for their lives. For three days, they staved off the Germans. Running low on food and ammunition, the Americans were desperate.

"The Germans had plenty of resources," Houdek recalls, "so they kept firing away."

Eventually the Germans tired of shooting. They decided to use a flame-thrower to extricate the American soldiers from the sturdily built pillbox.

"It only took us a second to decide to surrender before we all became ashes," Houdek says. "It was a miracle none of us got burned from the onslaught of fire entering the box."

The Americans lined up, putting their hands up over their heads. It soon became clear that the Germans were looking for supplies and, in particular, cigarettes. Houdek recalls, "They asked us in perfect English if we had cigarettes inside the pillbox. I responded that, yes, we had plenty of them. Next, with the Germans' guns pointed at my back, I was told to surrender all the cigarettes. We actually had two different types. Believe it or not, the German was a picky bastard and did not want any of the Old Gold brand, and he gave those all back to us. He only wanted the premium brand, the ones that had the stronger nicotine kick to them."

Houdek ended up inside the prisoner-of-war camp Stalag 4B. With little food and a grueling work detail, POW life was horrific. He remembers the constant strafing from friendly forces. "The Allies thought we were the bad guys," he says. "That's exactly how the Germans wanted it."

Houdek, who today is 89 years old, was determined to survive: "As the planes came by, the line of bullets were hitting everywhere. It did not take me long to realize I was in the direct path and would be hit if I did not move—and fast. I turned away and ran for the largest hole I could find—the latrine. Not hesitating for a moment, I jumped in and plunged into the deep muck. If I had moved, I would have been killed. When the danger had passed, I climbed out of the latrine. Thankfully, the German guards could not stand my smell and offered me a cold shower. It took several months before the stench went away from my body. I was very thankful just to be alive. Thinking back—I did not have many friends during that time."

A few months later, Allied forces turned the town of Dresden into a glowing inferno. The intense heat turned the ground in the center of town into glass.

Houdek was tasked with cleanup detail after the fire subsided. "That changed me. There was so much destruction—so much death—I started to realize just how fragile life is," he says. "That thought alone helped shape me for the rest of my life into a more caring and understanding individual." ■

MARISSA STROCK

Deployment: Iraq 2005
Branch of Service: U.S. Army
Residence: Michigan
Occupation: Student

★ ★ ★ ★ ★

*"I want to live, enjoy life, and
do whatever is necessary."*

Serving in the military is a family tradition, according to Marissa Strock. "My uncle, both of my grandfathers, and brother all served in the military. So it was very natural for me to consider joining the military, too." In November 2004 she enlisted in the Army and received training to become military police officer.

After Strock's training was completed in April 2005, she was stationed at Fort Lewis in Washington State. Forty-two days later, Strock's boots hit dusty ground in the war-torn city of Baghdad.

As a military police officer, the 20-year-old woman would soon acclimate to her unpredictable surroundings, taking on additional responsibilities as her experience increased. She soon became involved with training Iraqi police officers. She taught them the techniques and skills necessary to maintain law and order inside Baghdad.

This new responsibility exposed her to greater risk because she needed to travel about the city on patrol. Then it happened.

On the 24th of November—Thanksgiving Day, 2005—while she was on patrol in a heavily armored Humvee, Strock's vehicle was almost blown to smithereens by a roadside bomb. "We had five people inside, three American military personnel, including myself, our Iraqi interpreter, and a high-ranking (colonel) police officer from the local Iraqi police station with us."

Three people lost their lives in the blast. Only Strock and the Iraqi interpreter survived.

Strock has no recollection of nearly every detail of the event; though she can remember the smell of burning flesh and the screams of dying men, her mind had dissociated from the horror. "I was told right after the incident I was making jokes about the situation to the medics. My eyes were open and I was communicating, but I was not at all in the real situation."

Strock was stabilized at the scene, but her injuries were life threatening. She had a multitude of internal injuries, a traumatic brain injury, and many broken and shattered bones. She was transferred from Baghdad, to Landstuhl, Germany, before she was flown to Walter Reed National Military Medical Center in Washington, D.C., where she would spend the next 18 months.

Due to the nature of her injuries, both of her legs had to be removed below the knees (Strock had her left leg taken immediately and her right taken the following March). It was nearly a month before Strock started to grasp exactly what had happened to her. The horrifying truth came when she wanted to get up to use the bathroom.

"I was becoming more aware of my surroundings, I was just out of my coma and needed to use the bathroom. I didn't understand where I was or how badly I was injured." Strock had a cast on her right arm from her

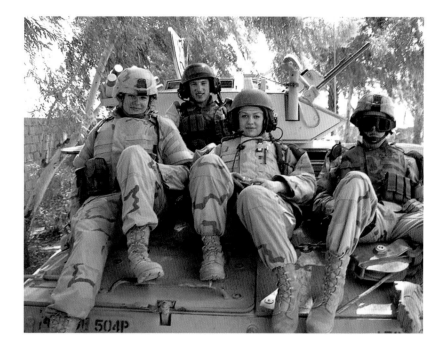

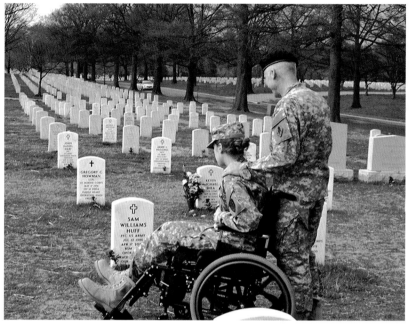

shoulder down to her fingers, further limiting her ability to move, and a nonspeaking tracheostomy in place.

"My mother, who kept a vigil at my bedside since I arrived at Walter Reed medical center, kept telling me I had a catheter in place and I did not need to use the bathroom. I remember just insistently trying to tell her through my tracheostomy 'I have to go, I have to go!' Finally I became real mad and was trying to get myself up and out of the bed. At this point, I had no clue I did not have any legs to move about with."

Eventually Strock was able to grab the trapeze hanging above her chest without her mother noticing and started to swing her broken body around to the edge of the bed. Throwing back her sheets, she noticed she had lost her left leg, and her right leg was in a fixator that was holding it together with pins. Looking at her mother's face and in total disbelief, Strock said, "This is all my fault."

This was the start of Strock's long road to discovering what exactly happened to her. After the initial heartbreak of realizing she was an amputee, she started trying to fill in the missing events. Soon she realized that only two people survived the blast—the interpreter and herself. It was devastating news.

Strock realizes today that she is one lucky girl. Her determination to live and move about unassisted with two artificial limbs is impressive. "I want to live, enjoy life, and do whatever is necessary. I'm deeply sad about the men who lost their lives inside that Humvee that day. I was just inches away from them. I just don't know how I was spared. Together—we never saw it coming."

Strock states, "I've vowed to live my life in my team's memory because that is what got me through my recovery, knowing that I had to live because they did not. It was a miracle I survived." ∎

ABOVE: *Marissa Strock pets her beloved dogs, Zero (left) and Sarge (right). "Both are a contrast in size but they love each other."*

OPPOSITE: *(Left) Strock (center) and fellow soldiers sit atop an armored security vehicle. (Right) Strock visits the graves of fallen comrades at Arlington National Cemetery on the same day that Col. Richard Swengros awarded her a Purple Heart.*

Matthew VanGiesen

Deployment: Japan 1994–95
Branch of Service: U.S. Navy
Residence: Washington State
Occupation: Telecommunications technician

★★★★★

"We think things happen by accident.
We think things are random."

But Matthew VanGiesen doesn't see it that way—not after what he's been through and the events he witnessed.

It was one of the worst days of his life—and about to get much harder—when VanGiesen realized his flight had been delayed. He wasn't going to make it across the country—to Dover, Delaware—in time for the ceremony.

At that point, he began to feel numb. He tried to focus on anything but the awful fact that his little brother, Ken, was killed on July 18, 2011, by an IED in Afghanistan.

Seven years apart, the brothers had been close, and had a lot in common, including a desire to serve their country. From their father all the way back to a great-great-great-grandfather who had been a drummer in the Civil War, military service had been a family tradition.

VanGiesen's time came during the first Gulf War. He signed up for the Delayed Entry Program while still in high school.

"With the patriotism of the first Gulf War . . . For a young man I think there is a natural draw to want to be part of something like that, something bigger than you. It just seemed like the right thing to do," he recalls.

At recruitment, VanGiesen was offered a place at the advanced electronic school in aviation with the Navy. He committed to four years with a two-year extension. In 1992 he left his home in Kane, Pennsylvania, and took his first plane trip from Buffalo, New York, to Orlando, Florida, for boot camp. VanGiesen traveled the world with the military, spending his remaining active duty on Whidbey Island (in Washington State) and then in Japan.

VanGiesen then secured a position in telecommunication technology. But he missed the brotherhood of the military and joined the Navy Reserve in 2001. He left in 2005 with the birth of his second daughter.

His time in the military and his unique career path made it difficult to stay in touch with his family back home. His little brother, Ken, was only 11, when VanGiesen left home. But the two still had a special bond.

He could go a few years without actually seeing his brother, but when the two entered the same room "it was like we just left."

Ken had also followed in their father's footsteps, joining the Army National Guard. He served four tours overseas, including Iraq and Afghanistan. Ken was serving in the maintenance battalion in Iraq, towing vehicles, when medical issues forced him to return home.

Returning to the armory, where he also worked as a civilian, Ken VanGiesen learned of another opportunity for deployment. Before he shipped out, the brothers shared a candid conversation about Iraq and Afghanistan.

"Right, wrong, or indifferent, I'm telling you we're here and we're doing good things," Ken confided in his older brother. "There are little girls

going to school in Iraq. There are kids that see us as their heroes. Their costumes are not Superman or SpongeBob—they're U.S. Army."

Three months later, VanGiesen got the call. A volunteer firefighter, he had been in a regular Monday night meeting. His father confirmed his worst fears when they spoke on the phone that night.

The U.S. government paid for Matthew to fly to Dover, Delaware, where his brother's body was to be delivered only days after the fatal incident.

Numb and exhausted, VanGiesen boarded the next available flight. Seated next to a woman and child who were clearly separated from the father, VanGiesen traded his roomy aisle seat for a middle seat between two African-American men.

It turned out the men he sat with were part of a large church group, and one of them happened to be ex-military.

For the first time, VanGiesen told somebody other than family or friends about his brother. His new friend asked if he could pray for him and introduced him to Uncle Willie.

"They held my hands and Uncle Willie prayed for me . . . The rest of the plane just kind of went away. He held my hand and told me God would take care of me . . . We landed, and I thanked him, thanked all of them. When I left the plane, I knew I was going to be in the right place at the right time."

Despite a fast drive from the airport, he missed the return of his brother's body, so he headed to the Fisher House, an organization that places military families close to a loved one who has died or been wounded. He arrived just as his family's bus returned from the ceremony.

With a strength he wasn't aware that he possessed, he was able to comfort his family.

"It's a phenomenal story," VanGiesen says. "We think things happen by accident. We think things are random. I was put on that later flight for a reason and I switched seats with that guy for a reason." ▨

Matthew VanGiesen's parents, Tom and Susan, attend the boot camp graduation for their younger son, Ken, in Kentucky in 1999.

DUTY

*"The one word you use in military flying is duty.
It's your duty. You have no control over outcome,
no control over pick-and-choose. It's duty."*

BRIG. GEN. CHUCK YEAGER

CARLOS "CHUCK" NORRIS

Deployment: Korea 1958–1962
Branch of Service: U.S. Air Force
Residence: Texas
Occupation: Actor, retired martial arts expert

★★★★★

*"What that night did for me was help crack that egg of insecurity I had carried around all those years.
I kept forcing myself to continue speaking until that egg was cracked completely open."*

At 75 years old, Chuck Norris is known worldwide as a successful martial artist, actor, film producer, and screenwriter. He has had a decades-long career starring in action films such as *The Hitman, The Delta Force,* and *Missing in Action* as well as later, the long-running TV series *Walker, Texas Ranger.*

And somewhere along the way, he became a larger-than-life legend with entire websites dedicated to the "facts" about Norris's ability to strike fear into villains both real and imaginary. Those details are often tied to his very real eighth-degree black belt in tae kwon do and brown belt in judo.

Every legend has an origin story, and Norris's began in Ryan, Oklahoma, where he grew up as an extremely shy kid called Carlos Ray Norris. Eventually his family moved to California, where Norris kept a low profile through high school graduation.

At 18, Norris had no interest in attending college and decided to enter the Air Force instead. He joined in August 1958 and was sent to South Korea for 13 months, where he worked as a military policeman.

"Shortly after I arrived, I became involved with judo and separated my shoulder while training," says Norris. "After performing my daily military duties with my arm in a sling, I decided to go for a walk around the village of Osan. That's when I looked over at a knoll and saw heads with black straight hair popping up and down in a very organized fashion."

Not sure what he'd seen, Norris decided to take a closer look. Oh my God, he thought, how could the human body perform kicks that high? Returning back to base, Norris quickly found his judo instructor and asked him about it. Smiling, his instructor told him it was called *tang soodo* (now called tae kwon do). Soon Norris was training in tang soodo for five hours each day, six days a week, after military duty. On Sunday he would train with judo. "At this point in my life, I never knew how studying the martial arts would turn my life around," he says.

It began with Norris catching the attention of his commanding officers, who noted his unique skill sets and promoted him, expanding his roles and responsibilities. His popularity grew in 1961 when he returned to the United States and continued to practice his sport at the March Air Force Base gym in Riverside, California. Before long, Norris had plenty of men asking him to teach them tae kwon do and judo.

In response to the growing interest in martial arts, Norris decided to give a demonstration on base and start a club centered on the martial arts. Then it dawned on him that he never had given a talk or demonstration before a group of people. Public speaking had always been unbearable for him, even back in school.

The night of the demonstration, more than 500 people were seated in the stands. "This was over 50 years ago and I can still remember it very

vividly," recalls Norris. "I remember the microphone was lying on the floor. I walk up, pick up the microphone, and I say to the audience, 'Good evening, ladies and gentlemen, my name is Chuck Norris and I would like to welcome you here tonight.' That's the last moment I remember. The very next thing I recall is walking out to the middle of the gym to do my demonstration. As I'm walking toward the mat, I'm asking myself, Did I finish my speech? Or did I just put the microphone down?

"Truthfully, to this day I still can't remember," adds Norris. "But what that night did for me was help crack that egg of insecurity I had carried around all those years. I kept forcing myself to continue speaking until that egg was cracked completely open."

Norris continued on to become a successful teacher of the martial arts as well as a six-time World Middle Weight Karate Champion.

He began acting after one of his students, actor Steve McQueen, encouraged him. McQueen also gave him career advice after critics bashed his early films. Eventually Norris began incorporating his martial arts knowledge into his TV series and feature film projects, turning himself into an action star. He later used his celebrity status to promote several organizations, including the Department of Veterans Affairs. None of this work would have been possible without his military experience, Norris says.

"Without the service to my country, I'm sure my egg would not have been cracked open." ∎

PAGE 110: *Chuck Norris (left) and one of his students, Sgt. Delbert Bryan, present an honorary black belt certificate to Lt. Gen. Archie J. Old, commander of March Air Force Base, Riverside, California.*

LEFT: *Chuck Norris in one of his most recognized acting roles, as Cordell Walker in the* Walker, Texas Ranger *television series*

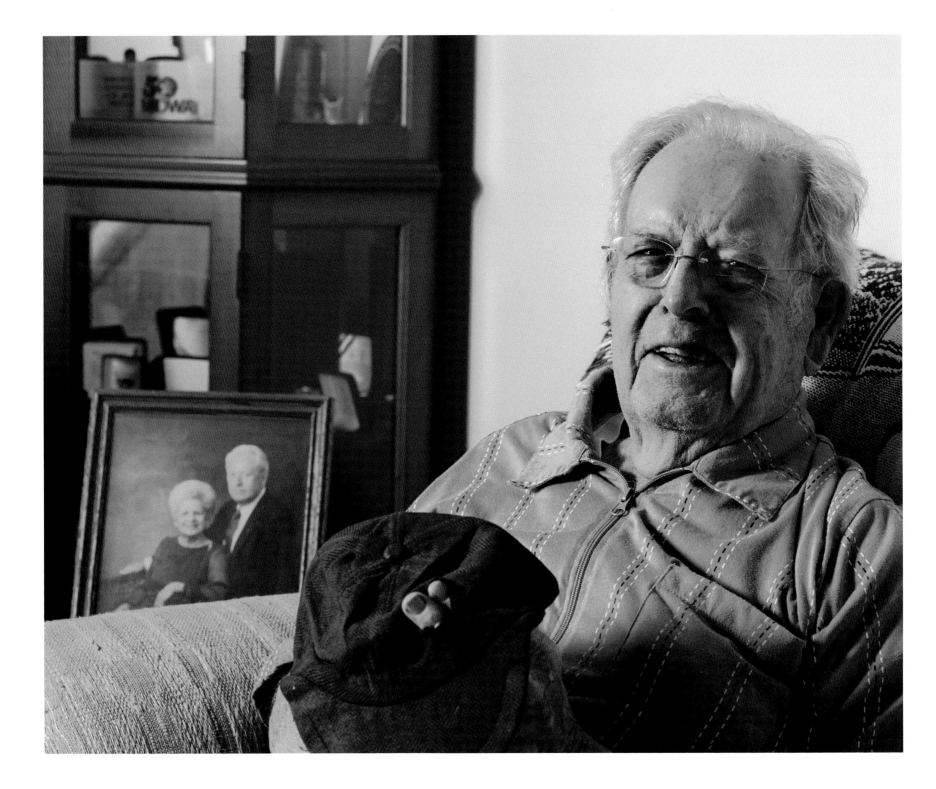

HARRY FERRIER

Deployment: World War II, Pacific 1941–45; Korea 1950–53; Vietnam 1964–1970
Branch of Service: U.S. Navy
Residence: Washington State
Occupation: Retired

★★★★★

*"In our six-airplane group,
we were the only ones left."*

Harry Ferrier wanted to be a Navy crewman and fly planes, and he saw no reason why his age should hold him back. His mother forged the date on his birth certificate so he could join the U.S. Navy at age 16.

He was sworn in on January 28, 1941, 11 months before the United States entered World War II. By September Ferrier had joined the ranks of Torpedo Squadron Eight (VT-8) in Norfolk, Virginia. Less than three months later, President Roosevelt announced the attack on Pearl Harbor, and Ferrier joined the fight against the Japanese in the Pacific theater.

Ferrier's first experience with aerial combat was devastating. He had been assigned to the aircraft carrier U.S.S. *Hornet* in June 1942. Several torpedo bombers launched off the ship intending to take out Japanese air carriers. The Douglas TBD Devastator planes had been considered the best Navy bombers in the world when they entered the service in 1937. However, they were outdated by the time of the Battle of Midway, resulting in all 15 planes being shot down during their torpedo attack on the Japanese.

Ferrier was aboard one of VT-8's new Grumman TBF-1 Avengers that launched from the island of Midway to aid the Devastators. Without fighter cover, they were exposed. Ferrier was in the back of the plane when the pilot notified the ship that he could see the Japanese fleet on the horizon. Within moments, they were under fire and their turret gunner, Jay Manning, was dead. It was up to 17-year-old Ferrier to defend the aircraft.

When the battle finished, five of the six planes had been shot down; the only survivors were pilot Ensign Albert K. Earnest and radioman Ferrier.

The two survivors returned to Midway, their plane gravely shot up, with damaged landing gear, controls, and a dead rear gunner. "In our six-airplane group, we were the only ones left. The other five were shot down. Our airplane was not flyable after the battle."

Ferrier himself was a little worse for wear. "I got hit," he says. The bullet struck him in the head. "And when I came out of it, the blood was warm on the machine gun I was manning."

Ferrier later learned that 45 of the 48 crew members and pilots in the Battle of Midway had died. He was the only crew member to survive.

Ferrier continued in the Navy, serving more combat missions aboard dive-bombers. In April 1944 he was promoted to chief petty officer, a big advancement for a 19-year-old.

After the war Ferrier served as a hurricane hunter and was assigned to the nuclear weapons program. Finally, he trained as an aviation electronics officer. In September 1970 Ferrier retired as a Navy commander. ∎

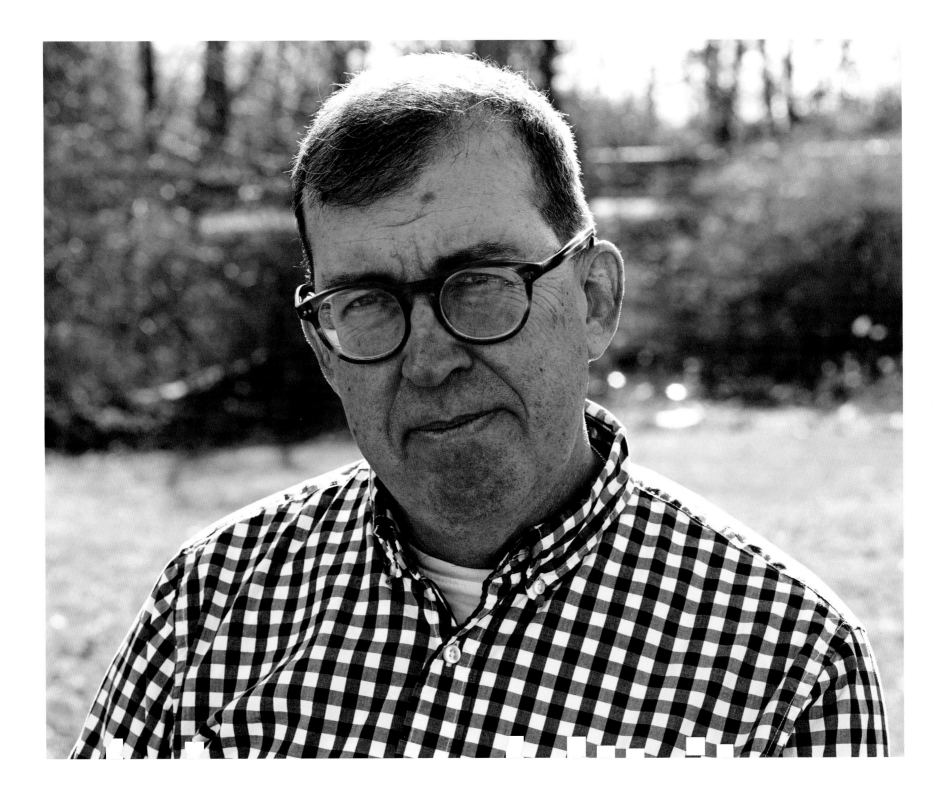

JAMES VANDENBERG

Deployment: Iraq 2004, Philippines 2005–06, Afghanistan 2008, Kosovo 2008
Branch of Service: U.S. Navy Reserve
Residence: Turkey
Occupation: Architect, engineer

★ ★ ★ ★ ★

*"By now, I was getting this reputation as this engineer that works
for the special forces in these dire environments."*

By 2014 James Vandenberg had acquired an unusual reputation in the armed forces. A Navy Reservist, the architectural engineer had become known for his willingness and ability to build hospitals, schools, roads, civic facilities, and utility structures in the remotest parts of the world.

He would spend a year or two in one war zone, hopping to sub-Saharan Africa, then to a jungle or a frigid climate, all in the name of the humanitarian efforts the United States was working to promote.

He had joined the U.S. Navy Reserve in 1993 as a way to serve his country while he pursued his career in architecture. In 2004 he would undergo a large career change as military deployments challenged his skills and shaped his outlook on what was necessary to promote peace in volatile regions.

Having joined the U.S. Navy Seabees, Vandenberg was sent to Al Anbar Province, Iraq, to oversee the construction of a new school.

"The idea was two-fold. We wanted to get money back into the Iraqi economy and hire their people so they were gainfully employed," Vandenberg says. "We were really interested in getting young Iraqis, 14 to 25, jobs so they weren't out shooting at us. It was removing combatants from the battlefield and giving them a job and giving their family some money."

It was a formula that worked very well, he said. But on his first excursion to look at a school's progress, Vandenberg and his unit were ambushed. One of the drivers had to be taken to the hospital.

"We were prepared for it, but we were kind of surprised by how much more difficult it was than we thought," he recalls.

Despite the unpleasant encounter, Vandenberg continued to work on building missions. His next stop was the Philippines, where he worked on projects while special forces hunted down terrorists.

In 2008 he went to trans-Saharan Africa, working in Mauritania, Niger, Mali, and Chad. Later that year, he was deployed to Kabul, Afghanistan. There, he oversaw the creation of a command control facility.

Vandenberg was later connected with the Office of Defense Cooperation at various embassies, mostly in the Baltic states—Estonia, Latvia, and Lithuania—as well as Kosovo. In 2010 he joined the State Department's Bureau of Overseas Buildings Operations. The Navy again requested his presence in Afghanistan to work on further projects.

After taking on several deployments, he lost his civilian job. But Vandenberg wasn't too upset by the news because his experiences had instilled a need to travel.

"Between 2004 and 2014, I believe I was only home for a total of nine to ten months," Vandenberg says.

Vandenberg is now based in Turkey while in between assignments. ∎

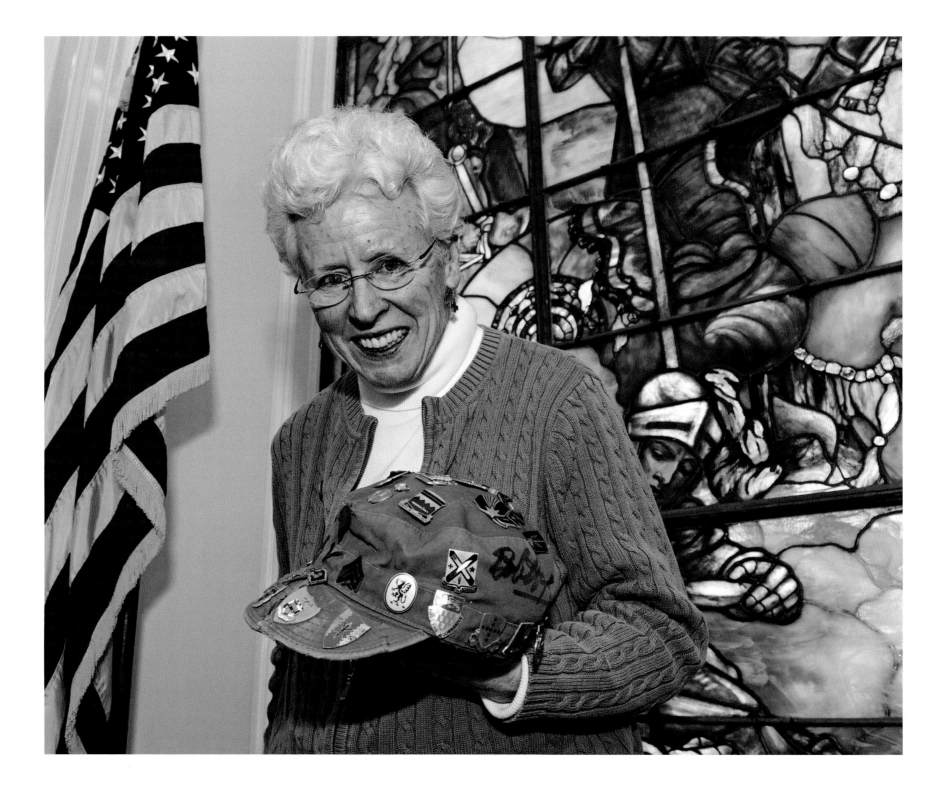

J. Holley Watts

Deployment: Vietnam 1966
Branch of Service: American Red Cross
Residence: Virginia
Occupation: Retired

★ ★ ★ ★ ★

*"I held out my Vietnam unit-insignia-laden hat saying,
'I missed you in Da Nang 20 years ago.' "*

In 1966 Jean Holley McAleese (Watts) was close to graduating from college. She had one goal: travel the world. Stopping in at her college placement office, she noticed a brochure about the American Red Cross Supplemental Recreational Activities Overseas (SRAO) wartime program. The Vietnam War Red Cross women were young, college-degreed women who spent a one-year tour as morale boosters for the American troops.

"The program seemed to have everything I was looking for—a paid position with on-the-job training, a choice of assignments, service to the military," the 70-year-old Virginia native recalls. "And most importantly, it offered extensive travel opportunities to far-off locations."

The program didn't disappoint. By September 1966 she was boarding a plane to support the troops in Vietnam. After a 30-hour flight, she arrived in Saigon in the middle of a hot and humid night. That's when she caught sight of several large plastic bags neatly lined up. Turning to one of the officers, she quietly asked what the bags contained.

"These are the remains of our men who gave their lives in this war," he said. "And they are now heading back home."

That's when Watts realized this would be one of the greatest challenges she had ever undertaken. For the next six months, Watts served the troops who passed through Da Nang. She would learn a great deal about death and wounds of war. Tears for the men came silently and usually at night.

By day, she and the other SRAO girls would smile, laugh, and remain upbeat. They looked like dolls in their Red Cross uniforms, earning them the affectionate nickname of "donut dollies."

They were a welcome sight to men returning from long battle stints. A dolly's job was to provide support and compassion using competitive games and activities that would make a connection, that all-important touch of home. Their presence was a large morale boost spoken about by veterans decades after the war.

Another morale boost was a visit from one of the world's most famous entertainers at the time. Actor and comedian Bob Hope performed at the base camp where Watts was assigned. It was a visit the GIs and dollies would never forget. They repeated his jokes for weeks after he left. But Watts missed everything. She had been hard at work in a nearby field hospital.

Twenty years later, Watts's path would cross again with Bob Hope. In 1986 Hope visited her hometown, Harrisonburg, Virginia. He had agreed to record some public TV fund-raising spots. In public broadcasting since Vietnam, Watts was in charge of writing the spots.

Finally she would be able to introduce herself and meet the man who made such a positive impact on the American servicemen during her time overseas. She planned ahead.

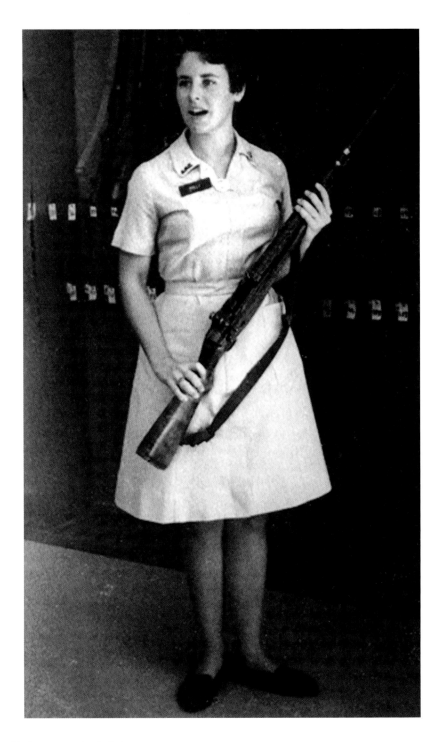

ABOVE: *The historic American Red Cross headquarters building in Washington, D.C.*

LEFT: *Jean Watts, a "donut dolly," checks weapons at the door as troops enter the Red Cross center on Freedom Hill in Vietnam for activities including variety shows and board games.*

"I was really excited. As we finished our taping session, I held out my Vietnam unit-insignia-laden hat saying, 'I missed you in Da Nang 20 years ago. Would you please sign my hat?' When he realized what I was asking, he smiled and immediately took my tattered hat from my hand, admired it, and found an open area that could bear his signature and boldly inscribed his name on it."

Unfortunately, her time in Vietnam caught up with her in an unexpected way. Watts began experiencing health problems, including a diagnosis of Parkinson's disease, a progressive nervous system disorder. She later learned that the Parkinson's was most likely caused by Agent Orange, a chemical used extensively during the war to eliminate foliage, which served as hiding places for the enemy.

Despite her diagnosis, Watts said she would do it all over again. She wrote a book about her experiences entitled *Who Knew? Reflections on Vietnam.* ∎

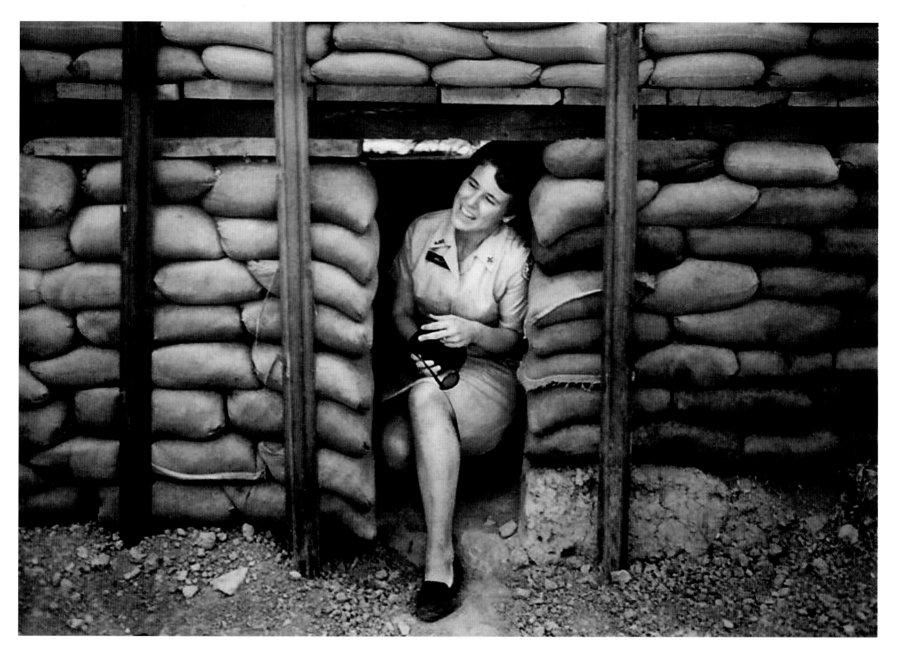

Watts holds her camera as she peeks out the doorway of a fortified bunker, surrounded by many layers of sandbags that made up her "home away from home" in Vietnam.

George Mitchell

Deployment: Berlin 1954–56
Branch of Service: U.S. Army
Residence: New York City
Occupation: Chairman emeritus and partner at DLA Piper law firm

★ ★ ★ ★ ★

*"I was always conscious of my own fallibility
in deciding the fate of others."*

Born on August 20, 1933, George Mitchell was the son of an orphaned Irish Catholic father and a Lebanese immigrant mother. Although neither of his parents was educated, they instilled the importance of faith, family, and country in Mitchell and his three brothers, who were raised in Waterville, Maine.

Mitchell would go on to become a lawyer, successful businessman, and a U.S. senator from Maine, serving from 1980 to 1995. He was also instrumental in getting the Good Friday Agreement signed, brokering peace in Northern Ireland.

He attributes much of the man he became to his experiences as a U.S. Army counterintelligence officer during the Cold War. Following college graduation, Mitchell was deployed to Berlin, Germany, from 1954 to 1956. At 21, his mission was to protect the interests of democratic West Germany from the Communist-run country to the east.

It was during that time that counterintelligence discovered a spy from East Germany who had crossed the East/West border. It was Mitchell's job to interrogate him.

But the alleged spy had other ideas. Mitchell found the man hanging from the window frame by his own belt.

"We immediately rushed over and found he was not dead, his toes were just barely touching the floor," Mitchell recalls.

It took three people to get the heavyset man down. As they did, the full force of his dead weight caused them to lose their grip and he plummeted downward, his face striking the desk. Blood gushed from a wound. A doctor helped stabilize his condition. Then Mitchell began interrogating him.

"It wasn't hard to determine he was not telling the truth," Mitchell says.

He admitted it, but he was more concerned about the women and two children who traveled with him.

"Do whatever you want with me," the spy pleaded. "But please let the women and children go. They don't know anything about this."

A day later, they turned him over to the West German police. The women and two children were cleared and returned safely back to East Germany.

"Those children have been my mental companions for life—because often in my life I wondered if I did the right thing with them. How did my decision affect their lives going forward? To this very day, I hope they ended up well."

Their story stayed with Mitchell when he became a lawyer and later a judge. "I was always conscious of my own fallibility in deciding the fate of others," says Mitchell. "Their liberty, freedom, and life, it was my decision to make. It's a daunting challenge. But having gone through my intelligence service in the Army, having made decisions like I did at 21, it had a profound impact on me and helped shape the person I have become." ■

"*Everything I had ever learned about air fighting taught me that the man who is aggressive, who pushes a fight, is the pilot who is successful in combat and who has the best opportunity for surviving battle and coming home.*"

MAJ. ROBERT S. JOHNSON

The Blue Angels fly in formation across blue sky in Guadalajara, Mexico.

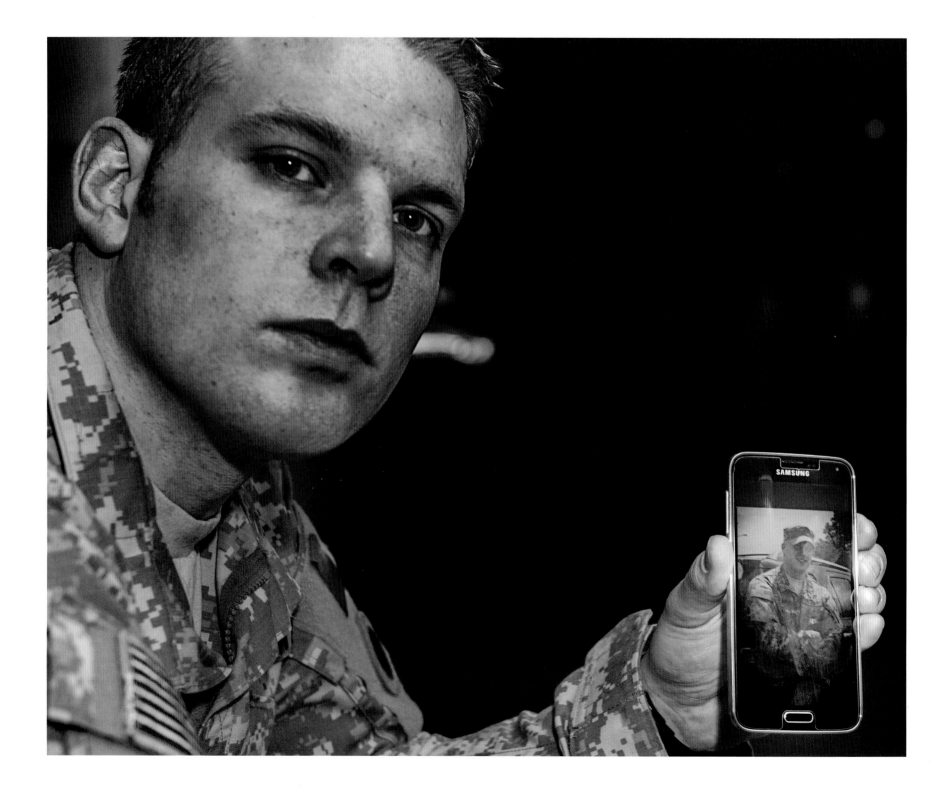

Jordan Lambka

Deployment: Afghanistan 2012
Branch of Service: U.S. Army
Residence: Michigan
Occupation: National Guard, part-time student

★ ★ ★ ★ ★

"Being twins we had this special,
unspeakable bond between us."

Reaching for his smartphone, Jordan Lambka points to the picture of a young man that could have easily been mistaken for him. "Being twins we had this special, unspeakable bond between us," he says, as tears fill his eyes.

His fraternal twin brother, Todd, had been his hero. Both Lambkas had dreamed of being a part of something greater than themselves. And after September 11, they knew they had to join the military.

After graduating from high school in 2006, Todd attended the U.S. Military Academy at West Point, graduating in 2010. Jordan joined the Army and spent eight years as a recon sniper. Both were eventually deployed to Iraq in early 2012, ending up in two different infantries and locations.

August 2, 2012, began like many other days for Jordan. The summer's heat combined with the dry desert made the conditions challenging. He had finished his patrol and was already inside the security gates of his camp when his Roshan phone started going off with secure text messages telling him he needed to immediately return back to base camp. Slightly amused with the timing, Jordan then heard his name being paged over the public address system to report to the commander's office.

"Thinking back, it's ironic. Everyone at the camp knew what was going on and why I needed to see our commander immediately. I had no clue what

was going on. As I walked, my Army buddies were approaching me and creating idle chitchat along the way. Feeling confident, I continued on."

As Jordan entered the commander's headquarters, his first sergeant met up with him, telling Jordan "he was a hard man to find." As they entered the room together, Jordan recalls, "What I remember is how strange my commander looked. I had never seen him act this way before. He had one hand in his pocket and his other hand was endlessly arranging the paper on his desk."

Shifting his gaze slightly to his left, Jordan saw a familiar scene that sent a cold shiver down his spine. A chaplain was present in the room. Jordan had been in this exact same situation several years earlier when he was pulled out of boot camp and was notified that his mother had passed away. "I immediately knew something was terribly wrong."

Before anything was discussed, his commander politely asked Jordan to surrender his weapons. "That's when I knew this situation was going to be personal. I disarmed and waited for [a] tidal wave of news to hit me." The commander quietly informed Jordan that his twin brother, Todd, had been hit by an IED the day before while leading his platoon on a mission. Thinking his brother was injured, Jordan asked, "Where is he now—what hospital was he transferred to—is he going to be OK?" After a long pause, the commander said, "Jordan, your brother is gone."

ABOVE: *Jordan Lambka displays his KIA (killed in action) tattoo as a reminder of his brother, Todd. "I wanted it to be permanent . . . There is one other person with the same tattoo . . . the medic who took care of Todd."*

LEFT: *Todd Lambka at West Point*

In total disbelief, Jordan hadn't really understood what his commander was saying. "OK, I get it he's gone, but gone where—if he's hit with an IED we transport them out to Germany or back to the States for treatment—right? So, where is he at, how severe are his injuries?" Looking Jordan directly in the eyes, his commander slowly said, "Jordan, your brother is gone. He has died from his injuries." The commander's message was a massive blow and made Jordan feel isolated and numb. His twin was dead; his life as he knew it was now changed forever.

Jordan and his father, Brian, became a military Gold Star family, a family recognized for making the ultimate sacrifice when their loved one dies in service to their nation.

Brian Lambka knows his son's sacrifice was not in vain. "Nothing was going to stop him from achieving his dreams," he says. Todd had thought about the military since he was eight years old. "My son had a purpose with his life. He was not afraid of any outcome associated with his choices."

And Todd continues to be an inspiration for Jordan. "Todd was my hero and I miss him greatly. He gave me the strength and the wisdom to become something bigger than myself. I will get on with life. I have to. But you can never forget, no matter how much time passes on." ■

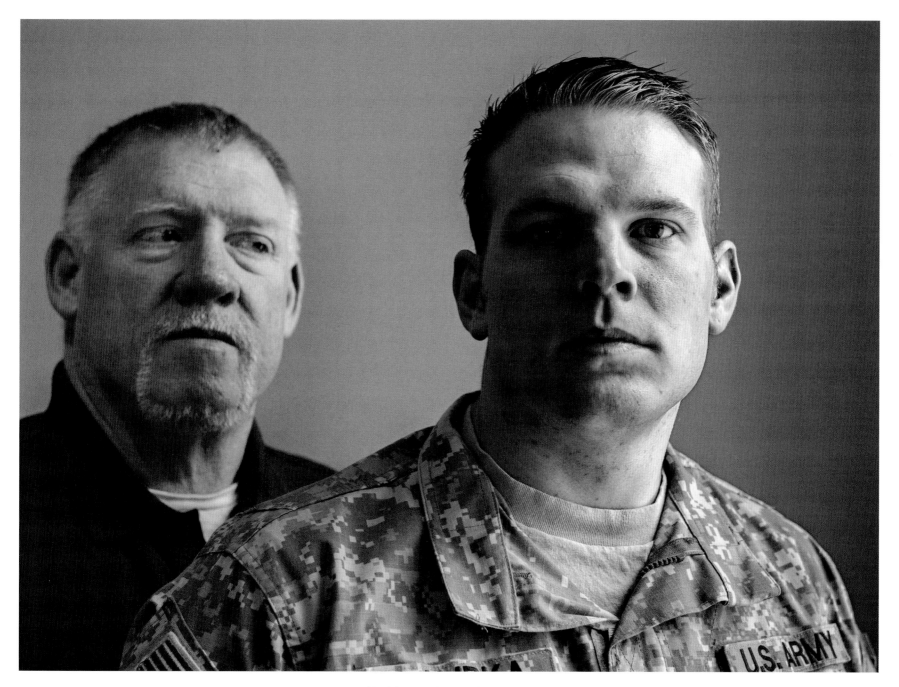

Brian Lambka (left), pictured with Jordan, knows the pain of loss.
He lost his wife, Donna, in 2006, and son Todd in 2012.

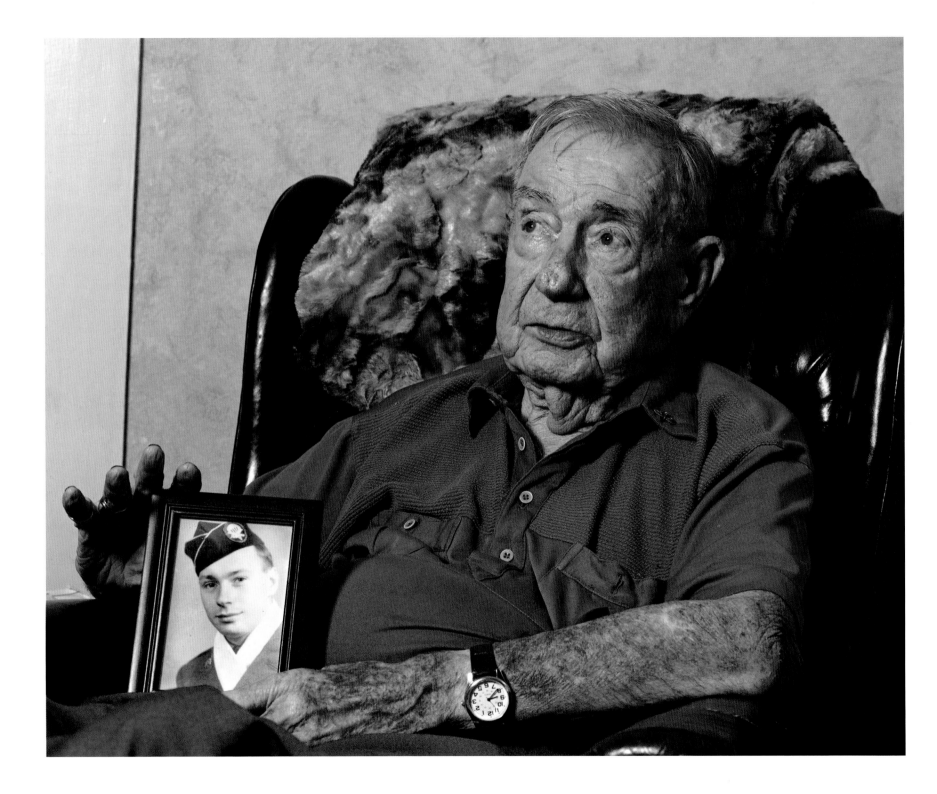

JAMES WELSH

Deployment: World War II, Europe 1943–1954
Branch of Service: U.S. Army
Residence: Louisiana
Occupation: Retired businessman

★ ★ ★ ★ ★

"So General Eisenhower said to me with a smile, 'What do you mean you can't have coffee with me?
Do I have to make that an order?' "

James Welsh spent his childhood moving from boardinghouse to boardinghouse. He was born in Alabama in 1925, just before the Great Depression. Separated from his father, his mother did her best to raise him by herself. She moved her young son to Chicago, where she had found work, before moving to Canada to help family.

Despite growing up without many luxuries, Welsh believes he had a good childhood.

"My early raising and development wasn't too unbearable. Education, good manners, and helping others were our prime objectives," he says.

Those values led a teenaged Welsh to join the U.S. Army, eventually becoming a paratrooper with the 551st Parachute Infantry Battalion.

On August 15, 1944, Welsh participated in Operation Dragoon, the invasion of southern France. Jumping behind enemy lines, Welsh fought the Germans in Vichy. Less well known than D-Day, the invasion allowed the Allies to place greater pressure on the occupying German forces throughout the country, especially in the north where progress had already been made.

Later that year, his unit was transferred to Belgium after the Germans surprised the Allies with their Ardennes Offensive, later known as the Battle of the Bulge. The Germans had confused the Allies by sending English-speaking Germans to impersonate American and British soldiers behind enemy lines. The fake soldiers were able to change signposts, misdirect traffic, seize bridges, and generally cause disruption.

Welsh would later meet the brains behind that operation, Otto Skorzeny.

During the German offensive, however, Welsh was recovering from his combat wounds at a hospital in England, where he met his wife.

In late 1946 Welsh transferred into the 7707 Military Intelligence Service Center, stationed in Oberursel, Germany. His assignments often consisted of providing armed escorts for high-level Nazis being held prior to being tried at Nuremberg. He was also a part of General Eisenhower's honor guard. Part of his job was to announce high-ranking visitors and meet notable prisoners.

On one occasion Eisenhower himself opened the door and said, "Come in, Sergeant Welsh. Have a cup of coffee with us." To which, Welsh responded, "Oh, I can't do that, sir. I'm still on duty."

Welsh remembers the next exchange well: "So General Eisenhower said to me with a smile, 'What do you mean you can't have coffee with me? Do I have to make that an order?' "

Weeks later, Welsh escorted Skorzeny as a prisoner. After having been a prisoner of war for two years, Skorzeny was acquitted of all charges at the Dachau trials. Skorzeny looked at Welsh's wings and said, with obvious respect, "Hmm. *Fallschirmjäger*," the German word for "paratrooper." ∎

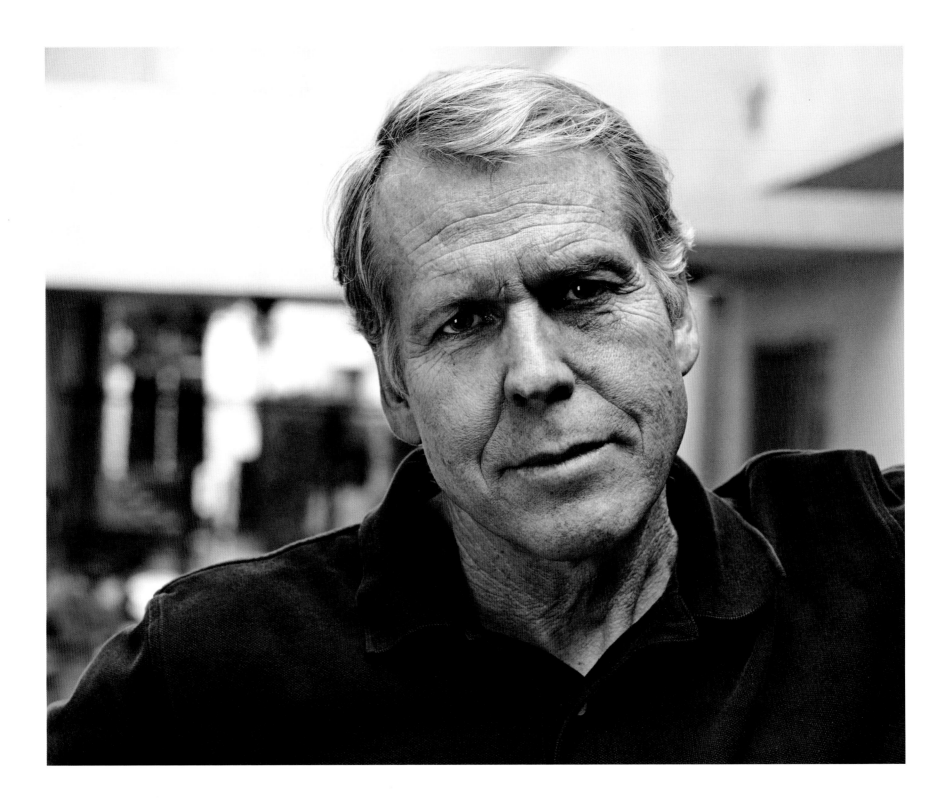

KENNETH GRIMES

Deployment: Gulf War 1991
Branch of Service: U.S. Marine Corps
Residence: California
Occupation: Documentary filmmaker

★★★★★

"The intelligence officer knocked on my door and said, 'I just thought you'd want to know, we started bombing Iraq! But you can't tell anyone.'"

Kenneth Grimes's ship had arrived in the Persian Gulf during Operation Desert Shield, and the scene before him was surreal. "The dark night was punctuated with bright orange fire as oil rigs burned in the distance, casting an orange glow on the clouds above," says Grimes. "As day dawned and the ship sailed closer to the shores of Kuwait, the sky was black. Oily-smelling smoke and occasional fires created an eerie atmosphere, as if the evil Sauron from the *Lord of the Rings* were wreaking havoc in Kuwait. It was absolutely hellish."

A reservist, Grimes had been studying motion picture production at graduate school at the University of Southern California in the summer of 1990 when he read the newspaper headline "Iraq Invades Kuwait."

His gut feeling told him he would be going to war. For the first time since the Korean War, reservists were being called to battle on the front lines. That included him. He had to leave his studies and join the Fifth Marine Expeditionary Brigade.

The LHA amphibious assault ship had been nicknamed "the Death Star," not for its strange appearance but for the rumor that once "you go there, you never get off!"

To the young marine, the ship looked more like a large floating metal box than a carrier. The narrow stairways were little more than ladders connecting the different levels.

Once aboard, Lieutenant Grimes worked as a reconnaissance officer for the admiral of the brigade at the ship's headquarters. Working under the intelligence officer, Grimes was privy to many details of their mission.

"I was in my stateroom, writing a letter, when the intelligence officer knocked on my door and said, 'I just thought you'd want to know, we started bombing Iraq! But you can't tell anyone.'"

"I thought, I'm in a little metal box in a bigger metal box in the middle of the Gulf! Who am I going to tell? So I just answered, 'Yes, sir!'"

Grimes's ship was part of one of the largest amphibious forces to be assembled since the Korean War. The ships were armed with impressive firepower in an effort to compel Saddam Hussein to release Kuwait City, returning it—and its precious oil—to the Kuwaiti people. President George H. W. Bush had issued an ultimatum with a deadline, but Saddam would not withdraw his ten armored divisions occupying Kuwait City.

With a fleet of enemy warships nearby, Hussein had expected an amphibious invasion and filled the gulf with water mines.

Grimes and his men worked with Navy SEALs to locate them, swimming in waters that were 18 feet or deeper. Most of the mines were World War I technology, "big globes with spikes coming off of them with a chemical at the end that breaks and sets off a charge. There were more modern Italian designer mines in the water as well, undetectable to sonar."

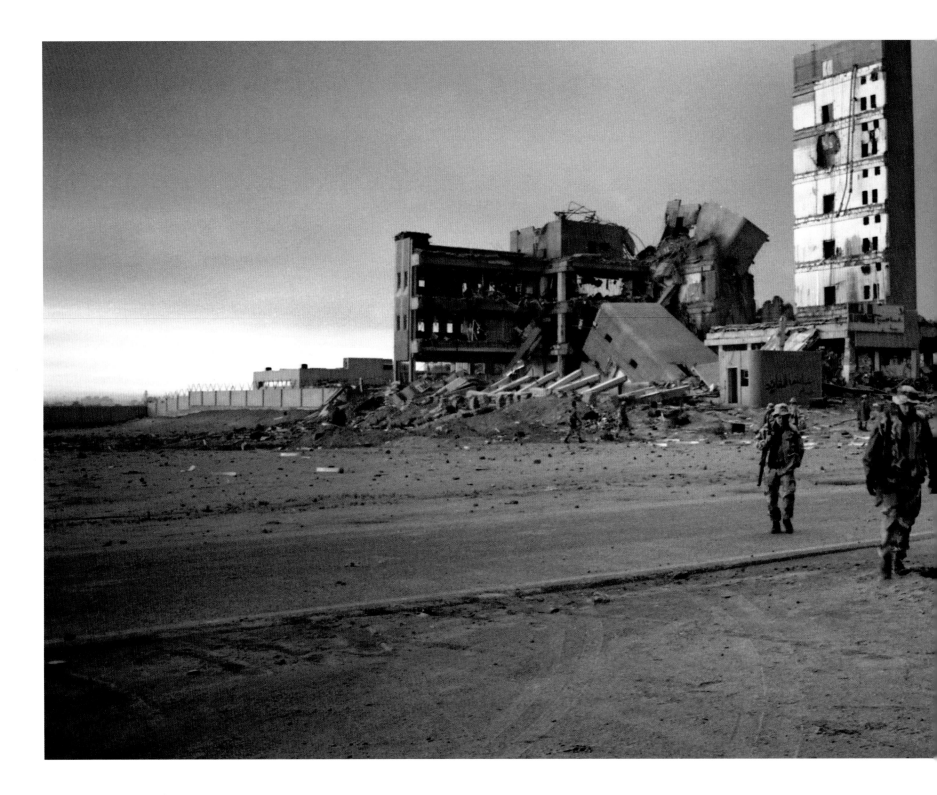

ABOVE: *Ken Grimes took this photo from a suburb looking back toward Kuwait City.*

LEFT: *Now a documentary filmmaker, Grimes took this photo of the telecom center in Al Ahmadi after a single hit from a cruise missile.*

When war did come, Hussein was taken by surprise. Rather than attack from the sea, ground troops invaded from Saudi Arabia while Hussein's troops were busy guarding Kuwait City.

"When I got the news, we were on radio silence, so we had to communicate using flashing lights, like in World War II. I was on the headquarters ship and most of my troops were on another ship, an advance force ship. So to inform them of our orders, I had to write a short message on paper, have it cleared by a senior officer, then give it to a sailor who then projected a light into the sky, flashing 'dot, dot, dash' signals in Morse code. The message was relayed to the next ship and then to the next—until an answer came back to me. Then I answered, 'Do this. Go here. I'll see you there.' "

Overall, Grimes was relieved the attack didn't come from the sea. The gulf was flat enough that anyone could have seen the brigade coming ashore. Besides, it would have been difficult to maneuver around the water mines.

"Yes, we would have bombed them to heck, but at the cost of massive casualties on our side," Grimes says. "It became a feint. We faked them out—our ships being there held Saddam's ten divisions in place. It was a brilliant idea and it worked really great." ◾

DON THIEME

Deployment: Vietnam 1968–69
Branch of Service: U.S. Army
Residence: Massachusetts
Occupation: Retired director of a hospital association

★★★★★

*"In the worst conditions,
there's a lot of humanity."*

Don Thieme had built a successful career as a health care consultant and executive director for a hospital association. Few would have guessed that the upbeat and outgoing man suffered from nightmares and relived terrifying memories.

He functioned well in social settings but struggled when alone. Driving from one client to another, he would turn on his radio at full blast in an attempt to drown out any thoughts about the Vietnam War. He didn't want to think about the men, women, and children who were ruthlessly murdered by the Vietcong after he had fought so hard to protect them.

When he was deployed in February 1968, Thieme had no illusions that the Americans could win the war in Vietnam. But the 24-year-old Army lieutenant wanted to go anyway. He had heard the stories of the Vietcong executing their rival village leaders in the dead of the night, and teachers in front of their students.

But there was no room for political ideas once the Massachusetts native arrived in the war-torn nation. When he arrived, the Tet Offensive—a military campaign launched by the North Vietnamese Army against the South Vietnamese and their allies—was already under way.

Thieme was responsible for a platoon of 30 to 40 men. Their mission was to expel the enemy by setting fire to their base camps, guarding bridges, and protecting villages from the coast to the Laotian border.

Thieme's goal was to get all of his men home alive. But that wasn't possible. In November 1968 Thieme's platoon was outside Saigon when a group of six men were ordered to set up routine ambushes on the Vietcong. Among them was Sgt. Roger Justice. Justice was in position when he heard the twang of one of their grenades go off.

"He knew the grenade was loose now, and he just covered it with his body so the rest of the men wouldn't get killed," Thieme says. "He died. He was 21, 22. He was a wonderful guy, just wonderful."

Justice was the only member of Thieme's platoon to die. However, several of his men were wounded, and many in his company were killed right in front of him.

In January 1969 the company suffered more casualties and ambushes. Before he returned home, Thieme saw friends killed and one man "vaporized" by a rocket-propelled grenade attack.

Thieme joined Special Forces in the Middle East for three years before entering the private sector. After several years of struggling, he reconnected with the men in his platoon. He had always admired their courage and willingness to protect innocents and one another.

"In the worst conditions, people really care about one another. That's when it really shows," he says. "People sacrifice themselves for each other. In the worst conditions, there's a lot of humanity." ▪

JEANETTE McMAHON

Deployment: Honduras 1984, Germany and Turkey 1990, Korea 1996,
Japan and Hawaii 2002, West Point 2005
Branch of Service: U.S. Army
Residence: New York
Occupation: High school coach, teacher

★★★★★

*"Through his eyes and heart, he gave me and others the strength and the courage
of understanding what honor and sacrifice really are."*

Col. Jeanette McMahon (Ret.) clears away the leaves and twigs around the tombstone of her late husband. His final resting place was important to both of them: the U.S. Military Academy at West Point's historic cemetery.

It has now been more than a decade since Army Lt. Col. Michael McMahon was killed while serving in Afghanistan. He was on a non-combat mission when the Blackwater 61 plane on which he was a passenger crashed into a mountainside.

"Mike made a difference with his military service to our country," McMahon says. "He was a leader, a caring and well-liked individual who will be missed. We both met and fell in love attending West Point," she recalls. Graduating two years earlier, Jeanette was the first to enter military service, followed by her husband. She eventually became a Chinook helicopter pilot and was a commanding general's speechwriter in the United States Army Pacific region.

It was Thanksgiving weekend in 2004 and the McMahons and their three young boys were living in Hawaii. Jeanette was fulfilling her military duties at Fort Shafter in Honolulu. Mike was in Afghanistan on deployment.

"In an instant, I went from being Michael McMahon's wife to being his widow," McMahon says. She remembers every detail of that day. "The boys and I were putting up the outside Christmas lights in our bathing suits when I heard a car door slam," recalls McMahon.

McMahon saw two men in neat green uniforms approaching her. "I was a senior officer and I should have known instantly why they were there—but I didn't." As they drew closer, McMahon finally realized that these servicemen were indeed there for her. She blurted out, "Is he dead?" The answer wasn't clear. They told her that her husband's plane was missing.

McMahon and her family agonized in uncertainty. Three days later, at 5 a.m., there was a knock at the door. Michael McMahon, along with five other soldiers, had perished in a crash on the side of a mountain. At the time of their dad's death, the McMahon boys were 14, 12, and 4. In addition to losing her husband and her partner in raising three young children, McMahon also had to contend with the media.

Immediately after the memorial service in Hawaii, a large group of reporters were waiting outside on the church steps. "The military was protecting us from the media, but once we got outside the church things became very different."

McMahon had promised her youngest son that, if he behaved during the service, he would be able to ride his new scooter in the parking lot of the church for a time. McMahon says, "Ricky was perfect in church

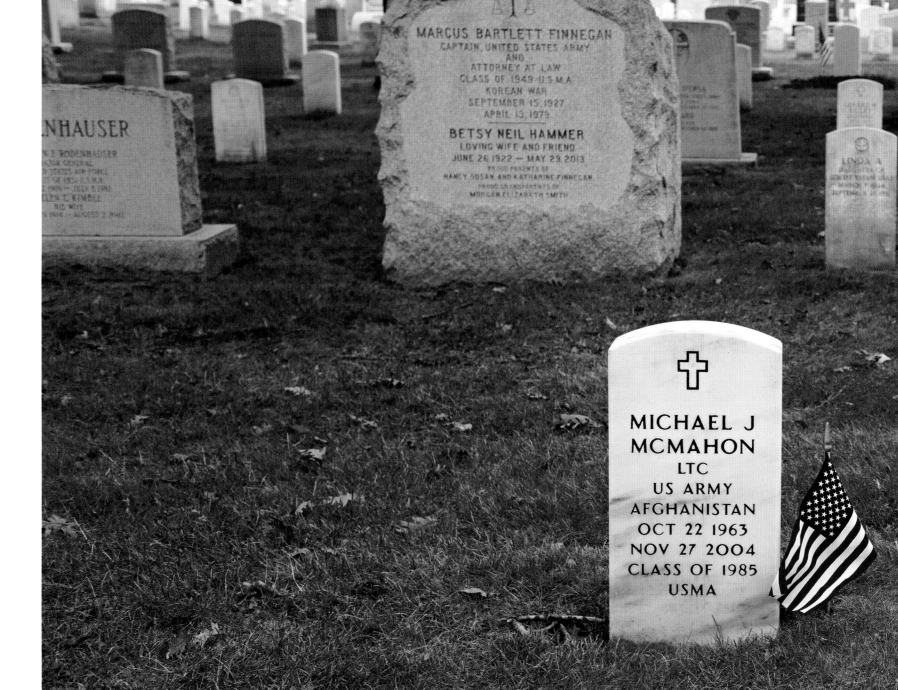

ABOVE: *Jeanette McMahon shares a moment of gratitude: "Mike was a leader, a caring and well-liked individual who will be missed. He was the love of my life."*

LEFT: *At West Point Cemetery, an American flag adorns the grave of Michael J. McMahon, beloved husband and father.*

so, as promised, I let him ride." One of the reporters asked McMahon if he could film Ricky, and she said, "Yes—go ahead." At this point, everyone was standing around looking at each other not sure what to do. Ricky circled around and headed back to where his mother and brothers were standing. It wasn't long before Ricky started openly talking about his father to the reporters: "Yea, my dad he was an aviator and he's a real hero because he went over to Afghanistan to defend his country. He was in a plane and the plane went into the wrong place, and the plane crashed and he died. Tonight he's going to be an angel in heaven, and tonight he's going to bring the stars out for everyone to see."

"Everyone present was awestruck as this four-year-old child told his father's story straight from his heart," McMahon says.

Later on, the piece aired on the evening news. The reporter told his story and showed the video of Ricky. "You would think four-year-old Ricky McMahon doesn't really understand his father was killed in Afghanistan serving his country—but you would be wrong to assume that."

McMahon credits her son for adding simplicity to this tragic event.

"Ricky knew his father was a hero and did something very important with his life. He was proud of his father. Through his eyes and heart, he gave me and others the strength and the courage of understanding what honor and sacrifice really are." ∎

GRATITUDE

"I do not believe that the men who served in uniform in Vietnam have been given the credit they deserve. It was a difficult war against an unorthodox enemy."

GEN. WILLIAM WESTMORELAND

HELMUT SCHMIDT

Deployment: World War II, Europe 1939–1945
Branch of Service: German army (Wehrmacht)
Residence: Germany
Occupation: Political commentator, chancellor of the Federal Republic of Germany (1974–1982)

★★★★★

*"I was disgusted at the way the court case was handled. And having observed it,
I realized how criminal the Nazi Party was."*

Former German chancellor Helmut Schmidt passed away in 2015 shortly after contributing his story to this book, but, at 96, he was still as quick thinking and keenly intelligent as he was during his long and illustrious political career. When asked about his experiences during World War II, he explained that he was called up early—a young man of 21 in 1939 when the war began. Like most of his comrades, he didn't give much thought to politics.

The once widespread belief in a German victory vanished from his mind in 1941 with the invasion of Russia, where he took part in the tank invasion of Leningrad. Schmidt spent the rest of the war obeying orders, though he thought the war effort was going nowhere. In 1944, after the unsuccessful July plot to kill Hitler, Schmidt was assigned to be one of about 150 observers at the court case—a farce, a show trial. "I was disgusted at the way the court case was handled," he said. "And having observed it, I realized how criminal the Nazi Party was."

On a more personal level, one of Schmidt's most vivid and long-lasting memories was from toward the end of the Ardennes Offensive, also known as the Battle of the Bulge. Schmidt was commanding officer of a flak unit charged with shooting down American planes. His unit did this reluctantly because they knew they could expect fierce and accurate retaliation from American artillery.

On one occasion Schmidt's unit shot down an American Thunderbolt. Then American artillery reacted before his unit was able to change its position. A grenade exploded at close range, hitting one of Schmidt's soldiers in the groin, which caused him to howl in unbearable agony. Now under heavy fire, the medics for Schmidt's unit became paralyzed with fear and could not manage to attend to the injured soldier. With the whole unit watching their comrade, who continued to scream wildly in pain, Schmidt knew, as the commanding officer, it was up to him to respond.

At considerable personal risk, he attempted triage on the dying soldier, and he tried to ease his pain. It was the first time the horror of the war had been so close, so personal. The soldier died that evening. The experience had an indelible effect on Schmidt's life. Speaking with passion, he said, "It was the most awful moment I had experienced in eight years of service." After the Battle of the Bulge came to an end, Schmidt left for home. But in April 1945, the British captured him near Soltau, about 50 miles south of his home in Hamburg. He briefly became a prisoner of war, but he was soon released and had returned to Hamburg by August.

During his distinguished political career, Schmidt worked with many of his former enemies, becoming lifelong friends with colleagues such as Lord Denis Healey, Valéry Giscard d'Estaing, George Schultz, and Henry Kissinger. ■

MARK O'BYRNE

Deployment: Iraq 2006, 2007–08
Branch of Service: U.S. Marine Corps
Residence: Nevada
Occupation: Security officer

★★★★★

*"I recently started telling myself, If you fight for others' happiness and freedom,
then why not be happy yourself?"*

Mark O'Byrne wasn't the best behaved teenager. He wasn't very motivated in school, and if there was trouble to be had, he found it. That started to change when his family moved near the Creech Air Force Base in Indian Springs, Nevada. The first day O'Byrne saw the airmen in uniforms, he knew he wanted to join the military.

He began taking school more seriously, enrolling in college classes. Once he turned 18, he joined the military, deciding he was best suited for the U.S. Marine Corps.

O'Byrne worked hard in infantry training, catching the attention of his drill instructor. His commanding officer noticed something special in O'Byrne, and when he learned he was to be deployed to Iraq, he asked O'Byrne to join him. The young man happily accepted.

O'Byrne served in Fallujah from January to August 2006. He worked 18-hour days, mostly dividing his time among the quick response force, the mounted patrols, and the foot patrols. If the marines didn't come under fire, then sleep would follow. He rarely had the luxury of modern conveniences or even basic hygiene. He once went 45 days without a shower.

In July 2007 he was redeployed to Fallujah. A lot had changed in less than a year. Eight fellow marines had been killed by IEDs under an overpass that O'Byrne once frequented. Almost everything was in ruins.

He was horrified by some of the things he witnessed and unable to let go of any of it when he returned home in 2008.

"I'm still trying to figure out what it was. Did we come back with demons? You could just feel the evilness in the air. I don't know what it is . . . We'd been exposed to that kind of stuff. We're looking at everybody [back home] like, you don't even know how bad it is."

O'Byrne got into fights, drank—anything to try to dull the internal battle. "I've spent a total of seven months in jail," he says.

Veterans Affairs medical facilities and other organizations tried to help him by prescribing medication, but O'Byrne abused the prescriptions by mixing them with alcohol.

Once, he woke up in a padded jail cell. Another time, he was informed that he took out his gun and aimed it at several people outside a bar.

This pattern of destruction went on for about three years as he struggled with going in and out of jail and homelessness. Finally he was ready for help, turning to his parents and other organizations to help him find peace.

"I have somehow through all of my run-ins with the law and being injured, as well as almost dying, ended up with stability," O'Byrne says. "I recently started telling myself, If you fight for others' happiness and freedom, then why not be happy yourself? Reap the benefits of your sacrifice." ∎

HALEY ZIMMERMAN

Deployment: Afghanistan 2009, 2013–14
Branch of Service: U.S. Army
Residence: Virginia
Occupation: Student

★★★★★

"It's a blessing that Final Salute offers this type of program so a woman veteran does not have to worry. The service Final Salute provides and does so well is to catch you before you fall."

Born in New York and hailing from Montclair, New Jersey, Haley Zimmerman enlisted in the Army after finishing high school in 2003. She entered basic training as a broadcast technician.

Zimmerman was stationed in Kandahar, Afghanistan, during her first tour of duty. She worked the night shift at the base.

"Thank God, my deployment was uneventful," she says gratefully. "My only job was to ensure the lines of communication were always open and functioning."

After Afghanistan, she eventually was stationed in Fort Meade, Maryland, where she remained on active duty until 2009. After leaving the Army, she tried unsuccessfully to find a job during the height of the recession before she decided to go back to college to study interior design. Meanwhile, she joined the Army Reserve in the fall of 2010.

Two years later, Zimmerman learned her reserve unit was deploying to Afghanistan. "I became so distraught—all I wanted to do was finish school and get on with my life," recalls Zimmerman.

In December 2013 Zimmerman headed back to Afghanistan. This time she was able to work as a broadcast journalist, allowing her to use her creative talent.

Returning to the United States in December 2014, she looked forward to completing her interior design degree. However, the school wouldn't allow her to reenroll mid-year, instead requiring her to wait until fall, almost nine months. Because she was not attending school, she could not draw her Army stipends, which she needed for living expenses. As hard as she tried, Zimmerman could not find a job that would pay her enough to support herself.

"Even though I'm a veteran, I was seen as not having enough experience by employers," she says.

With limited savings and resources, Zimmerman was facing homelessness. Compounding the problem was the fact that she needed to remain close to her military base in D.C. to fulfill her reserve duties.

Zimmerman was extremely stressed and uncertain about where to turn for help. Then she heard about Final Salute, a women's organization that addresses situations like hers. She was allowed entrance to Final Salute's residence for women in December 2014.

With a place to live, Zimmerman was able to focus on finishing college while collecting her Army stipend. She used the two-year opportunity that Final Salute provided to finish her schooling and build some cash reserves.

"It's a blessing that Final Salute offers this type of program so a woman veteran does not have to worry. The service Final Salute provides and does so well is to catch you before you fall," Zimmerman says with a smile. ■

BRIAN FRANK CARTER

Deployment: Cold War, Pacific 1958–1962
Branch of Service: U.S. Navy
Residence: California
Occupation: Artist

★★★★★

"I have been described as 'an artist who looks out many windows.'
I left behind a colorful trail."

My mother turned me in. 'They're here, Brian. The FBI wants to talk to you. Again . . . !' "

At 19, Brian Frank Carter had already avoided the draft for a year and a half. A military lifestyle simply did not suit his artistic temperament.

But the government would not be denied. If Carter was going to join the military, then he wanted to do so on his terms. The draft meant three years in the Army. So he chose four years in the Navy, hoping to see the world.

And he did—more so than most of his shipmates. Carter was selected to be a member of the flight deck crash crew on an aircraft carrier, one of 200 or so men whose job required him to be on deck, while the nearly 4,000 other men spent their time below.

Carter quickly built a unique reputation for himself. Resistant to promotions and endless protocol, he did find adventure in the Navy.

"I volunteered for everything," he recalls. "I loved the excitement. I had some very hairy experiences, but here I am."

It may have been peacetime, but the United States was engaged in the Cold War in the late 1950s and early '60s. War games took place daily and the flight deck of an aircraft carrier was one of the most dangerous places to be. One pilot was killed after his plane exploded during a night ops game, another crashed into the sea. Nine other crewmen died from "making the wrong move." In one instance, Carter had to hose down the remains.

Then there was a drill with an atomic bomb. Carter was almost positive that the treaty with Japan specifically forbade its use. But there it was—the largest weapon of mass destruction ever used—resting eight feet from him as the deck crew learned how to load it with marines standing guard.

While the drill was unnerving, Carter continued to remain active in all drills, volunteering for anything interesting. But he wanted to make sure he maintained his individuality. Tucked inside his 16-by-16-inch personal locker, Carter kept his drawing pad. In his spare moments, he would use a ballpoint pen or pencil and create multiple drawings that he would gift to other sailors, who kept them for years.

He also drew while he explored various countries. At one point, an ambassador's wife approached him while he was drawing the Simón Bolívar fountain in Lima, Peru. She invited Carter and his friend, Don Vickers, on a grand tour of the Inca ruins, which led to a televised interview.

After his discharge, Carter worked in commercial art, later taking on independent projects such as murals, hand-painted highway billboard ads, portraits, and watercolors. In 1980 and 1981 he bicycled around the world, supporting himself with his artwork.

"I have been described as 'an artist who looks out many windows,' " he says. "I left behind a colorful trail." ■

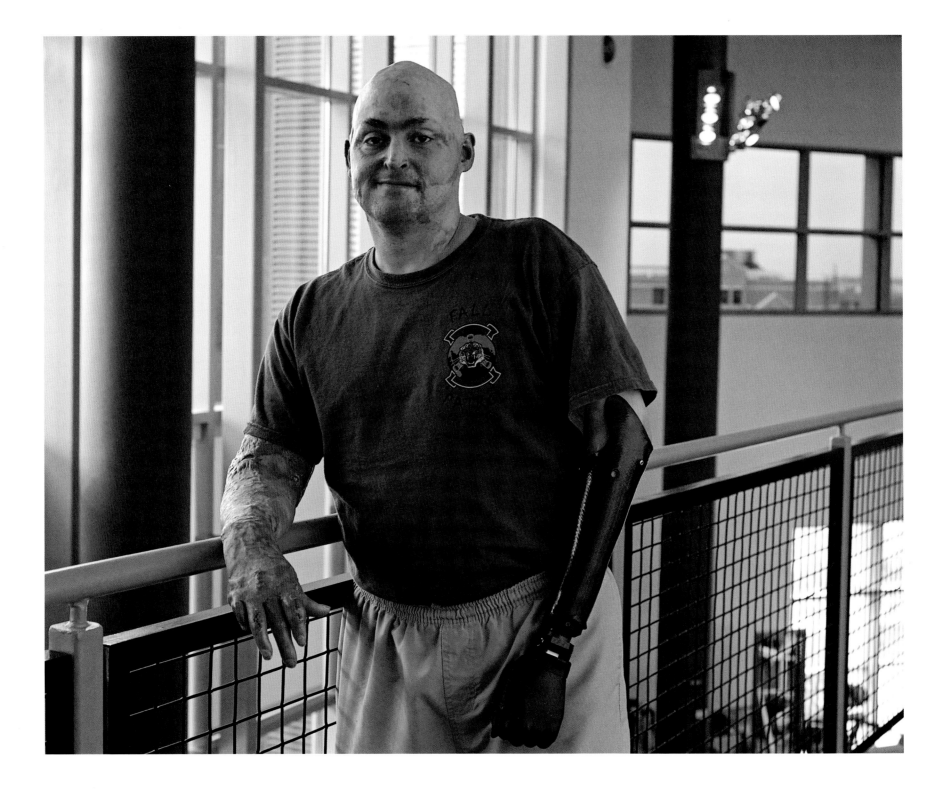

BRYAN FORNEY

Deployment: Iraq 2002–05, Southeast Asia 2011–13
Branch of Service: U.S. Marine Corps
Residence: Texas
Occupation: Marine in care

★★★★★

*"I was doing everything
I could to escape."*

When meeting Bryan Forney, you are drawn to his wonderful smile despite the extensive plastic surgery he has received on his face and body. With leg braces, the 40-year-old marine walks almost as well as he did before his February 20, 2013, helicopter accident. Much of his recovery and endurance can be attributed to his optimistic outlook.

"I don't know of another way to react to this," he says. "I'm lucky I had a wife and three kids before I got hurt. The fact that they were in my life gave me something important to live for."

He thought of them as his helicopter went down.

As far back as he can remember, Forney wanted to be a marine. He succeeded and went on to become a CH-46 Marine helicopter pilot. He was serving in Okinawa, Japan, at the time of his accident.

During a routine training mission high in the mountains of Thailand near the city of Phitsanulok, Forney was flying with three other marines. He balanced the two rear tires of the helicopter on the ledge of a mountain, while the front wheel dangled in the air.

"I landed on the ledge safely, but as soon as I took the power off the helicopter one of the rotor blades hit a large tree. The helicopter started shaking violently, and I had to move it so we wouldn't fall off the mountain."

The blade broke and Forney's helicopter went crashing down the mountain in a hard landing.

Forney remembers everything. Two of his crew members were thrown out of the damaged aircraft on impact. The copilot was able to get out safely, but Forney was trapped inside.

Forney's left arm and shoulder were completely destroyed. Using only his right arm, he managed to get out of his five-point harness, moving his injured legs to the copilot's seat.

"I was doing everything I could to escape," he recalls. But he was helpless against the uncontrollable flames inside. He could see the fire creeping along the cabin ceiling of the helicopter and could feel it burning his flesh.

Still, he struggled. "I wanted to survive. I wanted to get back to my family."

Unable to get away, Forney began to lose hope. "I came to the realization I was not going to make it—that was it for me. I thought of my wife, Jennie, and my three kids. I said my goodbyes."

The entire helicopter was now engulfed in flames and thick black smoke. For a moment the smoke cleared, and fellow marine Gavin Christian noticed Forney's boots on the copilot's seat.

"Gavin ran up towards the flames, grabbed my legs and pulled me out. He absolutely saved my life. He basically stuck his hands in the flames to get me," says Forney.

ABOVE: *Bryan Forney shakes hands. "It took me a while to get the hang of it," he says.*

LEFT: *Forney greets Gary Sinise as Forney prepares for his grueling daily rehab at Brooke Army Medical Center.*

Rescuers eventually found the helicopter by following the smoke of the crash site. They airlifted all four injured marines to hospitals. The rest of the crew recovered from their injuries. But Forney still had a long battle ahead.

His injuries were critical and life threatening. He suffered second- and third-degree burns that covered 54 percent of his body, lost his lower left arm, and had a multitude of other injuries from the accident. After he was stabilized, Forney was moved to Singapore for treatment. From there, the U.S. Air Force and U.S. Army Burn Flight Team performed the longest single-leg air medical evacuation in history, from Singapore to Brooke Army Medical Center in San Antonio, Texas, where Forney spent three months in the Burn ICU and two months in a step-down unit for his injuries.

On July 26, 2013, five months after his accident, Forney left the step-down unit and entered into extensive physical and occupational rehabilitation. The doctors told him it would take years to complete his recovery.

His daily progress reminds him he's one step closer to his recovery goals, and he is looking forward to the future. "I have a lot to live for—my wife, Jennie, and my kids. They all need me and that was the single biggest motivating factor for me to survive and to continue on with my life."

"I get that my experience is an inspirational story to other people. But to me . . ." He stops for a moment thinking. "It sounds trite—but I don't know what else to do. I don't know of another way to react to this . . . I thank God for my life every single day." ∎

Gary Sinise pays a special visit to Forney while he begins his recovery from multiple serious burns and other injuries resulting from a helicopter accident in Thailand.

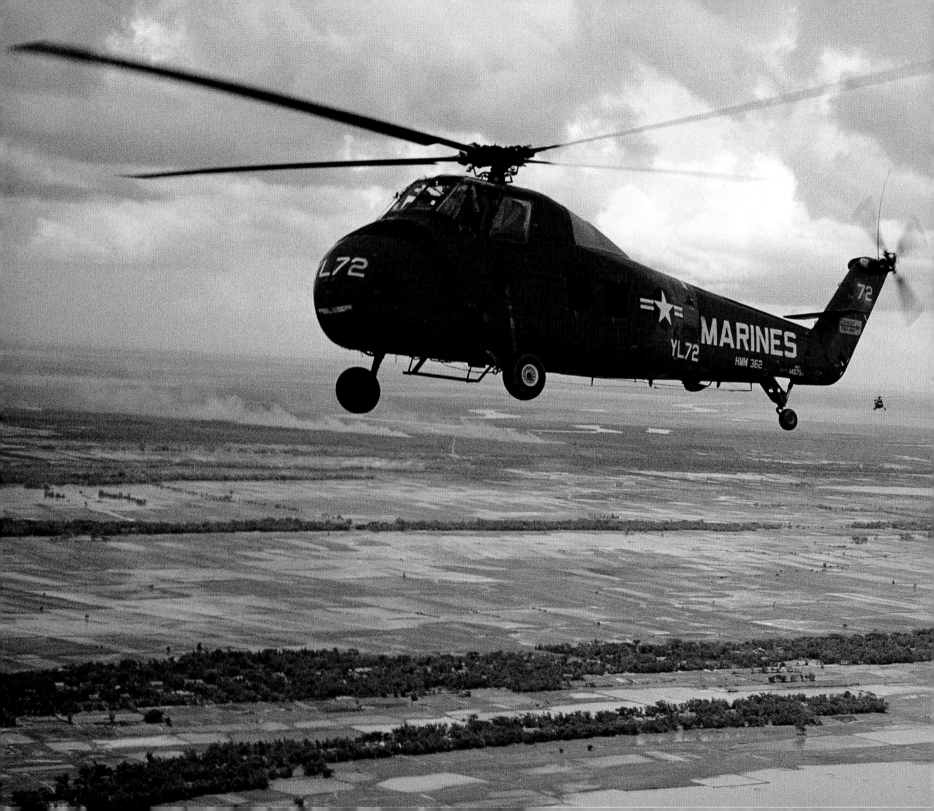

"Older men declare war. But it is youth that must fight and die.
And it is youth who must inherit the tribulation, the sorrow,
and the triumphs that are the aftermath of war."

HERBERT HOOVER

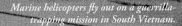

Marine helicopters fly out on a guerrilla-trapping mission in South Vietnam.

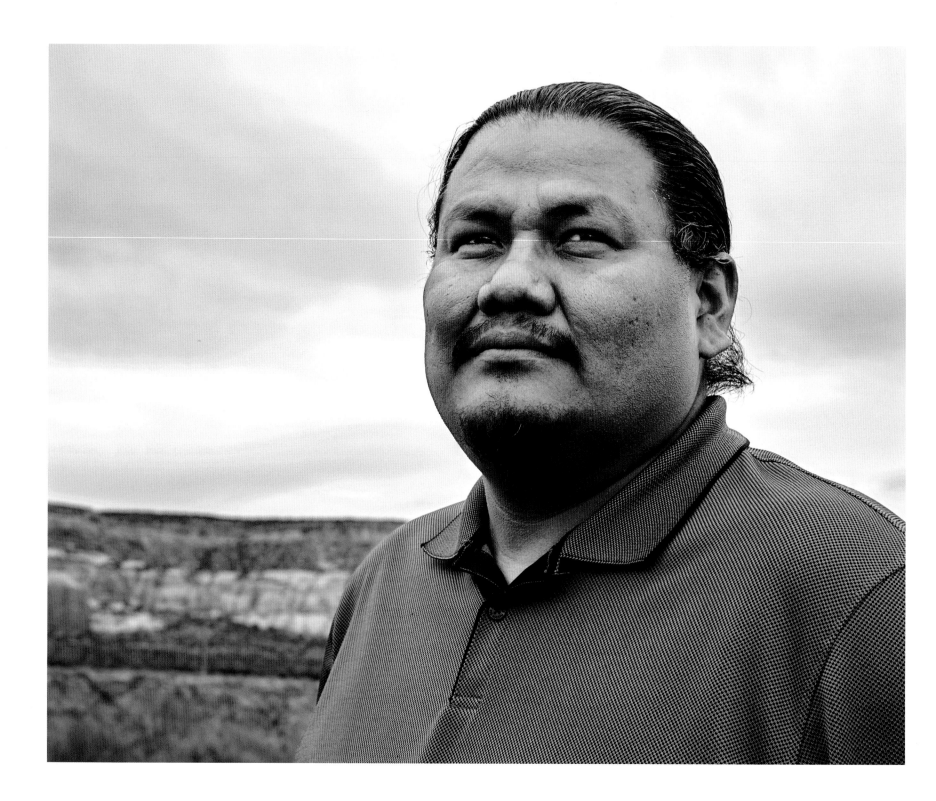

THALE GOODLUCK

Deployment: Iraq 2004
Branch of Service: U.S. Army
Residence: Arizona
Occupation: IT teacher

★★★★★

*"We as Navajo natives have always valued warriors. I felt I was being part of a long
and valuable tradition, like my grandfather, father, brothers, and uncles."*

Thale Goodluck had been looking forward to this day for quite some time. He was about to follow in the footsteps of his grandfather, father, brothers, and uncles. He, too, would be a warrior, fighting for his country.

But before he deployed to Iraq, he paid a special visit to his grandmother. Navajo traditions run deep, and he would not leave until she had shared the same sacred stories that had been imparted to his father and brothers before him.

Her late husband, a medicine man, had imparted the stories to her, and now she told them to her grandson. Goodluck tried to absorb every word his grandmother spoke. The ancient tales were meant to inspire the warrior and give him a sense of purpose.

He would take her message with him to Iraq.

Goodluck's first brush with danger came while on border patrol, overseeing Jordanians trying to enter the country.

He and another soldier were guarding their post when a small demonstration began near the Jordanian border. It all seemed rather harmless until an Indian camera crew arrived on the scene.

"Iraqis just go crazy when they see a video camera," Goodluck explains.

In an instant, 100 angry protesters arrived where there had only been 10. Goodluck and his buddy found themselves at the center of an angry mob.

The two young soldiers were pushed to the ground as protesters struck them with brooms, shoes, and any objects they could find. Their Kevlar gear was all that protected them from severe injury.

While they were both armed, they were not in a good position to defend themselves, especially as it appeared that a riot had just begun. Goodluck managed to call the quick reaction force for backup.

"Usually I don't like gunfire, but when I heard the sound of gunfire I thought it was the best noise ever," he recalls. "The force arrived with a group of Humvees and began shooting in the air to disperse the crowd and restore order."

Goodluck knew he would never forget what it felt like to be at the center of a mob's fury, and he was glad to make it out alive.

At first, he found it difficult to adjust to life back in the United States, but he did have support.

On his return the tribe held ceremonies and sweat lodge sessions in his honor in order to help him reintegrate. Then he took a road trip to visit four other tribes, finishing in Canada to see one of his brothers. While most of the tribal members were strangers, their encouragement helped him move beyond his time in Iraq.

Goodluck went on to earn his degree in computer science and is currently looking for a job teaching information technology. ▪

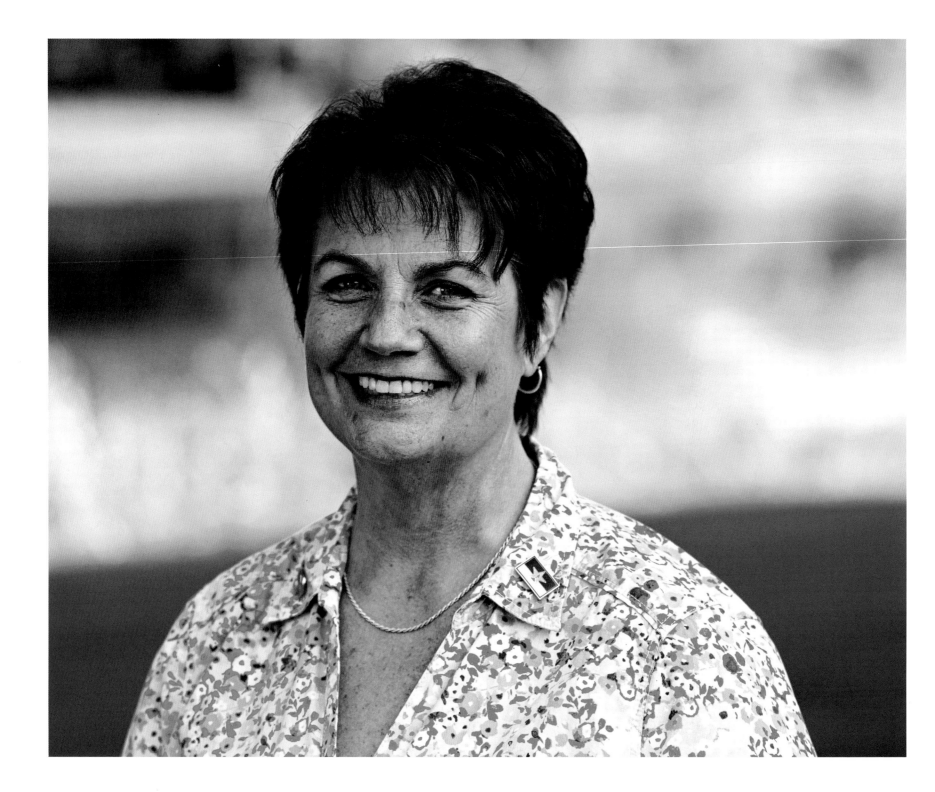

KAREN WRIGHT

Deployment: Grenada 1983
Branch of Service: U.S. Air Force
Residence: New York
Occupation: Mobile communications specialist

★★★★★

*"You just never knew
whose number was up."*

Karen Wright's grandfather was a medic in World War I, and her father was a paratrooper in World War II. Her father witnessed the man ahead of him jump out of the plane and get chewed up by the propeller. He swore right then that if he made it down alive, he would become a minister. He fulfilled that promise.

Wright grew up as a preacher's kid, following her father's ministry behind the iron curtain of Czechoslovakia (now the Czech Republic). She sang in churches with a traveling youth choir. Between high school and college, Wright explored the country, which was under Soviet rule. She noticed the communist propaganda, the poverty, and the men carrying bayonets on the sidewalks.

When she returned to the United States, Wright was so grateful to be an American that she wanted to give something back to her country. She followed her family's military tradition, and joined the U.S. Air Force. Her unit of the rapid deployment force was part of a multinational force interacting with Korea, Libya, Lebanon, Egypt, Grenada, Honduras, Chad, Italy, El Salvador, Iran, Sinai, the Persian Gulf, Italy, and Bolivia, as well as long-haul circuits and communications with places all over the United States.

One of her most dangerous assignments took place in 1983, when Wright was deployed as part of a joint task force in Operation Urgent Fury, the U.S. invasion of Grenada. The invasion took place after the nation's revolutionary prime minister, Maurice Bishop, was deposed and killed. Bishop had led a revolution in 1979 that had resulted in mass killings on the street and much civil strife. While the operation was swift for a military campaign, it wasn't without loss.

"The worst part of service was losing friends, getting to know someone and working alongside of them and then having them gone the next day," recalls Wright. "One night, a couple of guys would go out on a mission, and the next day they would be gone . . . You just never knew whose number was up next and it could have even been your own."

Wright survived the invasion, and in the end Grenada was restored to a prerevolutionary government.

After she left the service, Wright became the New York State director for Honor and Remember, an organization that assists grieving families who have lost someone in the service. Families are presented with an American flag, an official national symbol, recognizing with gratitude and respect the ultimate sacrifice made by their loved ones. Through this symbol and recognition, Wright hopes to promote awareness of the men and women who died serving our nation. The chapter of Honor and Remember that she represents was recognized by the Department of Defense Vietnam War Commemoration. ■

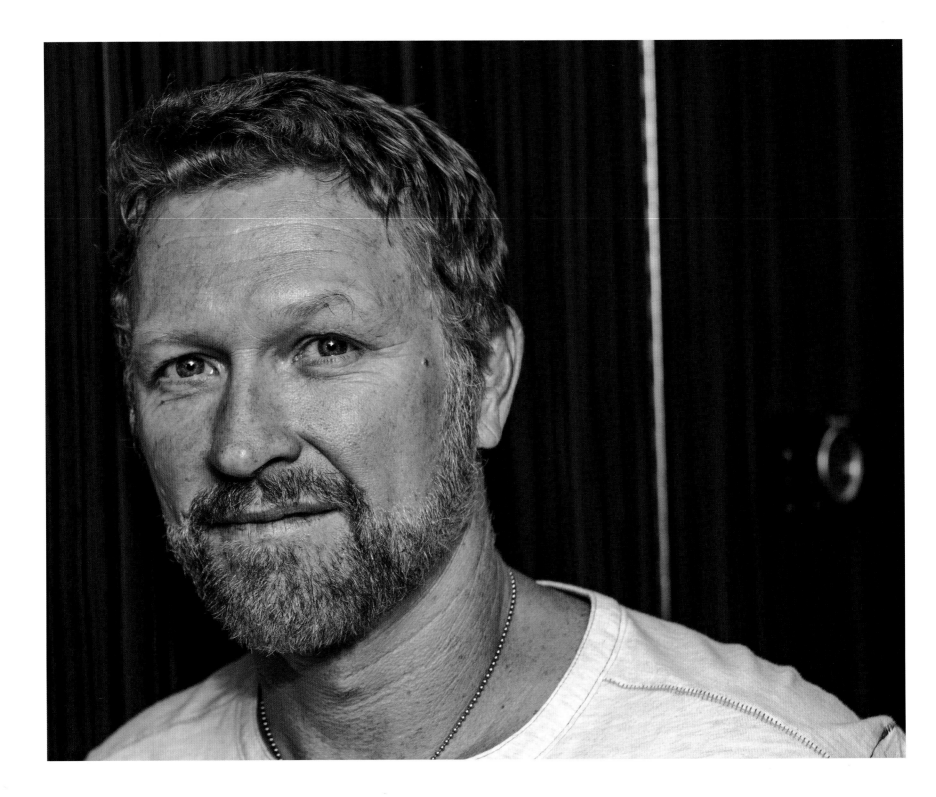

CRAIG MORGAN

Deployment: Panama 1989, Gulf War 1991
Branch of Service: U.S. Army
Residence: Tennessee
Occupation: Country music artist

★ ★ ★ ★ ★

"I thought you should know we had some troops that were fans of yours who
were tragically killed in a helicopter crash on a side of that mountain over there."

Craig Morgan was close enough to an active combat area in Afghanistan that he could hear the gunfire and flak going off in the distance. But he continued to sing the songs that made him famous, including the nostalgic "Almost Home." He was there for the 2002 USO tour. And despite the nearby battles, he was able to give his military fans a performance they would remember.

Shortly after he finished, Morgan was walking off the stage when a covert military person dressed to fit in like the locals came up and introduced himself.

"I thought you should know we had some troops that were fans of yours who were tragically killed in a helicopter crash on a side of that mountain over there," he said, pointing his finger. "I think it's important for you to know that before every mission, this group would play your song 'Paradise' and when they safely returned they would play your music again. You inspired them and they loved your music!"

The man's story brought Morgan to tears as he learned more about the men who died in the tragic accident. "This was a moment in my life that I will absolutely never forget. I'm glad I could give those men something for their service."

From the time his music career began to take off in 2002, Morgan had made it a point to remember his military brothers and sisters. After all,

he had spent 17 years on both active duty and in the reserves for the Army. He served in Panama in 1989 during the ousting of Manuel Noriega, and was deployed again during Operation Desert Storm with the 82nd Airborne Division.

Already a seasoned military person when his music career began in 2000, Morgan was reluctant to leave the military altogether, concerned that his music wouldn't pay the bills. Morgan's transition from the Army to a successful recording career was a slow one.

The turning point for Morgan was during one of his meetings with his commanding officer to discuss his reenlistment. "He told me, 'Craig, you could possibly be the sergeant major of the Army one day. You have the potential to do that and you have a great skill set, but I also believe that you should not pass up the opportunity to be a singer. I believe you have a shot at that,' " Morgan recalls.

"I was in the Army Reserve when I started my music career in 2000. I left active duty, and quite honestly, I did not think the music thing would work for me. I decided to give it a try while in the reserves, in case I needed to transition back into active duty," he says.

Morgan pursued his music career during the week, but his weekends belonged to the Army when he participated in drills. "It became pretty strange when I was having hits on the radio while serving my country,"

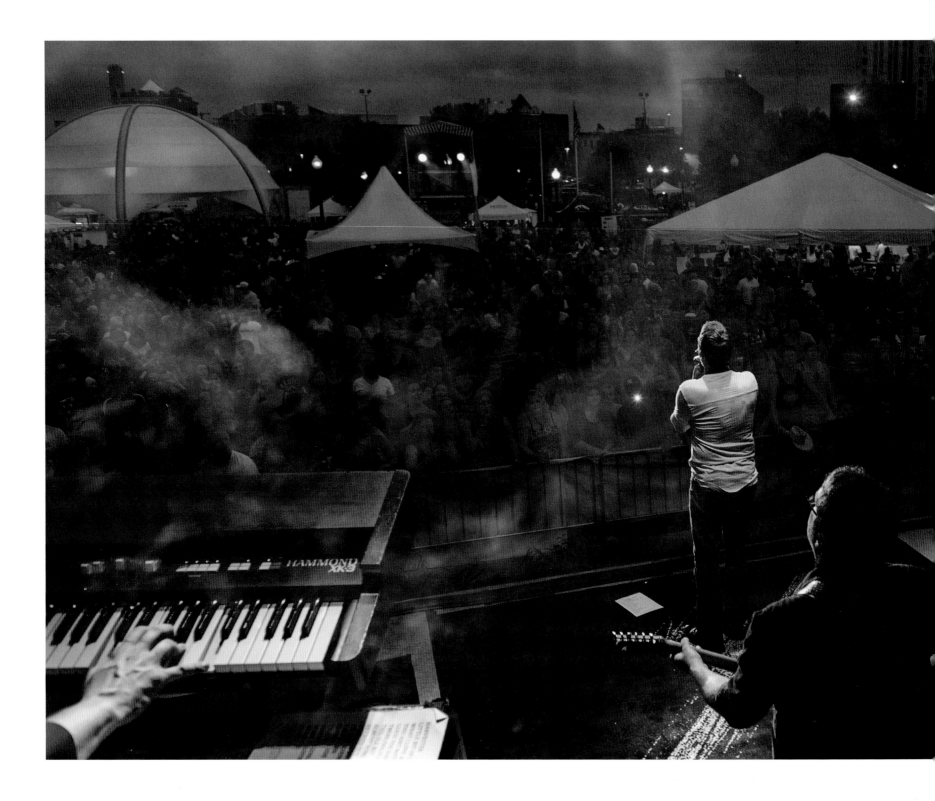

ABOVE: *Craig Morgan communicates with field operations during Desert Storm.*

LEFT: *In front of an audience in downtown Kalamazoo, Michigan, Craig Morgan and his band perform a touching rendition of "Paradise," a favorite among soldiers.*

he says. "And my fellow soldiers started asking me for my autograph." His talent and hard work seemed to pay off, however, and Morgan eventually left the military to pursue music full time.

"Music is at the center of my life," says the man known as one of country's best singers and songwriters since "Almost Home" put him on the map in 2002. But he doesn't believe he would have had the same success if it weren't for his time spent in the Army.

"My service helped shape my goals, my commitment and responsibility to my country and to myself and family."

Morgan reflects on his military experience almost daily and jokingly tells people "the military helped train me for the rigors of the music industry."

Since his music career has soared, Morgan has performed frequently for military audiences both stateside and abroad, and has earned the USO-Metro Merit Award. A member of the Grand Ole Opry, he was invited to play at Fort Bragg, one of the places he was stationed during his military career.

"The military is one great life lesson. I think the people who serve in the military have a sense of appreciation and gratitude because they get to see the other side of life and the struggles around the world," says Morgan. "I'm glad I did it. It has helped make me into who I am today." ■

MARC TUCKER

Deployment: Kosovo 1999, Iraq 2007–08, Afghanistan 2011
Branch of Service: U.S. Marine Corps
Residence: Virginia
Occupation: Organic farmer

★ ★ ★ ★ ★

"When you wake up, you'll no longer have your left arm.
But whoever put that tourniquet on your arm saved your life!"

In the middle of a forest in Virginia is a house surrounded by tall trees. This is where Marc Tucker lives with his wife and three children while he builds his organic farm. Work has already advanced on the chicken coop, made mostly from recycled wood, and the family has begun to enjoy fresh farm eggs.

"Learning to garden while in recovery gave me a greater appreciation for creation, nurturing and compassion, much like the corps, but in a different sense," Tucker says.

Born in New York and raised in Maryland, Tucker went to college on a wrestling scholarship. His plans changed after an injured elbow forced him to take a year off from the sport. Rather than sit around waiting, he decided to join the Marine Corps.

One of his first deployments was a peacekeeping mission in Kosovo in 1999, the year of the NATO bombing of Yugoslavia. Tucker loved the idea he could be a part of a peacekeeping mission and disaster relief effort in what was initially a conflict situation.

He would deploy again to Iraq in 2007 and finally to Afghanistan in 2011.

It was during his last deployment that Tucker had his closest brush with death. He was part of a task force charged with safeguarding the thoroughfares to the Kajaki Dam, necessary to restore power to Helmand Province.

In order to do that, the marines had to take their tanks through checkpoints, including ones known for IEDs.

As the Marine captain, Tucker was in one of the last tanks to pass a checkpoint. He was leaning over the tank with the hatch open when a 200-pound bomb went off.

The blast shook the tank, but with a quick assessment Tucker noted that no one had been injured and urged them to keep moving.

Allowing himself a few moments, Tucker scanned his own uniform, pausing when he saw his left arm. He could see right through it. But there was no pain and no bleeding. He barely registered his see-through arm, too preoccupied with fighting and surviving to consider the damage.

Members of his team felt otherwise.

"Sir, are you OK?"

"What are you talking about? Of course, I'm OK," he replied.

That's when Dave stepped in. "Bullshit!" the loader responded, kicking him in the neck to prevent any further movement.

Within moments, Dave had secured a tourniquet around Tucker's left arm. "I gotcha. You're good!"

Afterward, Tucker was quickly transported to a field hospital in Camp Leatherneck.

"I'm sorry to say I have some bad news for you," a doctor named Jay

told him. "When you wake up, you'll no longer have your left arm. But whoever put that tourniquet on your arm saved your life!"

Tucker accepted the inevitable before losing consciousness. When he awoke 12 hours later, the first thing he did was look for a stump where his arm used to be.

But to his amazement his arm was still attached, repaired with tissue that had been taken from his thigh. Concentrating, he found he was already able to move two fingers.

"I love you, Jay!" he yelled to an empty room.

While his limbs were spared, Tucker still had to return for more surgeries. It was during one of the procedures that he says his wife, Sarah, saved his life.

"There was one occasion when I was to be operated on to further repair my arm and as the sedative started to work the nurse asked her if I was allergic to iodine, which I am—highly," Tucker recalls. "So if you can imagine, figuratively, as the lights are going out, Sarah is pulling the IV bag out of my arm and frantic. The next thing that I know, I'm awake. That would be the first of many times that she saved my life, literally."

"She's the strongest person that I know," Tucker states. "Without Sarah I would be lost. The strength and resilience she has demonstrated far supersedes any that I've ever displayed."

With the help of his wife and family, Tucker has found a way to reenter civilian life. Taking on organic farming has helped him.

The practice has made him aware of his physical, mental, and spiritual well-being, he says. He can see how it relates to his earlier service with the Marines.

"The idea and practice both are ancient and pure, fulfilling the promise to return to civilian life better than when the corps enlisted me." ■

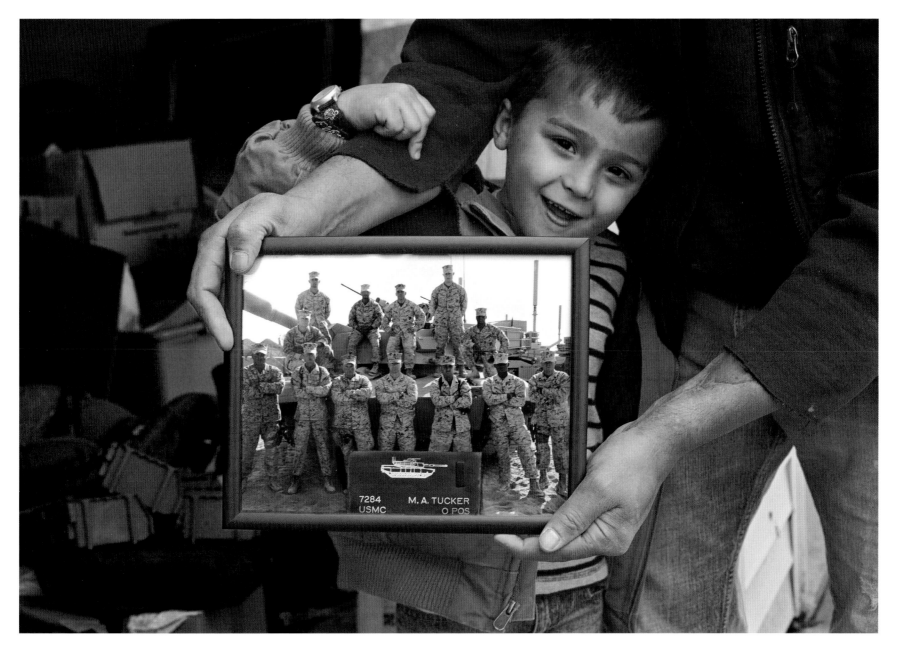

ABOVE: *Marc Tucker and his son, Hixon, hold a photo of the officer and enlisted company leadership for Company D, First Tank Battalion.*

OPPOSITE: *(Left) Tucker built this chicken coop mostly with recycled wood. It's located on his organic farm. (Right) Tucker holds an end connector, the piece of tank thought to have caused the injury to his arm.*

PAUL STANLEY

Deployment: Vietnam 1966–67
Branch of Service: U.S. Army
Residence: Colorado
Occupation: Minister

★★★★★

"Sir, please don't do that.
Let me have him back for three weeks."

Paul Stanley was worried. Just days before, he had sat down with a young private named Edward who couldn't handle the war zone around him.

A newlywed with a young child, the young man from New Jersey felt like his life had fallen apart after he was shipped off to Vietnam—for a war he didn't believe in. If that wasn't enough, Edward's wife had to move in with his in-laws because his private's pay couldn't cover their bills.

And now Edward was missing.

Stanley assumed he had run off, a dangerous move in unfamiliar jungle terrain. Stanley and members of Edward's platoon searched for him. Four days passed before they found him hiding in a 40-foot container nearly dead from heatstroke and dehydration.

Once he recovered, Edward was in serious trouble. He had deserted his unit in a combat zone. His battalion commander had few options and little concern for Edward. He planned to turn him over to the military police. But Captain Stanley intervened.

"Sir, please don't do that. Let me have him back for three weeks."

"Don't try this religious stuff on him, Stanley . . . He is a risk and a coward," his battalion commander retorted. But then he gave in. "OK, but just three weeks!" As an Army company commander, Stanley had some sway within the ranks. Stanley and Edward flew back to their company. Edward stayed with him as a radio carrier for the next five days. This wasn't the first time Stanley had become a personal mentor for one of his soldiers, both in combat and faith.

A devout Christian, Stanley shared the Bible he carried in a Ziploc bag with Edward. For the next few days, the two men spoke about Jesus Christ and his message. Stanley shared his views on their role in Vietnam. He believed in supporting the South Vietnamese who had suffered at the hands of the Vietcong, who had starved, raped, and murdered their people.

After a short while, Stanley felt his protégé was ready to rejoin his platoon. Edward was a different soldier and person.

Edward's platoon mates were unwelcoming at first, but gradually Edward proved to be a model soldier. After some months, he was asked to replace the battalion's chaplain's assistant . . . to the battalion commander's surprise.

Stanley lost contact with Edward after Vietnam, but he still feels connected through the friendship and shared beliefs. He hopes to meet with him again someday.

In the meantime, he devotes himself to an organization called the Navigators, an international and interdenominational group that evangelizes about Jesus Christ. Stanley joined the organization in 1970 and continues to do speaking engagements and lead Bible studies. ∎

WISDOM

"I look forward to a great future for America, a future in which our country will match its military strength with our moral restraint, its wealth with our wisdom, its power with our purpose."

JOHN F. KENNEDY

DAVID GALLES

Deployment: Iraq 1991, Bosnia 2002
Branch of Service: U.S. Army
Residence: Azerbaijan
Occupation: Foreign Service officer

★★★★★

"There is a satisfaction in serving your country, and in my case working with other nations in times of peace, that impacts the relations we as a nation have with them."

David Galles arrived in northern Iraq a few months after the United States military had pushed the Iraqis out of Kuwait. His mission was to assist the Kurds, an ethnic minority who had been slaughtered by Iraq's dictator Saddam Hussein in the late 1980s, mainly through chemical warfare. The Kurdish people were again in fear for their lives after a failed revolt against Hussein in 1991.

Nearly a million Kurdish refugees tried to flee the country but weren't accepted in Turkey or Iran. The United States stepped in, and Galles would begin his first peacekeeping mission.

Galles and his unit had been sent to Iraq to offer the Kurds security and protection. A brand-new second lieutenant at the time, Galles was to meet with the local Kurdish leaders to find out their needs (water, food, supplies) and whether they were being threatened.

While he valued his infantry experience, Galles wanted a more creative and challenging career. He became a foreign area officer, a politico-military adviser who would assist in grant distributions and negotiations.

Then in 2002, he was sent to Bosnia and Herzegovina as the Office of Defense Cooperation chief. His first responsibility was the distribution of grant money for rebuilding a joint military among the Bosnians, Serbs, and Croats. Because the country was fraught with religious and ethnic fighting throughout the 1990s, Galles's task was a challenge.

The Standing Committee on Military Matters, made up of nine guys, had blossomed into their ministry of defense, recalls Galles. "But at that time it was just made up of nine people sitting around a table who, of course, all had grudges with one another for different reasons."

"I would be sitting at the table with the Serb, who was the unit commander, who happened to bomb or shell the Bosnian's family's house and killed his aunt or uncle during the war. They knew each other very, very well."

Galles knew, and they knew, it was in their best interest to find "some middle ground." His efforts paved the way to a successful formation of a coordinated military. Using his language and negotiating skills, Galles helped the men to agree on how officers should be formed and who would be in charge in certain areas, and to find common ground on sensitive issues.

He also was able to work on humanitarian projects, such as the reconstruction of schools, clinics, and other organizations. One of his favorite memories involved a ribbon-cutting ceremony for one of the elementary schools in the Brcko District of Bosnia and Herzegovina.

"When you're involved in something like that, you start to see the rewards—at least tangible results," he says.

After 24 years in the military, Galles retired, but his experience led to his latest career move as a Foreign Service officer in the State Department. His first assignment has taken him and his family to Azerbaijan. ■

WILMA VAUGHT

Deployment: Vietnam 1967
Branch of Service: U.S. Air Force
Residence: Virginia
Occupation: Foundation leader (Women in Military Service for America Memorial)

★★★★★

"We worked very hard as women
in the military to get integrated."

"This is the most important thing that I will ever do in my life," says U.S. Air Force Brig. Gen. Wilma Vaught (Ret.). The 85-year-old is referring to her work to build and operate the $22.5 million Women in Military Service for America Memorial (also known simply as the Women's Memorial), the only major U.S. memorial to honor the service of all military women. The memorial is one of many ways Vaught has worked to advance women in the military.

Her own career began in 1957, five years after graduating with a business degree from the University of Illinois. Vaught joined the Air Force when less than one percent of the military were women. In those days, most women served in the medical or administrative fields, as did Vaught, who was in management analysis and data automation.

In 1966 she became the first woman to deploy with a Strategic Air Command Bombardment Wing on any operational deployment. Eventually she rose through the ranks, becoming a brigadier general. After 28 years and shortly before her retirement in 1985, Vaught was recognized as the first woman to command a unit to receive the Joint Meritorious Unit Award, the nation's highest peacetime unit award. She was also the first woman to be promoted to brigadier general from the comptroller field.

Vaught retired as commander of the U.S. Military Entrance Processing Command and as the chair of the Committee on Women in the NATO Forces. She then set her sights on helping women in the military find recognition, a cause that has continued for three decades.

She has spoken often of women's accomplishments in the military and of their continued and growing presence in the U.S. armed forces. She notes that three million women have served or are serving in all branches, making up 15 percent of the military population. That's one reason she has fought so hard for her female colleagues to be recognized.

She is president of the foundation that built and now operates the Women's Memorial, which seeks to recognize not only women's service but their fight to be included in the military. "Women in the military had to fight," says Vaught. "They had to sue the government, the secretary of defense, and the service secretaries to attain their rights, rights that should have been given to them just the same as any man."

"We worked very hard as women in the military to get integrated," Vaught says. "As we started to receive those rights and honors, they trickled out to the civilian sector."

That fight for equality and recognition has driven Vaught's work and her foundation. The Women's Memorial is a source of comfort and recognition for family and friends of those who served.

"I want to ensure that the Women in Military Service for America Memorial will be here in the future," states Vaught. ■

STEVE MCALPIN

Deployment: Bosnia 1996, Afghanistan 2002
Branch of Service: U.S. Army
Residence: New York
Occupation: Retired special education teacher

★★★★★

*"I was the first person to teach formal English in Afghanistan in 23 years.
Nobody taught it. That was against the rules."*

From a safe house in Kabul, Afghanistan, Steve McAlpin lifted the tiny paintbrush and began filling the piece of plywood with his most recent memories and wishes. Four boys, eager to learn, gathered in the left balcony. A young girl gazed curiously at a book for the first time while another hid behind a column. Taliban wandered the streets.

McAlpin chose his colors and symbols carefully, calling his painting "Window of Opportunity." It was therapeutic for the civil affairs officer, who had spent several months working to create an English program for the Afghan youth outside of Bagram Air Base, only to have it shut down under new management.

As a special education teacher, McAlpin had viewed the military as a way to support humanitarian campaigns. His interest in the military began when he read a book about the Holocaust, vowing to fight if that sort of situation ever arose again. When it did happen in Bosnia and Herzegovina, McAlpin transferred units and deployed to the region torn apart by ethnic cleansing. In 1996 he arrived in Bosnia as part of a NATO peacekeeping force, tasked with negotiating on behalf of the Bosnian Muslims and Catholics and Serbians, in hopes of creating tolerant interaction.

In February 2002 McAlpin was sent to Afghanistan to work again in civil affairs. His job was to work as a liaison between the Army and the local population.

He met with the local religious leaders and mayors to learn what they needed most. They told him of a school just outside the base in Bagram. There were only about 15 elderly teachers present because all the others had either been executed or escaped to Pakistan for their own safety.

"At the school, the students were sitting on bare concrete, no windows, no doors, no roof. The blackboard was black paint on a concrete wall. So I asked the base commander, Ed Dorman, if I could begin teaching English there. He agreed, on condition that he could 'be a part of it, too,'" McAlpin recalls.

McAlpin was excited. The local youth knew little about the West except what they'd learned from the Taliban. This was an opportunity to change that negative perception.

"So I put up signs up all over the base with my office number: 'Wanted: English teachers.' We managed to recruit 17 teachers, and I went through their teaching plans with them."

Out of tradition, McAlpin worked with males, but he also befriended a female American translator, Najla, who worked with the local girls.

On his first day, he introduced himself to his class of 17- to 29-year-olds and asked if anyone knew where New York (McAlpin's home state) was. One hand went up, so he asked about the United States. A few more hands were shown, so he asked about North America. A few more hands

went up, but he realized he would have to bring in a map to explain the relative positions of the United States and Afghanistan in the world.

"No, sir," his translator said. "A globe would be better so they could understand the world isn't flat."

That evening he found a small globe to show the class the next day. His students were eager to learn, and the Army was happy to assist. Army engineers also built 208 desks and benches to give the school a good start and every student a place to sit.

But McAlpin's progress was short-lived. A new colonel had been assigned to the base, and closed the program, citing that "teaching English to Afghans is stupid." McAlpin couldn't help but argue. "But sir, they are not fighting with us. They love it."

In the end, he had to say goodbye to his students who had "honored the ground we walked on as teachers."

Sent to the safe house in Kabul for the remainder of his deployment, McAlpin finished his painting. Wanting to make a statement about the authenticity of life in Afghanistan, he sent his work to the office of President George W. Bush. He didn't expect much to come out of it until he received a letter from the George W. Bush Presidential Library and Museum in Dallas, thanking him for his painting. It had been chosen for permanent display, one of just 300 out of more than 43,000 objects that had been given to the president over eight years. ∎

JAS BOOTHE

Deployment: Iraq 2008–09
Branch of Service: U.S. Army
Residence: Virginia
Occupation: Founder and president of Final Salute, Inc.

★★★★★

"I just had to do this . . . As it stands right now, America itself doesn't recognize the service and sacrifice women provide that is equal to our male counterparts who serve in the military."

"I just had to do this," Jas Boothe begins. At 37, the Chicago native and disabled Army veteran has made it her mission to help homeless female veterans and advocate for soldiers.

Boothe served in the military for 14 years, deploying during the Operation Iraqi Freedom and Operation Enduring Freedom campaigns, before her life was upended.

In 2005 she was a single parent in the Army Reserve living in New Orleans. Early in the spring, she learned she would be deploying to Iraq. In August Hurricane Katrina slammed into the Gulf Coast, completely destroying her home. Everything she had ever owned was lost. Then in September she received a devastating diagnosis. She had an aggressive type of head, neck, and throat cancer—making her ineligible for deployment.

Boothe quickly discovered her options were extremely limited and would pose significant challenges. Because of her illness, she was facing immediate discharge from the military.

She lost her income, which she relied on not only to support her young son but to cover the expenses of the full-time medical care she now required. She sought assistance, but she quickly learned there were no existing programs for female veterans with children. She was told to explore welfare and social services instead.

Faced with homelessness, Boothe realized that America and its military had forgotten about the many women who have served, fought, bled, and died alongside their male counterparts in wars around the world. With the support of family, Boothe managed to survive, but it was an extremely difficult process.

In 2010 Boothe watched an episode of *The Oprah Winfrey Show*. The focus was on homeless women veterans.

"I became outraged," she says. "I had always thought I was an isolated case. I couldn't believe even five years after my ordeal, there was still nothing being done for women who served."

A few days later, Boothe began working on a program to help those women. The result: Final Salute, Inc. It took her nearly a year to get her new organization up and running. Boothe charged nearly $15,000 to her credit card for start-up funds. Her initial attempts to get support fell on deaf ears as few people realized that homelessness among women veterans was a serious problem.

But Boothe wouldn't give up. "I had to share stories: my story, and stories of the women who have served, fought, and bled for our nation. Once those stories resonated, it got better, but not easier," she says.

She would also point to the numbers. More than 30,000 of the female veterans who served in Iraq or Afghanistan were single mothers. It is

estimated that there are 55,000 homeless female veterans living in the United States. And according to the U.S. Department of Housing and Urban Development, female veterans are four times more likely to become homeless and impoverished than women who have not served.

By 2011 Boothe had opened her first shelter—in Fairfax, Virginia. By 2015 Final Salute had assisted more than 900 female veterans and children in over 30 states and territories. Women have benefited from a variety of programs, including receiving assistance with financial burdens such as utilities and overdue rent, obtaining help with résumés and proper business attire, and, when necessary, getting access to transitional housing.

"As it stands right now," says Boothe, "America itself doesn't recognize the service and sacrifice women provide that is equal to our male counterparts who serve in the military."

Relying purely on donations, Final Salute receives no funding from Veteran Affairs. But the support the organization has received has led to four homes operating in the D.C. metro area as well one in Columbus, Ohio. "I think people have this misconception when it comes to women. We look at our male war fighters when they fail—we feel our country has failed them. But we look at our women veterans—if they fail and fall on hard times the misconception is that they have failed all by themselves," Boothe says. "We need change. These women do not have the resources available to them as veterans to help them climb out of their hole. Until that happens, my efforts and Final Salute will continue until it improves." ◼

In front of a television audience, Oprah Winfrey and Team Toyota brand ambassador Amy Purdy honor Jas Boothe for founding Final Salute to help homeless female veterans.

"*In peace sons bury fathers, but in war fathers bury sons.*"

HERODOTUS (CA 484–425 B.C.), *THE HISTORIES*

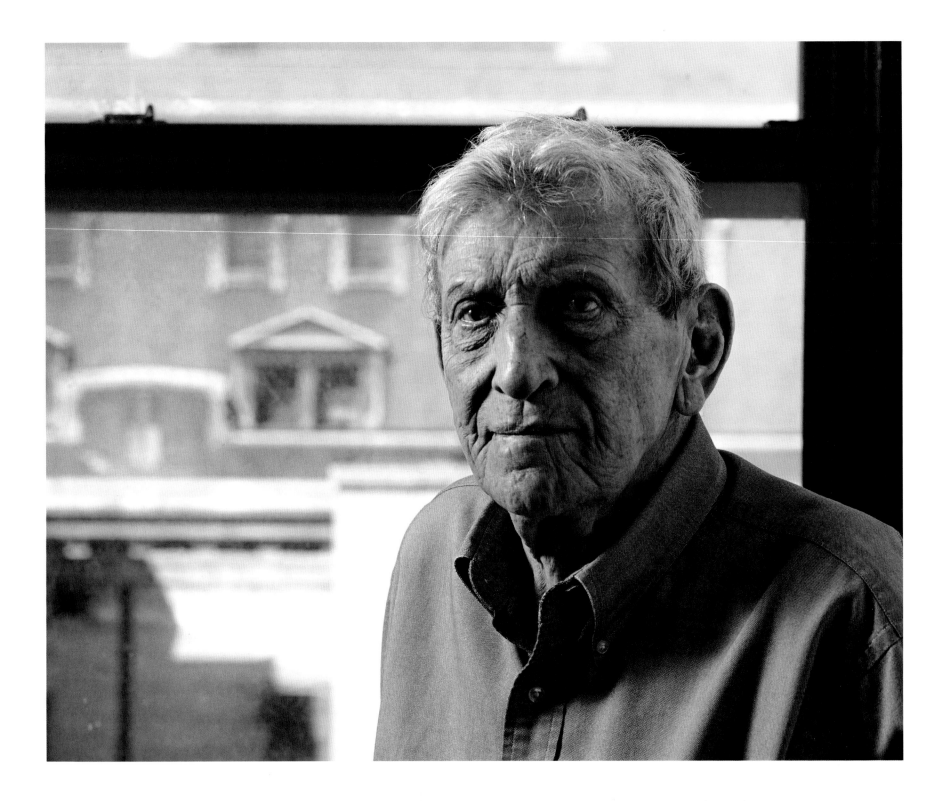

Jack Masey

Deployment: World War II, Europe 1944–45
Branch of Service: U.S. Army
Residence: New York
Occupation: Graphic and exhibition designer

★★★★★

"By doing what we did,
we undoubtedly saved American lives."

At 91, Jack Masey still works out of his New York office. There he spends his days surrounded by books and lots and lots of boxes. Each box contains photos, drawings, papers, and films that document moments of America's foreign policy in the last half of the 20th century.

They also reveal the life and accomplishments of a young artist turned soldier, Foreign Service officer, and finally the founding partner of Meta-Form Design International.

The U.S. Army drafted Masey shortly after he graduated from the New York City High School of Music and Art. Because of his artistic gifts, he was assigned to the 603rd Engineer Camouflage Battalion, also known as the Ghost Army. Masey's job was to inflate rubber equipment, including fake tanks, jeeps, guns, and even men as decoys to deceive the Germans.

"I thought it was a huge joke," he admits.

His mission began in earnest two and a half weeks after D-Day, when his unit arrived in Brest, France, where the Germans defended their position on the coast.

Masey's unit got there in time to set up an inflatable army, four soldiers at each fake weapon. They used either a bicycle pump or their own breath to finish the job. The Germans responded by firing a few rounds at them before giving up.

"They did not waste any ammunition on these jokers. I think they were on to us," recalls Masey.

They redoubled their efforts. Masey and his unit improved their methods to make their camouflage more believable.

"Our job was to confuse them, distract them, bewilder them, give them wrong information," Masey says. "Then our brother American forces could proceed without being attacked."

The young men would also enter local towns, villages, and even the heart of Paris wearing Third Army patches in order to gain the attention of German informants.

Masey and his colleagues moved through France and Belgium organizing similar displays and frequenting local towns. They arrived in Luxembourg in late 1944, with the expectation that the war would soon be over.

"Then suddenly, out of nowhere, there was a German counterattack, later called the Battle of the Bulge. We had to get out of there quickly. I remember having seen many American flags on our arrival, which were now being exchanged for swastikas when we left. It was all about survival for the people of Luxembourg."

The Ghost Army did manage to confuse the Germans by sending fake signals through the radio.

Shortly after V-E Day, Masey went home proud of his accomplishments.

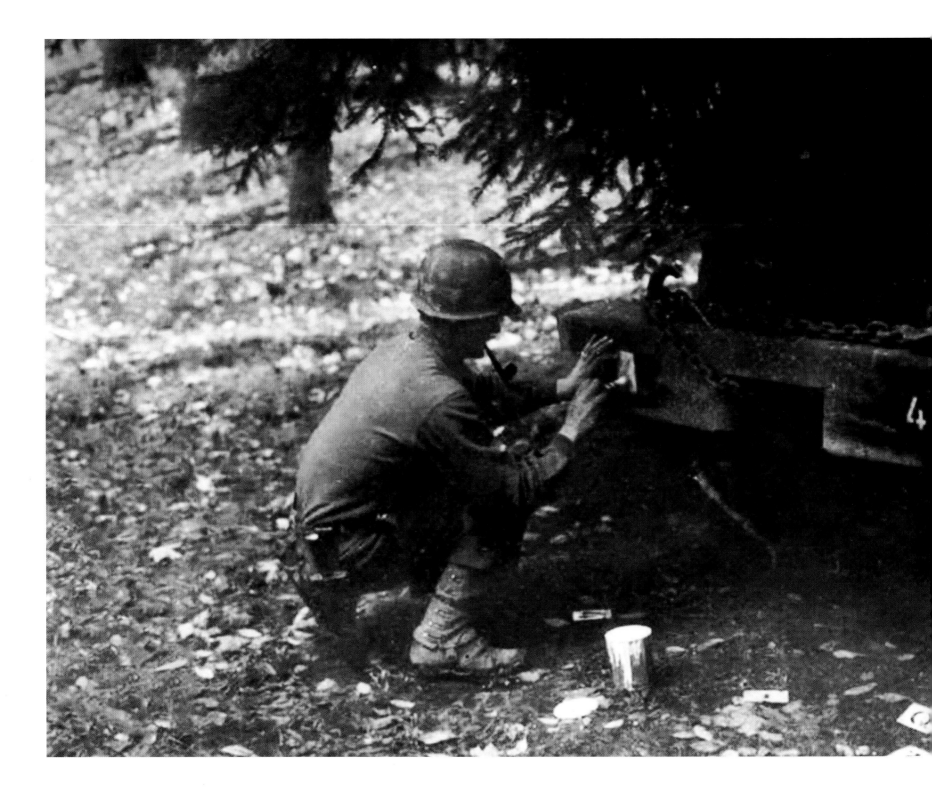

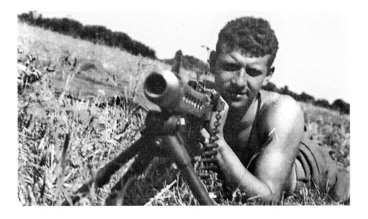

Above: *Jack Masey engages in boot camp training before being selected for the Ghost Army.*

Left: *A member of the Ghost Army stencils markings on a jeep, one of the many deceptive methods used by the battalion during World War II.*

"The fact that I got through the war intact was something that personally made me feel good," he says.

But his government career was far from over. After graduating from Yale University with a degree in architecture and design, he was recruited as the director of design for the U.S. Information Agency.

He traveled the world creating exhibits displaying American architecture, design, technology, crafts, and more as a way to promote democracy during the Cold War. The U.S. government assigned him to places as diverse as New Delhi, Osaka, and Montreal.

In 1979 he founded MetaForm, an exhibition design firm creating exhibits for institutions such as the Statue of Liberty Museum, Ellis Island Immigration Museum, and the National WWII Museum. In partnership with his wife, Beverly Payeff-Masey, he has created the Masey Archives, preserving U.S./international exhibitions of the Cold War era for future generations.

The Ghost Army and the Foreign Service played pivotal roles in safety and cultural diplomacy, facts that make Masey proud.

"By doing what we did, we undoubtedly saved American lives."

The story of the Ghost Army will be told in an upcoming film produced by *American Sniper* star Bradley Cooper. ∎

JOSH FORBESS

Deployment: Iraq 2003
Branch of Service: U.S. Army
Residence: Germany
Occupation: Wounded Warrior mentor

★★★★★

*"I am who I am. And nobody's
going to change that."*

Josh Forbess had just left the intensive care unit of San Antonio's Brooke Army Medical Center when he received a surprise visitor: J. R. Martinez. Martinez was another wounded soldier who had suffered severe burns.

Martinez took a seat next to Forbess.

"I am who I am," Martinez told the deeply scarred soldier. "And nobody's going to change that."

For the first time since the accident, U.S. Army Staff Sgt. Josh Forbess felt he was ready to look at himself in the mirror. He studied his reflection. He was missing an ear and half his nose. His entire face had been ravaged by severe burns. Yet he was still there.

He knew he would have a lot to work through, physically and mentally, but he was prepared to do the work, especially if meant helping other wounded soldiers. The first step was talking about it. Forbess began sharing his story.

His life had changed on November 15, 2003, when ground fire caused his Blackhawk helicopter to collide with another Blackhawk over Mosul, Iraq. Because of the severity of his burns and the fragility of his medical condition, he was sent to San Antonio, where he was placed in a medically induced coma for two months.

"On waking up, I faced a lot of challenges," Forbess says.

For one, he didn't remember the accident. "I didn't get much information about it. We were dependent on Iraqi satellite phones and I couldn't call to find out how my people were doing," he says. "That was the worst thing for me, not knowing."

His mother did her best to get him some information and learned that Forbess was one of five servicemen out of twenty-two to survive the collision. As one of the unit leaders for the 101st Airborne Division, Forbess had taken on several roles in his unit: parent, sibling, and leader. Most important, he had made a promise to his soldiers' families that he would bring their loved ones home alive, a promise he couldn't keep.

It was Martinez's visit that gave him perspective and a goal for his recovery. Forbess realized the value in talking to other wounded soldiers. He accompanied Martinez on his visits around the hospital. Spending time with the two burned soldiers became a highlight for many patients. Sometimes they kept the conversation light, talking about sports. At other times, the men would fall into deep conversations, finding catharsis in their shared experiences.

Shortly after Forbess was discharged from the hospital, he asked to be reassigned to active duty. He remains committed to mentoring wounded warriors. ■

HERBERT CYRLIN

Deployment: World War II, Europe 1943–45
Branch of Service: U.S. Army
Residence: New York
Occupation: Retired financial executive

★ ★ ★ ★ ★

*"I was just doing my job
the best way I knew how."*

When Herbert Cyrlin decided to assist five Jews rescued from a German death camp, he had no idea that his findings would facilitate some of the largest recovery efforts in post–World War II Europe. The now 92-year-old veteran was a 21-year-old private first class, and his detachment was sent to a small city in Germany to oversee Army functions before an occupation could begin.

Cyrlin says he was sitting in an office when five men recently liberated from one of the camps entered asking to trade information for money.

Practically fluent in German, Cyrlin told them that he had family members who had died to liberate them and if they had information they should share it. But he also took pity on them. "I'm of the Jewish faith, and we had only recently learned of the existence of the camps and what was happening," Cyrlin recalls. "Here these five came in smelling like a sewer, shriveled up, and I felt very, very bad for them."

He said he quickly made a phone call to the local police chief, threatening to shoot him if he didn't find them a place to stay. An hour later, the chief located an apartment belonging to a lead Nazi general and his family who were told to collect their personal belongings and leave. He gave the men a bar of GI soap, the packages he had received from home, cartons of cigarettes, and even made sure they were given a stipend to cover their food, travel, and clothing expenses.

The men were very grateful. They had been spared death because of their skills with engraving and art. In great detail, they shared what they knew. Cyrlin recalls, "This man told us that the Nazis were producing a British five-pound note and the American dollar bill so skillfully that they were undetectable as counterfeit. When the Allied troops were approaching their camp, the Germans immediately moved the entire printing operation into massive salt mines located in Austria. He also knew the exact location of the move."

The former prisoners soon unleashed even more information about what was located inside the salt mines, including vast stockpiles of precious art and valuables looted from the Louvre and other museums throughout Europe. "I had no idea whatsoever of the enormity of this information or how it would positively impact the recovery efforts for Europe," Cyrlin says. "I was just doing my job the best way I knew how."

The efforts of Cyrlin and his staff were instrumental in the recovery of priceless cultural items, including paintings, silver, currency, books, and religious treasures.

Seventy years later, Cyrlin still thinks about that time and the men who helped him. Cyrlin hopes they were happy.

"I hope those men found peace and solitude for the rest of their lives. They deserve it." ∎

JAMES BERTOTTI

Deployment: Korea 1985–87, Haiti 1995, Cuba 2004, Iraq 2005
Branch of Service: U.S. Army
Residence: Virginia
Occupation: Budget analyst, State Department

★★★★★

"I missed all the intangibles;
the camaraderie, the morale."

James Bertotti enlisted in the U.S. Army at 17, aiming to "get as far away from home as possible," and to earn money for school. After conducting paralegal work for the military in Korea, New York, and Germany, he completed his service in 1990 and took a position with a law firm. However, he explained, "I missed all the intangibles; the camaraderie, the morale." Within nine months, he reenlisted.

He returned to work as a paralegal for the Army. In 1995 he was deployed to Haiti in a peacekeeping role. On the mission, a chaplain offered Sunday trips to visit an orphanage in the refreshingly cool mountains. Bertotti and a few of his friends were happy for an opportunity to leave their base. A small crowd of children swarmed the soldiers as they stepped off the bus.

"They were affection starved," he realized. Bertotti spent the day playing ball games and building with toy blocks.

Haiti "reaffirmed everything," he explains, adding that it "gave me new focus, gave me a new path. That was a transition of how I saw my service in the Army."

Rather than just being part of a fighting force, he saw himself called to serving others, whether advising attorneys or mentoring others in legal offices. He learned that he enjoyed facilitating projects.

After September 11, 2001, Bertotti worked for the Joint Personal Effects Depot, where his team worked to receive, safeguard, and ultimately return the property and personal effects of those who had been impacted, killed, or injured when American Flight 77 was flown into the Pentagon. He described the young soldiers tasked with cleaning the items as having an "extraordinarily impressive dedication to get their job done."

Following that, Bertotti managed the Office of Military Commissions at Guantanamo Bay in Cuba, where his work included establishing the system that would later prosecute detainees, a process that had not been undertaken since the aftermath of World War II. Bertotti explains, "It was a balance of awareness and understanding, because certainly those things are going to influence the decision makers."

Later, Bertotti served in Operation Iraqi Freedom, providing administrative and budgetary support in managing resources from Camp Victory in Baghdad.

Bertotti retired from the Army in December 2011. "I really enjoyed working with all the attorneys throughout my entire career and all of the other paralegals and all of the other members of the JAG corps," he shares.

Presently, Bertotti works as a senior budget analyst for the U.S. State Department, where he continues to focus on making a positive impact in his own way, most recently managing the budgets for diplomatic missions to Iraq. ∎

LOYALTY

"*I don't miss the bureaucracy of being in the Army. But I still love the relationships you can build. And it doesn't have to be in military service—it can be anything you're doing with someone that matters. You develop a bond.*"

GEN. STANLEY A. MCCHRYSTAL (RET.)

ROBERT BARRON

Deployment: Japan 1963–66
Branch of Service: U.S. Marine Corps
Residence: Virginia
Occupation: Prosthetic specialist

★★★★★

"We found out we couldn't penetrate in areas where we could get a lot of information.
So we had to come up with sophisticated disguises."

There was a time when Robert Barron's greatest ambition was to design Christmas cards for Hallmark. But his career shifted dramatically after he joined the Marine Corps in 1963, just after graduating from art school.

To Barron, entering the Marines would be the ultimate challenge, and doing so as an E5 would allow him to prove his abilities in combat.

It looked like he would head to Vietnam, but fate stepped in. His friend, Richard, a captain, knew of Barron's artistic talents and recommended him to the Marines in Washington, D.C. He was transferred to Quantico's graphic arts department.

Barron followed the Third Marine Division to Okinawa, Japan. When the division shipped out to South Vietnam, Barron stayed behind to become an amphibious-grade school instructor in helicopter and hill rappelling. He returned to D.C. to design exhibits for the Navy and Marine Corps.

Shortly after his honorable discharge, the Pentagon recruited him as an illustrator and art director for naval magazines.

But his next job would take his career beyond simple drawings. The CIA needed help in the forgery department. Barron learned how to reproduce the numerous documents that a caseworker might need.

After a few years in graphics and design, Barron found himself craving more of a challenge. He talked to the chief of disguise. The department only had traditional disguises: beards, mustaches, and wigs. They weren't enough.

"We found out we couldn't penetrate in areas where we could get a lot of information," Barron recalls. "So we had to come up with sophisticated disguises."

Through trial and error, Barron and a team of scientists were able to create sophisticated silicone masks with lifelike skin and features. Obsessed with detail, Barron made sure the multilayered masks could generate realistic facial expression, utilizing the muscles underneath.

"They were so sophisticated they could pass scrutiny of six to twelve inches," Barron says.

"The masks could also be put on and taken off within three seconds," he adds.

He could make exact doubles of individuals, including their pockmarks and nose hair.

Those skills were useful when a case officer came under the scrutiny of Russian officials. The officer would need to get to American soil quickly but couldn't dodge a tail. In order to spirit him away, Barron would create an exact replica dummy of the officer to be placed in the vehicle as a decoy. Meanwhile, the officer had 15 seconds to don a typical Russian-looking mask, slip out of the vehicle, and walk right past surveillance.

The master of disguise's work went beyond appearances. It wasn't enough to look like a member of the Russian population. The spy had to act and smell like one as well, wearing Russian deodorant and using Russian toothpaste.

Successful disguise even included mannerisms and movement. "The American way of walking with your arms swinging out left and right of your body would immediately get noticed, so we had to teach people to keep their heads down and arms close to their bodies," Barron recalls.

Barron has no idea how many officers were saved because of those methods—only that his workload was always full.

"That was a career that I'll never forget," Barron says.

By 1993 Barron felt ready to move on to a different career. He had served his country through his skills, and now he wanted to help others.

With the agency's permission, Barron marketed his ability to create prosthetic devices for men and women who suffered from a malformation, often resulting from trauma, disease, or congenital defects. He knew that disfigurement could profoundly affect the quality of a person's life.

"I have had patients that have contemplated suicide, and they found out about me and they're still living today," the now 73-year-old Virginia man says.

Barron creates noses, ears, facial masks, and other body parts that couldn't be helped with plastic surgery with the same realism he used in his spy days. It's a job from which Barron never plans to retire. "My priority is to fulfill their needs," he says, noting the psychological and social benefits.

"What I'm doing now is such a gratifying experience, to give someone back the quality of life they were used to before their differences," Barron says. "God gave me the gift. Now I'm using it to help those he wants to be helped." ∎

ABOVE: *Robert Barron spent several years creating realistic masks for CIA agents.
He now keeps "spare parts" to show clients what to expect.*

OPPOSITE: *Barron took these before and after photos of Vietnam veteran
Donald Magaha wearing the prosthetic ear he created for him.*

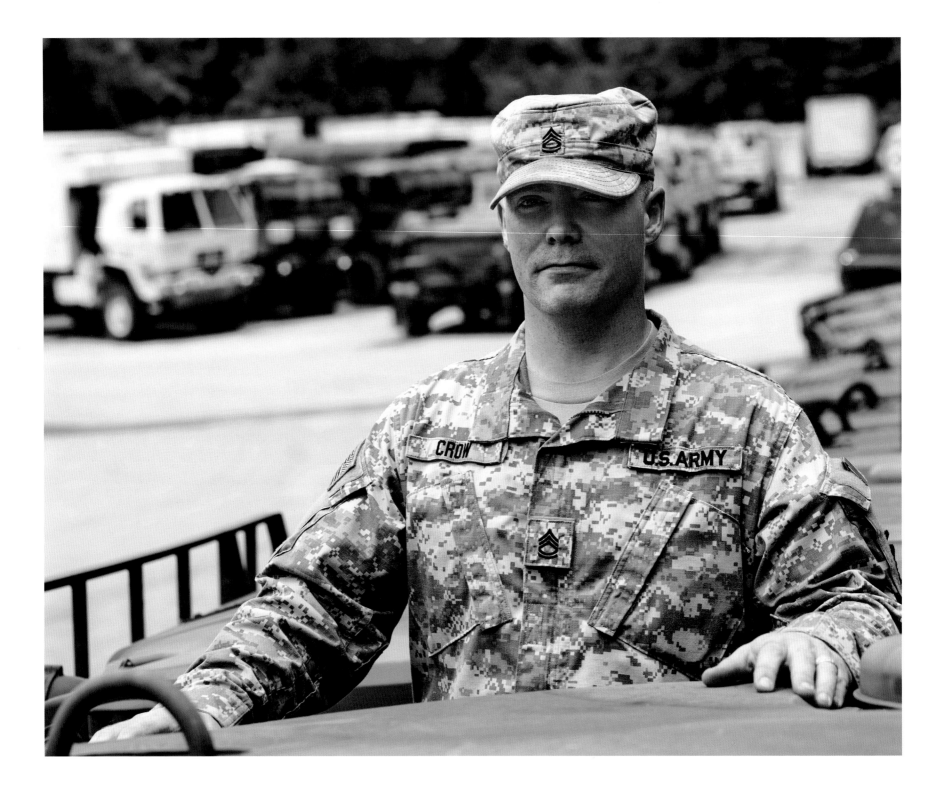

DANIEL CROW

Deployment: Germany 2002
Branch of Service: U.S. Army National Guard
Residence: Pennsylvania
Occupation: Soldier, casualty assistance officer (as needed)

★★★★★

"You just hope that if that time should come for you that someone is there to help your family through it as best they can."

The phone calls from the Casualty Assistance Center were dropped again among the winding roads and mountains of rural Pennsylvania as Daniel Crow made his way from Pittsburgh to the small town of Kane.

This was one of the most important jobs he had ever undertaken in his decade-plus of service in the Army National Guard. A sergeant first class, serving full time in the Pittsburgh-based 128th Brigade Support Battalion, Crow had received special training to act as a casualty assistance officer.

In July 2011 he received the call that a young staff sergeant, Ken Van-Giesen, had been killed in Afghanistan. His family would need help with transportation to Delaware, where the body would be transferred, and assistance with funeral details, finances, and any other loose ends.

Crow felt a pang of sadness that this particular job would even need to exist.

He thought, Am I up to this challenge? Am I good enough? Can I help this family?

It was understood that military personnel risked their lives for a mission, for their country, to make the world a better place. As a 42-year-old father of three, Crow also realized that losing a child was something most people couldn't comprehend, regardless of military background and history.

Crow had been raised in a military family and joined the National Guard in his mid-20s. Deployed once, a year after September 11, he had been sent to Germany to guard important medical facilities that would be needed as war continued in Afghanistan and, later, Iraq. His battalion was never deployed as a unit again, but some members deployed based on their occupations, much as VanGiesen had.

Though he was fully prepared to perform casualty assistance officer duties, Crow had fervently hoped to avoid having to actually use his training. Nevertheless, he soon realized it was vital in helping the VanGiesens.

"With casualty assistance, you have this moment where everything has gone wrong. Someone is not coming home," Crow says. "It's the unfortunate side effect of what we do. It's not easy to see. It's not easy to deal with. And you just hope that if that time should come for you that someone is there to help your family through it as best they can."

The VanGiesens were a close-knit, loving family, who mostly agreed on arrangements, much of which Ken had prepared in advance. That wasn't always the case with grieving families. At first, Crow felt like an outsider. But as funeral plans progressed, he got closer to the family.

Crow felt he had made a difference by assisting a family in their greatest time of need. He says that of all his responsibilities, "It was the most worthwhile of any of the things I did in the military." ■

RORY READY

Deployment: Afghanistan 2009–2010, 2011–12
Branch of Service: U.S. Marine Corps
Residence: Maryland
Occupation: Student

★★★★★

"Listening to the Taliban's chatter on the radio, we realized they wanted to give up.
But they couldn't as they had forgotten where all the IEDs were."

Ready's story began soon after boot camp at Camp Lejeune, North Carolina, when he was deployed to Marjah, Afghanistan, from 2009 to 2010. Marjah was controlled by the Taliban and littered with dangerous IEDs. Part of his job was to help train the Afghan National Army in how to use weaponry and equipment. At night, he would huddle with other soldiers for warmth as they slept beneath a seven-ton truck.

But Ready's biggest task was clearing IEDs.

At one intersection, he and his team cleared a total of 18 IEDs before being able to move to the next one, which was similarly rigged. Progress was gradual. First they had to locate the devices, and then try to handle them after removing them carefully from the ground.

Sometimes they were able to learn the whereabouts of explosives by listening to the enemy's radio with the help of an interpreter. Other times, the chatter left them frustrated.

"Listening to the Taliban's chatter on the radio, we realized they wanted to give up. But they couldn't as they had forgotten where all the IEDs were," he says.

The Battle of Marjah kept Ready and his colleagues in constant fear for their lives. Some of his fellow soldiers were killed. There was turmoil at home as well because Ready's father had died in December 2010, leaving him heartbroken.

A year later, he redeployed to the same region, where the fighting intensified.

Everything caught up to him when he returned to the States. Ready had reenlisted after he returned home, serving at Patuxent River Naval Air Station in Maryland. It proved to be too much for him. He began experiencing flashbacks while participating in hazardous mock gear training. Being home felt harder than being deployed. To escape, he began drinking. Finally he turned to Walter Reed for treatment for PTSD. That's when he learned about the Warrior Canine Connection.

A dog lover since childhood, Ready signed up for the program. He began training Tammy, named in honor of Tammy Duckworth, a congresswoman from Illinois who lost both legs and damaged her right arm while serving as a helicopter pilot in Iraq.

All the Warrior Canine Connection dogs are given special names in honor of veterans. Ready's first introduction to one of the dogs had been Lundy. He had personally known hospital corpsman Brian Lundy, who died during Ready's second deployment, so it seemed that fate was nudging him toward the program.

For now, Ready and Tammy keep each other company. She has helped Ready reconnect with family and community. And once his time with her is complete, she will help the next veteran. ■

JOE JACKSON

Deployment: Gulf War 1991
Branch of Service: U.S. Army
Residence: California
Occupation: Student

★ ★ ★ ★ ★

*"No one wants [to be] or ever plans
on being homeless."*

The building at 250 Kearney Street in San Francisco is home to 130 veterans, including Joe Jackson. It is one of the many housing units operated by Swords to Plowshares, a veterans service organization in the Bay Area. Before Kearney Street, Jackson's life had sunk as low as it could possibly go—he was homeless.

"No one wants [to be] or ever plans on being homeless," says Jackson. "It just happens, and when it does the intense feelings of fear, loneliness, and despair are impossible to describe."

Jackson remembers many of the "first" milestones in his life: first time he went to school, first time he played baseball, first time he drove a car, first kiss, and first time he stepped on foreign soil serving our country as a member of the military. The most painful first of all, though, was his first night sleeping on the streets of San Francisco. Unfortunately, Jackson ended up spending several years on the streets, roaming around the city as a part of an invisible community.

Jackson spent 20 years in the Army and left with the rank of warrant officer, having been all over the world on military exercises. He provided humanitarian aid in places like Haiti and supported the war effort in Iraq in 1991. He loved his work and was a dedicated member of the military community, appreciating the structure of Army life and the easy camaraderie with his fellow soldiers.

Jackson had been looking forward to retirement, but things didn't turn out as planned. Everything, including family life, was a challenge. His marriage ended in divorce, leaving his three boys with his former wife. He couldn't find a job, and feelings of emptiness and desperation led him to turn to alcohol. His health sharply declined until his drinking habit became so severe that he woke up in the emergency room at a VA hospital in the Bay Area with little memory of how he'd gotten there. He explains, "Thankfully, the VA hospital put me back together. After my initial recovery, I was immediately placed in rehab—I had lots of issues to work out, and the biggest was my addiction to alcohol. Over time things started to make sense again, and I realized I had a chance of correcting my life and that it was not over yet. The VA connected me with the folks at Swords to Plowshares. They provided me a place to live, counseling, and direction that has made a positive impact for me."

Swords to Plowshares provides Jackson and other veterans with housing and educational guidance. Former veterans run the organization and truly understand the potential issues inherent in transitioning back to civilian life.

Jackson's effort to reinvent himself is going well. He is enrolled at a community college, where he is close to completing his degree in business administration. He hopes to graduate soon, find a job, and complete the arduous trip back from homelessness. ∎

ROBERT HAMREN

Deployment: Iraq 2003, 2005
Branch of Service: U.S. Army
Residence: Colorado
Occupation: Security officer

★★★★★

"The military helped me wise up and be an adult.
I learned to spread my wings."

When he was only 18, Robert Hamren realized his life was headed in a terrible direction. Surrounded by alcoholism, he had already found several ways to get into trouble. He knew he had to take control of his life. With few job opportunities available on the Navajo reservation, he decided to join the U.S. Army. Entering the military was a source of pride among the Navajo, he noted.

He enlisted as an infantryman in 1996, serving as a mortarman working with indirect fire support.

In 2003 Hamren and his unit were deployed to Iraq. During the first deployment his troop spent most of their time heading to different camps. Morale was high, he says. "We'd play jokes on each other. There was always a smile on our faces."

Hamren returned to Iraq in 2005.

"The first week we were there, we lost seven people to an IED," he says.

That set the tone for the rest of his tour.

Once, Hamren and his troop were on a foot patrol. He thought an Iraqi policeman honked his horn at them. "As soon as that happened, we heard gunfire."

They had no choice but to proceed. Bullets were flying from the building they had planned to enter. They continued but had to cross an alley where grenades were lobbed at them. One exploded, barely missing Hamren, and hitting his partner in the groin with shrapnel. The team completed the mission and made it back to camp, including Hamren's partner.

"It got to a point where we didn't want to know each other," recalls Hamren. "We didn't want to live through losing another friend."

In a lot of ways, that mentality never left him. Today, more than nine years after serving his country, Hamren describes himself as guarded and unwilling to make too many emotional connections.

When he ended his service with the Army in 2006, Hamren had trouble finding a job. Like many veterans, he was diagnosed with post-traumatic stress disorder. He struggled with drinking and nightmares. Again he had to make a choice.

He chose his family.

"I lead by example," he says, noting that he wants to be honest with his children about both his failings and his willingness to overcome them.

Life has gradually improved for Hamren. In addition to working, he has decided to go back to school.

Despite the emotional turmoil, Hamren has no regrets. "I'm proud of it. If it weren't for the military, I'd still be on the reservation getting drunk. The military helped me wise up and be an adult. I learned to spread my wings." ■

"It is the function of the Navy to carry the war to the enemy so that it will not be fought on U.S. soil."

ADM. CHESTER W. NIMITZ

A fleet of American and French naval vessels sail in formation on the Arabian Sea.

JIM GASSAWAY

Deployment: Cold War 1977–1984, international waters
Branch of Service: U.S. Navy
Residence: Virginia
Occupation: Missionary

★★★★★

*"I thought, I want to work with
men like this."*

Capt. James Gassaway was a senior at the U.S. Naval Academy when he decided to spend his Navy career aboard a submarine. His first two years at the Naval Academy were devoted to learning the submarine, but it wasn't until the summer before his senior year that a six-week midshipman cruise confirmed his passion. More than anything, he enjoyed working with brilliant men, most of whom had backgrounds in engineering, physics, or nuclear training.

"I was impressed with the crew of the submarine I was on. I thought, I want to work with men like this." It also helped that he did not suffer from claustrophobia.

"Sometimes I would inspect spaces that were tight, even got stuck once in a while, but it never bothered me."

After graduating, Gassaway went on to become the mechanical systems officer for both nuclear and non-nuclear submarines. He began leading crews like the one he had worked with as a student.

"Of course, when you get in there you realize it's a challenge to lead these guys that are very sharp professionals. A number of the guys already had college degrees. Had they gone another route, they could have been officers," he says.

Gassaway's career began in the 1980s, at the height of the Cold War. With a rapidly expanding Soviet Navy, the American nuclear-powered fast attack submarines (SSNs) monitored and conducted intelligence, surveillance, and reconnaissance missions. They also deterred any oncoming nuclear attack by maintaining a retaliatory strike capability against all nuclear threats.

From 1980 to 1983, Gassaway was assigned to an SSN. His job was to find, locate, and trail Soviet submarines. "We were quieter than they [the Soviets] were; we had better engineering."

The Soviets were running on diesel, making them loud and easy to follow with sonar equipment. Gassaway's submarine was nuclear, quiet, and not easily detectable.

In the Mediterranean the Soviets began targeting U.S. carrier ships with their diesel missile shooters. It became Gassaway's task to learn as much information as possible about their ballistic submarines while following them at a safe distance. If an enemy submarine should get too close to one of the U.S. carrier ships, the Americans were ready to torpedo them first.

Although tensions were often high during the Cold War, Gassaway admits, "I didn't feel that we would ever launch weapons against them, but you never knew."

Gassaway served 18 years in the Navy and 10 years in the Navy Reserve. For the last three decades, he has worked as a missionary to the U.S. Navy at Virginia Beach. ∎

MICALA HICKS SILER

Deployment: Korea 2002, Iraq 2003, Afghanistan 2007
Branch of Service: U.S. Army
Residence: Germany
Occupation: Executive director of AFFEO (A Family for Every Orphan)

★★★★★

*"One little boy, Abed,
especially captured my heart."*

"Thank you, God," Micala Hicks Siler whispered. "For finding me, even when I'd given up looking for you."

The words spilled out as she watched her traveling companion of several hours head toward his next flight. She had barely noticed him when their journey from Kuwait to Germany began, but the conversation they had just shared had managed to give her the boost she sorely needed. Siler knew it wasn't a coincidence that he had been seated next to her that day.

When the flight took off on September 4, 2007, Siler could barely lift her hand in acknowledgment. She leaned back in her seat, grateful that she could finally rest. Her mind drifted to the list of frustrations she had endured in the past three days. Overbooked flights and mechanical failures had led to a three-day delay in travel. Siler was still wearing the same dirty Army combat uniform she had on at Bagram Air Base.

The first female graduate of the U.S. Army's rigorous Sapper Leader Course, Siler had spent the last nine months in Afghanistan, overseeing a 20-soldier logistics team in her engineer construction battalion. They were responsible for managing all the contracts, flight schedules, supply and maintenance requisitions, and distribution for 800 soldiers spread out between at least 15 different remote locations within a 500-mile radius of the eastern half of the country.

Siler was grateful for small reprieves, including visiting children in the hospital. Early in her deployment, Siler learned that local Afghan children were receiving care at the same hospital as some of the U.S. soldiers. The children had been victims of IEDs or caught in crossfire.

As soon as she learned she could visit them, she contacted her mother and friends back home to see if they could send toys and games. As the oldest of seven, Siler had a natural love for children. In fact her youngest two siblings had been adopted, and her parents fostered ten children in their home over a seven-year span.

"One little boy, Abed, especially captured my heart," Siler recalls. "Abed was walking down the street with his father when a vehicle-borne suicide bomb exploded. His father was killed instantly and Abed suffered third-degree burns over roughly 75 percent of his body. The tiny three-year-old moaned and cried in pain when the doctors moved him to change his bandages. He had several skin grafts and it was doubtful that he would ever walk again."

"Sometimes on Sundays, our slower days, I was able to spend an hour or more with Abed, doing puppet shows or making him Play-Doh shapes or singing to him in English. Every once in a while, I could sneak in to see him for a few minutes during the weekdays . . . Never once did I see him smile."

Then one day, Siler arrived to see an old man in Abed's bed. The child had been sent home—to a cave—to stay with his surviving family. Broken-hearted, she couldn't help but wonder if he would get an infection, if he would walk, if he would survive.

Siler jolted awake when the plane touched down on the landing strip in Germany. She learned that her traveling companion was part of the medical team east of Bagram.

As the sergeant described his job, he brought up one little boy who visited him, even though he was almost completely healed from burns all over his body. "We all love Abed so much that we looked forward to seeing him, so we started him on a physical therapy program," he told her.

Listening to his description, Siler knew that it was the same boy who lost his father and sustained the horrible burning scars.

She could barely contain her excitement when she told the sergeant that she knew the toddler and asked him how Abed was doing. The boy was happy, he assured her. And he had the biggest smile he had ever seen.

Siler "knew with certainty that it wasn't coincidence that had brought me to that particular seat on the plane."

Siler's love of children continued after she left the military in 2009. She got married and is the mother of three girls, with another child on the way. While raising her family and accompanying her husband on his military assignments, Siler has also become the executive director for A Family for Every Orphan, a charity that helps orphans find loving families in their home countries all over the world, including Ukraine, Russia, Nepal, Bangladesh, India, Kenya, Uganda, Kyrgyzstan, and Romania. ■

Micala Hicks Siler reunites with four of her siblings in uniform (from left to right): Phillip Hicks, Micala (Hicks) Siler, Mary (Hicks) Staudter, Patrick Hicks, and Nathaniel Hicks.

MICHAEL EDINGER

Deployment: Space and missile operations 1991–2001
Branch of Service: U.S. Air Force
Residence: Virginia
Occupation: Foreign affairs officer

★★★★★

*"Without a doubt, my time in the Air Force
shaped who I became as a person."*

Standing in the middle of Red Square, Michael Edinger saw his entire career come full circle. Just 20 years before, he had been aiming missiles at that exact location in Moscow.

Now he was working for the Defense Threat Reduction Agency, cataloging broken parts of nuclear weapons that once posed a great threat to Americans.

Edinger had joined the U.S. Air Force in 1991, just as the Cold War was ending. His first job was overseeing launch codes. Edinger was part of an interesting transitional period in geopolitics, aware that the Soviets could pose a threat, and looking at brewing issues in the Middle East.

Edinger had known he wanted to join the Air Force at an early age. Growing up in the 1970s, the waning days of the Apollo program, he fell in love with space technology.

When Edinger was nine years old, his family moved near Scott Air Force Base in southern Illinois. Once a year, he and his father would travel to see the jets on display and watch live flying demonstrations at the air show there. He knew he would join the Air Force someday.

During ROTC, Edinger learned that he would never fly a plane—his vision wasn't good enough. But he knew he wanted to find a career where he could operate a weapons system on a larger scale. Becoming a missileer was the next best thing.

As a missileer he would be in charge of controlling intercontinental ballistic missiles, nuclear weapons that could reach up to 3,400 miles in range and carry several warheads at once. Their existence acted as a deterrent to any aggressive nation that might consider launching a nuclear attack against the United States or its allies.

He was one of thousands of Air Force personnel working in the Minuteman missile field. Aside from his personal satisfaction with performing a job he enjoyed, he had the special responsibility of initiating the use of nuclear weapons from a launch control center. It was a job he held for four and a half years, and it was one of his favorites.

At the end of a diverse career, Edinger took his last military assignment: working for the Defense Threat Reduction Agency (DTRA), located in Fairfax, Virginia. Charged with safeguarding the nation from weapons of mass destruction, the DTRA verifies that treaties are upheld, oversees research and development in response to threats, and prepares to defend the nation from threats.

Through this last assignment, Edinger was able to see how he had played a role in making the world a safer place.

Edinger still speaks fondly of his career. "Without a doubt, my time in the Air Force shaped who I became as a person, and I am a better person for having served than if I had not." ■

MICHAEL CONNER HUMPHREYS

Deployment: Iraq 2007
Branch of Service: U.S. Army
Residence: Mississippi
Occupation: Student

★★★★★

"I was almost killed so many times—it feels like
I'm living on borrowed time now."

More than two decades have passed since the movie *Forrest Gump* made a splash at the Oscars, winning six Academy Awards. *Forrest Gump* was a fictional biopic about a man who eventually becomes a Vietnam veteran with modest heroics.

Born in 1985 in Independence, Mississippi, Michael Conner Humphreys was eight years old when he attended an open casting call for the part of Young Forrest Gump. Humphreys often told his mother about his plan to be an actor when he grew up. He loved movies like *Big, Back to the Future,* and *Who Framed Roger Rabbit?* His mother saw an ad for a casting call. Thinking her son might enjoy the experience, she took him to Memphis, where Humphreys won the role.

On the set of *Forrest Gump,* Humphreys was taken to Parris Island, near a Marine training camp. Humphreys remembers sitting inside an F/A-18 combat jet. Over the next ten years, he would often think about his time at Parris Island, which ultimately inspired him to join the military.

In November 2004 Humphreys enlisted in the Army and was shipped out to basic training at Fort Benning as an infantryman. He was assigned to the 1st Battalion 36th Infantry Regiment and deployed to Iraq's Al Anbar Province for a year.

"My time in Iraq was the most important time in my life," recalls Humphreys. "The single most important thing I've ever done."

Sometimes, Humphreys admits, his minor celebrity status got him picked for jobs. Unit commanders gave him assignments above his rank, but reassured him that "we wouldn't be giving you this job if you weren't a good soldier." He worked hard to do the best job he could and took the opportunity to learn about the cultures he encountered. Luckily, Humphreys was never injured.

"[But] I was almost killed so many times—it feels like I'm living on borrowed time now."

When he returned to the United States, Humphreys was transferred to Fort Riley, Kansas, and ended his enlistment with the Army on June 4, 2008. Although Humphreys would hang up his official military uniform, he would portray a soldier—this time on the big screen.

Humphreys landed his first role after his service in the independent film *Pathfinders: In the Company of Strangers,* playing Eddie Livingston. The film is about volunteer paratroopers whose mission is to mark strategic drop zones for the top secret navigation equipment for the assault on D-Day.

Currently, Humphreys is studying international relations at the University of North Alabama. He is simultaneously pursing acting and a career in international relations in the hope that someday he will leave a positive mark on the world. ∎

MARIE CHUNKO

Deployment: Stateside
Branch of Service: U.S. Army
Residence: Michigan
Occupation: Retired newspaper street vendor

★★★★★

"I always believed you just need to put one foot in front of the other and you will eventually get to where you need to get. I'm happy I did everything in my power to serve this great country."

It's 8 a.m. on a Saturday morning at a local restaurant in Detroit. Seventy-two-year-old Marie Chunko is trying to decide if coffee or beer will be her eye opener. The feisty Chunko is a seasoned city dweller. Legally blind, she can just see fuzzy shapes and outlines, barely enough for her to navigate around the city with her walker. And as a child, she was diagnosed with a severe form of dyslexia, coupled with another learning disability.

"While in school I struggled really hard and had great difficulties with reading and spelling. But if I heard it once, I could repeat it and use it to my advantage," says Chunko. "The counselors and teachers labeled me as the girl who only could be tested orally." Eventually Chunko fell through the cracks of the Detroit Public Schools system. She dropped out of high school in 1959. Doing odd jobs and selling newspapers to get by, she finally passed an oral version of the GED.

Chunko decided to fulfill her dream and join the military.

"I told the recruiter right up front that I was almost illiterate and it was impossible for me to take written tests because I would not understand what I was reading," says Chunko. "His response was 'No problem.'"

Chunko agreed to join. "I was happy, and the recruiter was thrilled that he was adding to his recruitment quota. To make sure everything was perfect, the recruiter filled out all the forms for me."

Chunko entered the Army in October 1967 as a private. She did her basic training at Fort McClellan, Alabama. Soon her superiors and fellow soldiers discovered her severely compromised learning and reading handicap.

Up to that point, her training had been physical. But as her duties expanded, officers starting asking questions. Concerned, her sergeant presented her with a form to read and comprehend. Sadly, Chunko could not do it.

"I was caught, even though I was now doing my physical jobs very well," says Chunko.

Her superior officers were kind as they broke the news of her discharge. Impressed as they were with her drive and determination, the Army had no way of offering her the specialized support she needed. Chunko was honorably discharged from the Army and entitled to receive full benefits. She had spent four months serving her country as best she could.

Chunko settled back in the heart of Detroit. She proudly displayed her Army insignia coat wherever she went. She returned to selling newspapers at an outdoor stand located on the corner of Woodward and Washington Avenues. She faithfully did this for 50 years until she retired in 2013.

"I'm happy I did everything in my power to serve this great country," says Chunko. "I'm proud to be a veteran." ■

HONOR

"*It is foolish and wrong to mourn the men who died.*
Rather we should thank God that such men lived."

GEN. GEORGE S. PATTON

DANIEL JACKSON

Deployment: Iraq 2004, 2005
Branch of Service: U.S. Army
Residence: Virginia
Occupation: Defense contract supervisor

★★★★★

"They aren't too different than us. They just want to be able to take care of their families and go to work. A lot of them did not have that opportunity."

Daniel Jackson, 35, still struggles with the question, Why me? Why did I make it and so many of my buddies never came back from Iraq?

Aspiring to serve his country from a young age, Jackson joined the Army out of high school in 1999. As a parachute infantry and combat engineer, Jackson served at Fort Bragg and spent time at Fort Polk, Fort Dix, and Fort Irwin. His final year brought him to Iraq, where we was placed in charge of protecting his unit as they worked to clear the nation's roadways of hidden explosives.

With a calm, friendly demeanor and always ready with a witty response, Jackson is beginning to find answers through a men's group at his local church and by sharing stories with other veterans.

He says, "I know that God has a purpose for me. Now I realize that God has always been tugging at me, saying, 'Daniel, I'm still here.' "

Honored, he humbly admits that his buddies in Iraq somehow recognized his quiet faith because they asked him to bless their Thanksgiving meal and often to bless the missions before the unit left to check for IEDs, a crucial undertaking in keeping military travel and the Iraqi economy open and moving.

The threat of IEDs along routes could starve villages and towns of supplies. Insurgents sowed improvised explosive devices into key roadways.

Varying in size, the hidden, homemade explosives were designed to penetrate vehicles and inflict as much bodily damage as possible.

While most military and civilians tried to avoid IEDs, Jackson's unit patrolled key roads in order to neutralize IEDs, which also included being out in front of insurgents ready to remote-fire the devices.

Jackson recalled the Iraqi dust storms, the smell of sulfur from nearby mines that gave him splitting headaches, and the time he provided security for diggers charged with unearthing a mass grave from Saddam Hussein's massacres. And then there was the suicide bomber dressed in an Iraqi security uniform who murdered his friends in an attack at the base dining facility.

"The Man Upstairs was looking out for us because our unit was never seriously injured. But sometimes after we cleared the route, another convoy after us was hit. An Iraqi hiding in a village, watching us, must have planted a mine after we drove by."

Regardless, Jackson believed in helping the Iraqi people. "They aren't too different than us," he explains. "They just want to be able to take care of their families and go to work. A lot of them did not have that opportunity."

Now Jackson is making the most of his opportunities. The happily married father of three has had several defense contracting jobs, is working toward an M.B.A., and is considering starting his own contracting business. ■

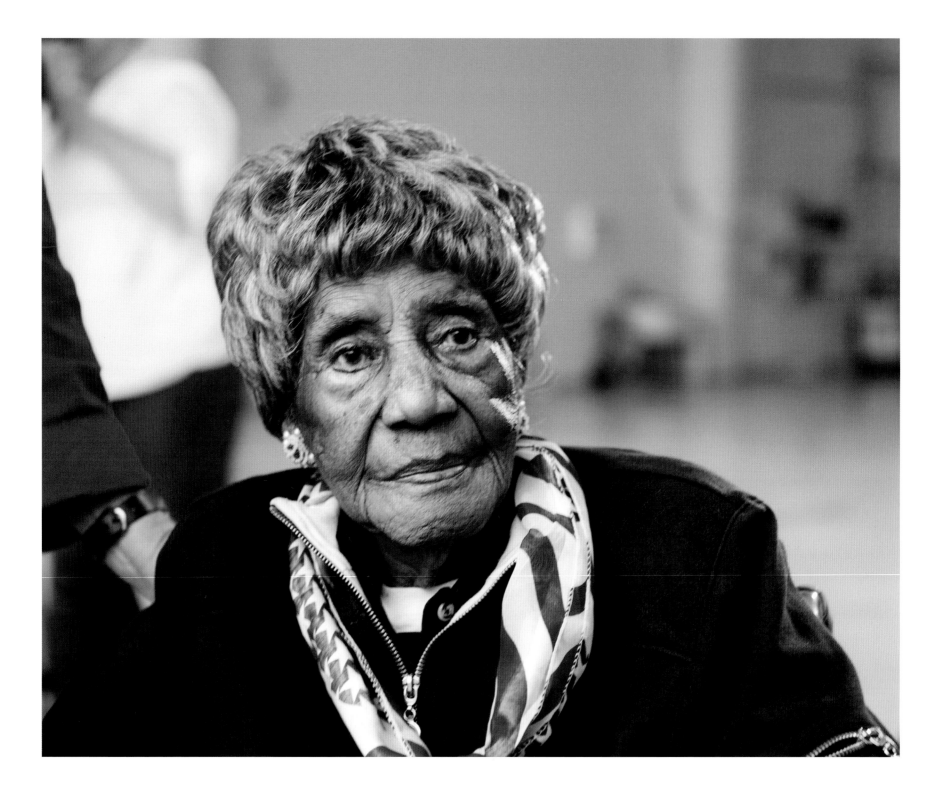

EMMA DIDLAKE

Deployment: World War II, stateside 1943
Branch of Service: Women's Army Auxiliary Corps

★★★★★

"I wanted to do different and interesting things in life
and raise my children at the same time—so in 1943 I decided to join
the Women's Army Auxiliary Corps to serve my country in a great time of need."

It was barely 7 a.m. when Emma Didlake entered the small airport in Pontiac, Michigan. A small contingent of reporters and photographers eagerly awaited her arrival. At 110, the petite African-American woman held the distinction of being America's oldest living veteran.

That hot July day in 2015 was a unique one for the centenarian. President Barack Obama was going to honor her in Washington, D.C. Vibrant yet soft-spoken, Didlake gladly shared her stories of service and more. Her memory was sharp, and she had an answer for any question asked of her.

When asked what it felt like to be the country's oldest living veteran, her pleasant face broke into a wonderful smile. "I like it."

A month later, Didlake would pass away, but her courage, service, and strong personality won't be forgotten.

Charming and good-humored, Didlake earned the title "Big Mama" from her grandchildren. She confided that she liked to remove nine golden raisins from a jar of gin every afternoon. Then she would then add another nine to the jar before partaking in the marinated delights, a long-standing ritual.

Didlake was born on March 13, 1905, in Boligee, Alabama. Later, her family moved to Lynch, Kentucky. She married Oscar Didlake in 1922, and they had five children. Didlake's drive and passion to do what she wanted in life was evident from the beginning. At the age of 38, she could not suppress her desire anymore and decided to take a bold step forward.

"I wanted to do different and interesting things in life and raise my children at the same time," said Didlake. "So in 1943 I decided to join the Women's Army Auxiliary Corps to serve my country in a great time of need."

During that time, most women stayed at home and maintained a household. Defying widespread sexism, Didlake served stateside for seven months as a chauffeur and occasional truck driver. Because of her sincerity and pleasant disposition, Didlake was selected over many other military personnel to join the military motor pool to chauffeur the high-ranking officers in and around the military base at Fort Des Moines Army Base in Des Moines, Iowa. On the front seat of her vehicle lay her copy of the Bible, which she took everywhere she went.

"I enjoyed what I was doing in the Army because I committed myself to focus on the need to help my country during a war," she said.

It was very unusual at that time for an African-American woman to have a driver's license, so Didlake was extremely proud that she knew how to drive and could fulfill that much needed role in the military. Didlake was honorably discharged after her completion of service.

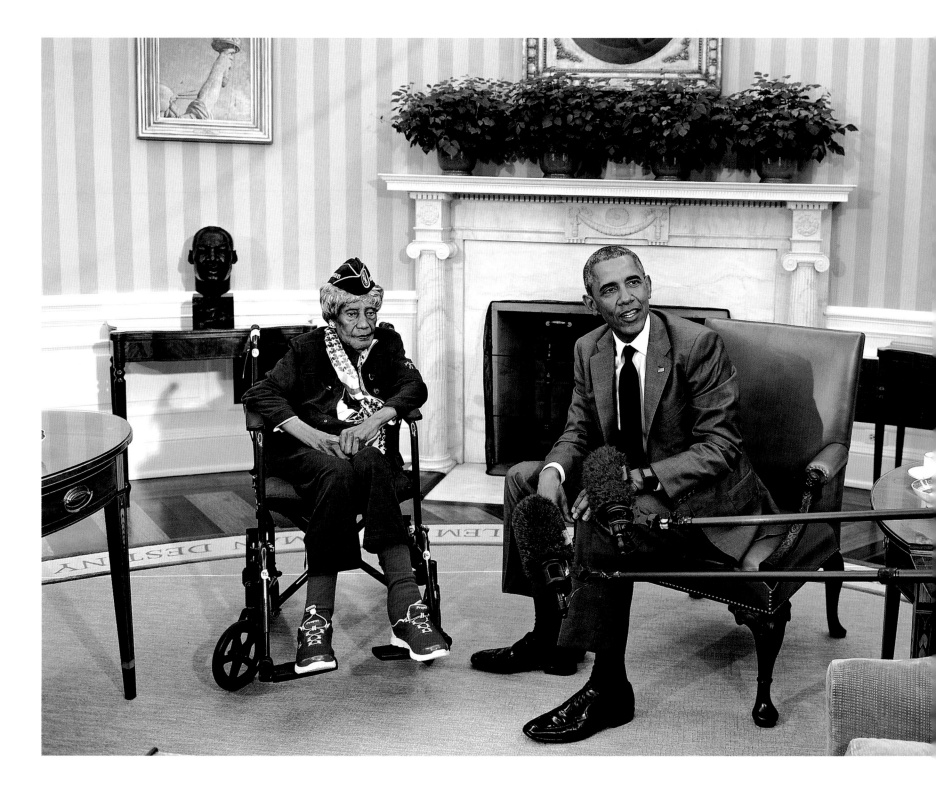

Afterward, Didlake traveled around the world and received many distinctions for her military service. She received the Women's Army Corps Service Medal, American Campaign Medal, and World War II Victory Medal. After the war, she joined the NAACP and even marched alongside Martin Luther King, Jr., when he visited Detroit in 1963.

"I've seen a lot of events in my lifetime, and the evolution of change that has occurred in the military is staggering to me," she said. On July 17, 2015, she would hit another milestone when she met with President Obama in the Oval Office.

"We are so grateful that she is here with us today," the president said. "And it's a great reminder of not only the sacrifices that the Greatest Generation made on our behalf, but also the kind of trailblazing that our women veterans made, African-American veterans who helped to integrate our Armed Services. We are very, very proud of them. That's why we've got to make sure we do right by them."

It was a memorable trip for the 110-year-old, who told her family she liked the president and enjoyed her discussion with him.

Didlake passed away peacefully on August 16, 2015. "It was a month after we went to the White House," Didlake's granddaughter Marilyn Horne shares. "I think she felt she had accomplished everything in her life and could now take her well-earned rest." ∎

WEST SUMMERS

Deployment: Cuba 1961, 1962
Branch of Service: U.S. Marine Corps, U.S. Army Reserve
Residence: Louisiana
Occupation: Retired

★★★★★

*"Given the opportunity,
I'll do anything."*

It was 1959, and the young Louisiana native was excited to enter the Marine Corps. West Summers started training as a pilot, moved to artillery, and settled in the tank division.

While Summers was immersed in training, the U.S. government was in uncharted territory with Cuba. Summers was deployed to Guantanamo Bay in 1961. "Our mission there, surprisingly enough, was not to protect the base. If the Cubans ever crossed the fence, which was an expression they used, our mission was to destroy the base."

Fortunately, it never came to that, he says.

A year later, diplomatic relations between the United States and Cuba had heated up, and Summers was redeployed to Cuba. This time, the stakes were much higher. The marines awaited their orders during the Cuban Missile Crisis, the 13-day confrontation between the United States and the Soviet Union over Soviet ballistic missiles placed in Cuba.

"As a septuagenarian, I can look back . . . and say 'Boy, you are lucky as hell it wasn't anything.' But at the time we were really looking forward to some action—which never occurred."

In 1963 Summers left the Marines for college. But he wasn't done with the military. He had always wanted to serve as a paratrooper, so he joined the Special Forces airborne unit and later took a yearlong commission with the National Guard Reserve.

A month prior to discharge, he was offered an opportunity for officer training. He readily accepted, simultaneously working in the civilian world and attending Officer Candidate School, eventually receiving his commission as a second lieutenant. Summers took on several training and military opportunities during the next few decades, all while raising five children with his wife.

While he enjoyed his time serving in the military, Summers hadn't expected all four of his sons—Severin III, Sean, William, and Pierre—to do so as well. They each have strong, distinctive personalities, especially Sev, whom he called an "independent thinker."

"They've all paid their dues. They've been good sons, good soldiers. I'm immensely proud of them," he says, adding that he is also proud of his beautiful daughter, Andree, a businesswoman.

Still, Summers struggled when all four sons were deployed at the same time. On August 2, 2009, his eldest son, Staff Sgt. Sev Summers, was killed by an IED in Afghanistan.

For a while, Summers wore a bracelet with his son's name engraved on it, but he decided to get a tattoo on his forearm instead because it was more permanent.

Throughout it all, Summers has enjoyed his life and time in the military, and he is proud of all his children. ∎

JOANN PUFFER KOTCHER

Deployment: Vietnam 1966
Branch of Service: American Red Cross
Residence: Michigan
Occupation: Retired teacher

★ ★ ★ ★ ★

"Six pairs of eyes were watching.
The people attached to them were waiting for my decision."

A storm was threatening. Joann Puffer Kotcher was alarmed that the helicopter had landed in the jungle instead of flying out. The pilot explained, "Between the lightning up there and the VC down here, I prefer the VC."

It was Kotcher's last week in Vietnam, but she couldn't think about going home—not when she saw the immediate danger. She and another "donut dolly," an escort officer, and four helicopter crew members had been visiting the troops located behind enemy lines.

They had spent their day hopping from one Special Forces camp to another, completing the duties of the donut dolly—that is, to be a morale booster, and serve as a sounding board for soldiers who needed a good listener.

But night was fast approaching, and that meant the helicopter would be an easy target for the Vietcong. There were no good options: Stay on the ground overnight and be attacked by the Vietcong or fly out and be torn apart by the approaching storm.

Inside the Special Forces camp, the pilot told her, "The storm is closing in. We have to leave immediately or stay the night."

Everybody looked at Kotcher to decide. A noncombatant civilian, she was surprised it would be her call. Her simulated rank of captain gave her priority in travel and women's quarters. She had no tactical training. Everyone knew her civilian status gave her command authority rank.

"Six pairs of eyes were watching . . . waiting for my decision," Kotcher recalls.

"I decided to take our chances with God and fly out. I said, 'Let's go.' The pilot and the copilot, crew chief, and gunner stood up and began to move out. Our escort officer frowned at the risk."

Climbing into the helicopter, the group fumbled in the darkness to find the seat belts. "Lighten the aircraft," someone said. Everyone passed out boxes. Within moments they were ready for liftoff.

A flash of lightning lit up the helipad. The copilot exclaimed, "Ooh."

The pilot said, "Don't sweat it." He continued to check his instruments.

The rotor groaned into action; the gunner and crew chief readied their machine guns. The ship shuddered and slowly lifted. The pilot did not turn on any lights. He wanted to avoid attracting the thousands of Vietcong who were, no doubt, gathering in the immediate area. The helicopter began to rise and spiral into the air as the tail lifted.

Gravity pulled at the passengers. The force of the wind threw the ship in every direction. "It was raining so hard I was afraid it would blast the paint off the helicopter," Kotcher recalls. "Inside the ship everything was dark except for the green glow of the instrument lights. Lightning struck around us. The windshield wipers began to lose their struggle to keep up with the rain."

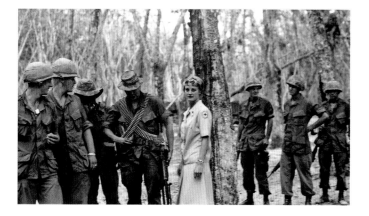

ABOVE: *Joann Puffer Kotcher mingles with troops at a large rubber plantation in Vietnam.*

LEFT: *Kotcher prepares for a helicopter trip to an outpost. As a donut dolly, she organized recreational activities for the soldiers to help keep morale high.*

Without warning, an evil flash of lightning streaked across the sky. Fiery forks reached for the helicopter. Dozens of fingers clutched all around it. Kotcher couldn't understand why they didn't seem to touch the ship. The helicopter jolted to the right; everything went black.

Kotcher braced herself, expecting to go into a free fall.

Instead, the ship righted itself and kept flying. The windshield wipers dutifully slapped back and forth with confidence. She and the ship were still in one piece. Kotcher sat there for a moment in disbelief. She became aware that they were going to make it through the hellish storm. In less than half an hour, the helicopter landed safely at their home base in Bien Hoa, Vietnam.

Kotcher's stomach found its assigned place in her body. Color that had been absent returned to her face. She was elated when she felt the wet dirt of the ground through her shoe leather.

Oddly, she didn't feel any great sense of success in making the right decision. She didn't view it that way. Rather, she had made a judgment call based on little information.

"I felt that some higher power shuffled the deck, drew a card, and put its money on us, allowing us to survive that flight." ■

An American veteran walks past marble walls engraved with names of fallen U.S. soldiers at the Manila American Cemetery and Memorial in Taguig, south of Manila, Philippines.

"*I only regret that I have but one life to lose for my country.*"

NATHAN HALE

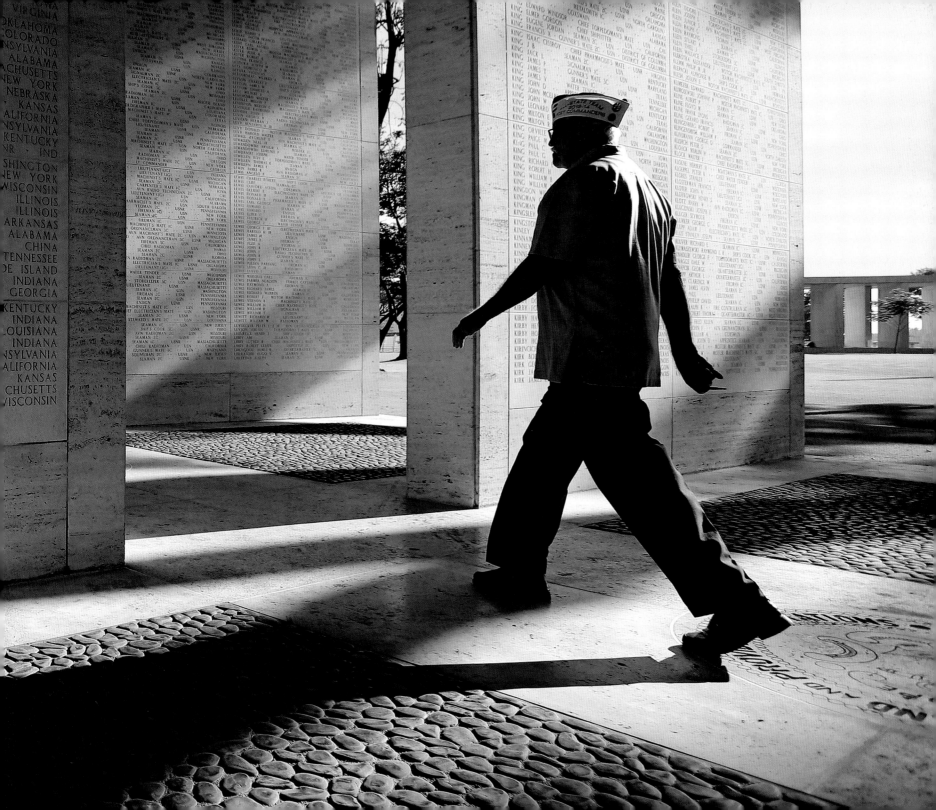

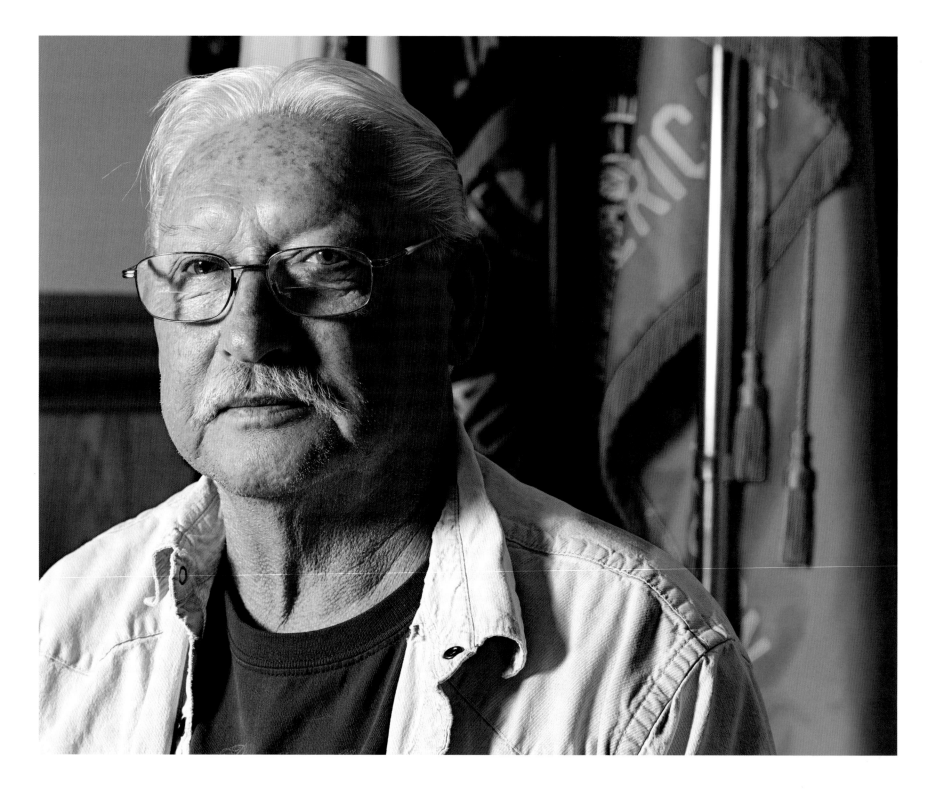

JOSEPH ANDRIUNAS

Deployment: Vietnam 1969
Branch of Service: U.S. Army
Residence: Arizona
Occupation: Retired

★ ★ ★ ★ ★

"Things are getting better."

In January 1969 Joseph Andriunas received his draft notice for Vietnam. The young Chicago native completed basic training and went on to technical schooling in artillery operations.

Andriunas arrived in Vietnam as a sergeant E5 squad leader, serving under the 101st Airborne Division. Set high along a barren mountaintop over central Vietnam's lush A Shau Valley, Fire Support Base Ripcord provided Americans with high ground over the North Vietnamese Army's primary transportation and supply route.

Andriunas launched mortars at enemy positions, sometimes miles away. Another specialist, a forward observer, would inform the artillery unit whether their strikes resulted in kills. Andriunas characterized his fighting with the enemy as "Nothing really that personal."

The occasional enemy shelling and attacks turned to a near-constant assault on July 1, 1970, when fewer than 600 American soldiers found themselves surrounded by thousands of North Vietnamese Army combatants. On a morning when his mortar squad was preparing to leave, an enemy combatant shot down a helicopter over the base.

Determined fighters converged around the base, far outnumbering the American soldiers. Andriunas's team was forced into a bunker, with their rucksacks and packed weaponry left to burn in the ensuing violence. As the violence outside grew worse, the team made a run toward higher ground. Once at the helipad, they loaded supplies onto newly arrived helicopters, along with the bagged remains of their fellow soldiers.

"That was where we took a lot of casualties," Andriunas recalls.

It took 23 days of fighting before the base could be evacuated. During that time, 75 Americans and 422 North Vietnamese were killed.

Then Andriunas's tour ended. Within four days, he went from being a combat soldier to a civilian living in downtown Chicago.

Few people knew about what he had faced, and the Battle of Fire Support Base Ripcord was not shared with the media. Stories of one of Vietnam's most deadly battles would surface over years, along with recognition for those who held the mountain fortress through its demise.

Like many who fought to keep the base, Andriunas received several medals. But there was one he would not accept. He didn't want a Purple Heart for his shrapnel injury, not when so many of his friends had received more grievous wounds.

Over time, Andriunas found ways to create normality in his life. He found people to rely on, including a manager who helped him to gain a sense of order as he started a career in the airline industry. He went on to work across multiple cities, fight cancer, and ultimately retire in Arizona.

Years away from battle, he has found that opening up about his past has helped. "Things are getting better," he says. ∎

ALBERT VELDHUYZEN

Deployment: Iraq 2005, 2007
Branch of Service: U.S. Navy
Residence: Virginia
Occupation: Chief of Administrative and Civil Law for the Army, Fort Belvoir

★★★★★

"They really need help when they are deployed on the other side of the globe and have legal problems at home. It was rewarding to provide a useful service helping individuals."

"That was the first and probably the last time I'll ever work in a palace!" Col. Albert Veldhuyzen explains of his 2005 deployment to Iraq, where he served as a legal officer for the Joint Forces coalition. Saddam Hussein's Al Faw Palace in Baghdad (Camp Victory) had been converted into the Multinational Forces headquarters, with the legal staff's offices inside the former dictator's bedroom.

Veldhuyzen's legal team worked on policies that enabled cooperation between the nations supporting Operation Iraqi Freedom. They handled issues from administrative law to ethics to equipment use agreements.

Although inaccurate mortar mostly landed in fields, explosions nearby were a regular occurrence. Once, Veldhuyzen was awakened when a nearby arms depot was destroyed. Another time, he and his colleagues rushed to the balcony to witness a "plume of smoke" arising at the complex gate, the final actions of a suicide bomber. In yet another incident, a fellow JAG friend (fortunately absent) had his room blown up by mortar. "It was hit or miss . . . You get immune; you just go back to work."

Three months into his deployment, he received a call from home. "Your baby is dying," he was warned. His command gave him a compassionate reassignment to return to Virginia.

"It was a difficult time. I was concerned about Anette and what she was going through, being alone at home with the other seven kids (one with autism) and having a complicated pregnancy." One week after his return, his daughter was born prematurely and required a month of intensive care. "It was a miracle that she survived. Only one out of eight with her special condition live."

Veldhuyzen alternated between caring for his seven children and visiting his wife and newborn at the hospital until they were healthy enough to return home.

Rather than request a reassignment in the United States, Veldhuyzen and his wife decided that he should finish the work he had started. He went back to support the coalition forces in Iraq.

Veldhuyzen returned to the Middle East again in 2007, to provide legal assistance for soldiers in Kuwait. "They really need help when they are deployed on the other side of the globe and have legal problems at home," he says, explaining that might include car repossessions, child support issues, or even divorces. "It was rewarding," says Veldhuyzen.

Now, with 13 years of active-duty experience, Veldhuyzen is a civilian, working as the Chief of Administrative and Civil Law for the Army in Fort Belvoir, Virginia, while also serving his 24th year as a reservist, serving as the legal adviser to the commander general of the U.S. Army Reserve Medical Command in Tampa, Florida. He also volunteers as the director of Project Paraguay, a nonprofit organization supporting Paraguayan churches. ■

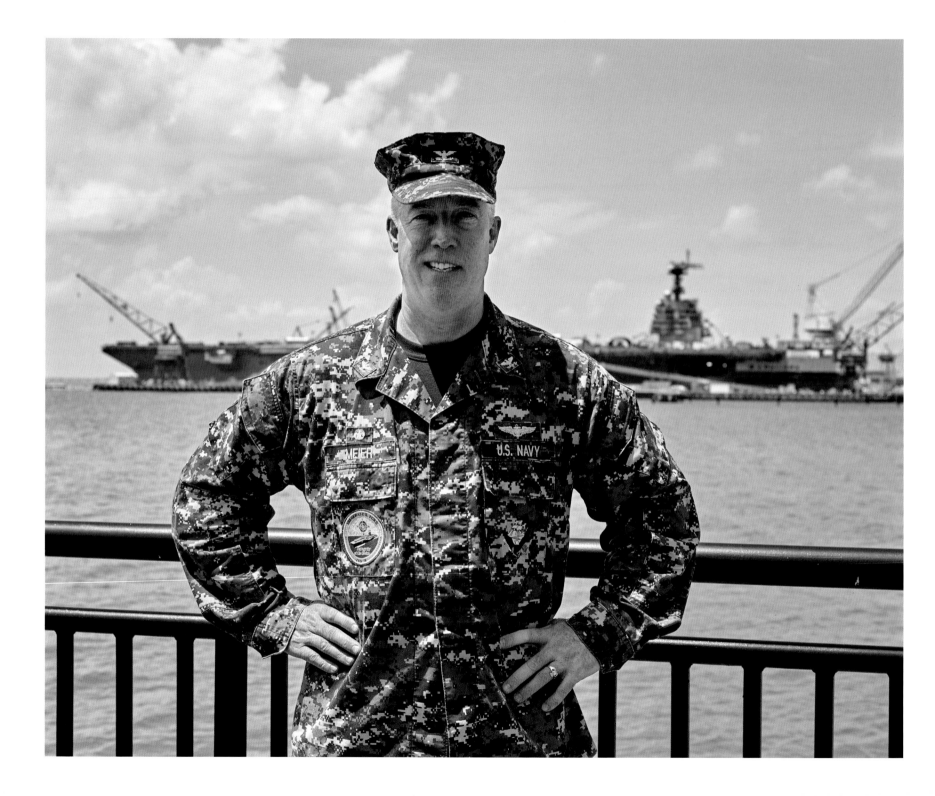

JOHN MEIER

Deployment: Gulf War 1991
Branch of Service: U.S. Navy
Residence: Virginia
Occupation: Commanding officer of the U.S.S. *Gerald R. Ford*

★★★★★

"You pray for peace
but you prepare for war diligently."

John Meier had been told that one in four of his squadron mates would likely die in the upcoming war in Iraq. He had to prepare himself. He was newly married, on his first deployment, and about to undertake his first mission.

The young lieutenant still felt a strong need to be a part of Operation Desert Storm.

"I don't think that as an aviator, as a warrior, that you ever hope for war. As a matter of fact just the opposite," he says. "You pray for peace but you prepare for war diligently. And if there is going to be a war, you want to be the one that was in the game. You have to convince yourself that you are the best at what you do, and if anybody's going to do this, it ought to be me."

That was the attitude the young pilot took with him when he deployed right after Christmas, 1990. However, he was a bit shaken a few days later when he had to eject from his jet after an accident.

"I wasn't gone a week when I ejected after the arresting cable parted on the U.S.S. *Theodore Roosevelt*," Meier says. "The plane went over the side. We all got out. We were all fine, but ejections are pretty rough on the body."

He couldn't help but think about the one-in-four prediction. But soon he was so busy flying two missions a day, jamming Iraqi electronic radars and launching missiles, that he didn't have time to consider this statistic.

It quickly became clear that the Iraqis were no match for the American forces. Their technology was not current and they couldn't withstand the air assaults. The one-in-four prediction was soon forgotten as it became clear that the Americans had won the war—and won it quickly.

After he returned home, Meier decided to enhance his career prospects and gain more experience on a naval ship. Nearly 25 years later, he was given the oversight of the building of a new supercarrier in Newport News, Virginia: the U.S.S. *Gerald R. Ford*. Construction of the ship began in 2005, and it is expected to join the U.S. Navy fleet in spring 2016.

"Every ship has its own tone, its own culture. It's a pretty big responsibility to build that from the keel up, and the tone set on this ship by its first crew will still be resonant 50 years from now, years after I have gone," Meier says with conviction.

"That's special to ships. We shift the emphasis to internal motivation, and that works with the best and brightest crew that the Navy has to offer. As captain, I concentrate on the culture, and have very good leaders who brief me, but I leave the details to them, as I continue to focus on this culture," says Meier. "The technology is very expensive and fantastic in quality. But the crew needs to understand that they are the real weapons system of the U.S.S. *Gerald R. Ford*." ∎

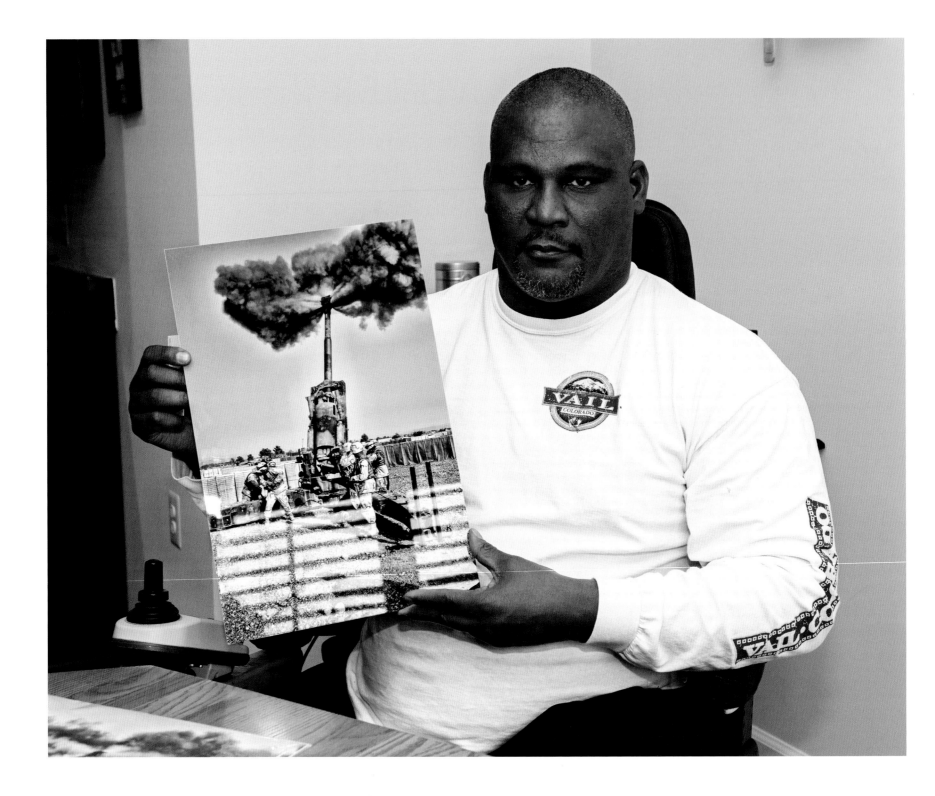

GREG GADSON

Deployment: Gulf War 1990, 1991; Bosnia and Herzegovina 2002; Afghanistan 2004; Iraq 2007
Branch of Service: U.S. Army
Residence: Virginia
Occupation: Photographer, actor, motivational speaker

★★★★★

*"I didn't know I wanted to serve in the military.
I was interested in football."*

Gregory Gadson's smile is contagious. He seems to not have a care in the world as he pushes himself around in his wheelchair and laughs openly as he discusses his recent career change from retired U.S. Army colonel to an actor with silver screen credentials. Gadson, a bilateral above-the-knee amputee, has made it a point to remain active as a photographer, actor, and motivational speaker.

"I didn't know I wanted to serve in the military," he said. "I was interested in football. I decided West Point would be my best option to play Division One football."

During that time, he excelled as a football player, graduating in 1989 before heading to college and several deployments. He shakes his head when he remembers his initial attitude toward battle.

"Being deployed—it was all about bravado and manhood. I got to take the ultimate test going to battle. It was supposed to be glorious, almost a spiritual event," says Gadson.

But his experiences proved otherwise. His first deployment to Iraq made him realize that "combat and war was the saddest thing mankind could resort to."

But sometimes war was necessary, and Gadson decided to continue with his military career, this time with a deeper perspective.

In a career that would span more than 20 years, Gadson rose through the ranks of leadership. He served in Operations Desert Shield and Desert Storm, Operation Joint Forge, Operation Enduring Freedom, and Operation Iraqi Freedom.

In 2007 Gadson was again deployed to Iraq. The deployment was a deadly one, beginning with the deaths of two soldiers from a sister battalion from Fort Riley after they were hit by an IED.

Gadson attended their memorial service on base before returning to his duties in the war-torn country. Staring out the window, Gadson thought about all the young men and women who would never see their dreams materialize.

"And that's when it happened, my up-armored Humvee was hit on the right by a roadside bomb on the night of May 7, 2007," recalls Gadson.

It was almost like a slow-motion event. Gadson could see the flash of the detonated IED even as his body was flung from the vehicle. Hitting the ground, he rolled uncontrollably until he finally came to a stop, lying on his back.

For a few moments all he could do was think and feel. He was responsible for numerous men and women, and now he was unable to help them. He felt a surge of anger before he fell unconscious.

Gadson woke to the sight of his fellow soldiers surrounding him. Confusion set in as he felt blood covering his body. Tourniquets had

been fashioned to both legs. As his team tried to lift him into a vehicle, Gadson realized that his foot was lying on his stomach. At the troop medical clinic, he saw the field hospital's surgeon rush toward him. That was when he realized that his condition might be fatal. Knowing very well he might never see his wife and children again, his last words to his brigade commander were, "Just make sure Kim and my two children know I love them."

Gadson was eventually stabilized and transferred to Walter Reed National Military Medical Center, arriving on May 11. After exhausting every medical procedure and treatment, Gadson was forced to give up his left leg in order to save his life. A short time later, doctors realized that Gadson was in serious danger of bleeding out due to the wounds on his right leg. It was also removed.

It took nearly three years for Gadson to recover. But he found the strength not only to survive but to thrive. With the support of his faith, family, and friends, Gadson worked to build his personal life and reshape his career. He became the director for the Army Wounded Warrior Program while pursuing his passion for photography and motivational speaking.

In 2012 he was cast in the movie *Battleship* as Lt. Col. Mick Canales (Ret.), a war veteran who regains his appetite for the fight when Oahu is threatened by an alien attack. Director Peter Berg cast him after reading articles about Gadson's career and injuries. The twists and turns in his new career have been a great source of enjoyment for Gadson, who has shared his story with several audiences.

"At first, to open my life to others was cathartic, and was about helping myself as much as others," he has said. "Now, it's flipped. I understand now that I may be helping others." ■

ABOVE: *Actor and director Robert Duvall makes a surprise visit to Greg Gadson and his wife, Kimberly, at Walter Reed National Military Medical Center in Washington, D.C., in 2007.*

OPPOSITE: *(Left) This was the state of Gadson's up-armored Humvee after being hit by a roadside bomb. (Right) Gadson, a bilateral above-the-knee amputee, shows off the hundreds of military coins he has collected over the years.*

ACKNOWLEDGMENTS

There are no words in our vocabulary to adequately express our gratitude for all the military veterans in this country who have graciously served and died for our nation's freedom. With that in mind, the authors would like to acknowledge the personal sacrifices of all the men and women who proudly serve in our military—*Thank You!*

To our corporate sponsor, Mayco International, Alicia and Larry Winget, and Nick DeMiro, who saw our vision for a book like this and understood the need for the stories of military veterans to be told. Without their help and support, this book may have not become a reality.

Creating a photographic essay book like *Veterans Voices* was a daunting but very rewarding task. It also required a great deal of support and help from many people. We would like to share our immeasurable appreciation and deepest gratitude for the following persons:

First and foremost, we would like to acknowledge our faithful friend George Lawson, a retired Navy veteran. George served as our senior story researcher. Because of his peerless efforts, we had a constant flow of interesting veterans' interviews coming our way. George's extensive military knowledge and his ability to cut through any red tape allowed us to access the very best and most interesting stories for our book. Without George's extensive veteran research and his hundreds of emails, phone calls, and follow-up with securing interviews, this book would not have been possible. Thank you, George!

Every author needs a skilled researcher and writer who can ensure that the story has meaning and is well written. We are very proud to have one of the best. We would like to gratefully acknowledge Meghan Millea for her tireless work, dedication, and perspective.

Meghan's enthusiasm and over-the-top writing skills certainly pushed our stories to the next level. Her ability to organize and focus our stories made the difference in allowing each story's true meaning to shine through in a way that we think will captivate our readers. Meghan, you know how vital you were to this book, so to you goes a heartfelt "Thank you!"

One of our biggest supporters in the creation of this book is Charlotte Tripp, the director of the Freedom Center, located inside the Detroit Metropolitan Airport. Charlotte and her staff welcome hundreds of active military and veterans every day as they pass though Detroit. Charlotte called us with a last-minute story about the oldest living U.S. veteran, Emma Didlake, who was on her way to the honor ceremony at the White House. A big "Thank you!" to you, Charlotte, for your eagle eye, and we share your sadness at Emma's passing at 110 years of age.

A sincere thanks of appreciation goes to Patrick J. Miller for his story research and seeking out special veterans for us to interview. Patrick provided us with great input and suggestions. His perspectives on different story elements helped a great deal.

Sometimes situations would not allow us to take the photographs and conduct the interview at the same time. In stepped Annemarie Sikora. Annemarie helped with the photography on complex stories and with the vital process of raw picture editing. Both Patrick and Annemarie proved that it is totally possible to work on a team as father and daughter, and it was always a special time when we worked together.

For help with editing and interviews, special thanks go to Melissa Montalbine, Jenny Lasala, Miranda Boyer, and Penny Schreiber. You

helped a great deal both while we were knee-deep in writing stories and in following new leads.

We thank Bob Woodruff, from ABC News and of the Bob Woodruff Foundation, for his exceptional and moving foreword. His inspiration and friendship are greatly appreciated.

For their varied and wonderful connections, hospitality, and input, grateful thanks go to Alice Verberne-Benamara, Helen and Hans Jamet, Douglas Gordon, Marsha and Scott Robertson, Paul Clifford, Chris Wolfe, Rick and Marilyn Beyer, Jeff and Annie Lowdermilk, Aryn Lockhart, Jennifer Grimes, Dan Schmitt, Maj. Kenneth French, Bill Creighton, Brian Jarvis, Kelly McFarland, Vicki and George Lawson, Joerg Pick, Marilla Cushman, Karin Berg, Brett Clark, Jan and Jim Fiorelli, Clarissa Frisch, Jenny Lasala, Gena Norris, Jeff Salard, Nancy De Santis, Terry Schroeder, Megan McTavish, Charlene and West Summers, Bernie and Linda Ayling, Tom and Cecilia Hernandez, and the Boy Scouts of America Store in Mesa, Arizona.

A special thanks also goes to Enterprise Car Rental for their support with our car rental needs around the country.

We would like to acknowledge regional manager Cel Vargus from Sony Camera and Vice President Chris Norman from Norman Camera, Kalamazoo, Michigan, for supplying 4K high-definition video equipment for our use.

We also acknowledge Camera Mart, Pontiac, Michigan, and its owner, William Sullivan, and general manager, Ruben Harwell, for supplying much needed Nikon photographic equipment and supplies for us to use.

A very sincere and special thanks goes out to the family and friends of our military veterans for their support with travel and other costs associated with producing this book, including the families of Bill Williams, Korean War (deceased); Francis Livsey, World War II (deceased); Paul Coen, World War II (deceased); and Staff Sgt. Kenneth R. VanGiesen (deceased); the McLean County American Legion Riders of Kane, Pennsylvania; Forest Place Optical's David Getschman; and George and Vicki Lawson.

It was an enormous privilege to work with the experienced people of National Geographic Books. Without your effort and dedication this book would not have been possible. Thank-yous go out to these special people: Barbara Brownell Grogan and Bill O'Donnell for their persistence in getting us to consider doing a veterans book. To the many talented National Geographic editorial team members: Susan Straight, editor and project manager; Susan Blair, director of photography; Laura Lakeway, photo editor; Sanaa Akkach, art director; Amy Sklansky, text editor; Agnes Tabah, legal counsel; and so many others: Thank you!

Finally, we would like to thank our spouses, Colleen Canty-Miller and Christa Wakeford, for the loving support and understanding they have shown to us during the last two years we spent endlessly writing and taking photographs for this book. We have and always will value their input and suggestions. They were both instrumental in ways of which they are probably not even aware. And we love them immensely for their never ending support, encouragement, and understanding.

— **Robert H. Miller & Andrew Wakeford, August 2015**

ILLUSTRATIONS CREDITS

All photographs by Robert H. Miller and Andrew Wakeford, except as noted below.

Cover, U.S. Army photo by Spc. Rashene Mincy, 55th Signal Company (Combat Camera)/Released; back flap (UP), Andrew Wakeford; back flap (LO), Christa Wakeford; 2-3, MILpictures by Tom Weber/Getty Images; 4-5, Wang Lei/Xinhua Press/Corbis; 6, Kenneth Garrett/National Geographic Creative; 10-11, Hannele Lahti/National Geographic Creative; 12-3, David H. Wells/Corbis; 14-5, Karen Kasmauski/Corbis; 16-7, Larry Downing/Reuters/Corbis; 23, Photo by Matthias Martin, courtesy of Aryn Lockhart; 30 (both), 31, Courtesy of Vernice Armour; 34-5, Michael Melford/National Geographic Creative; 48-9 (both), Courtesy of Robert Bleier; 64-5, Philip James Corwin/Corbis; 89, Genesis Production, courtesy of Chiquita Peña; 92-3, Wally McNamee/Corbis; 102 (both), Courtesy of Marissa Strock; 106-107, Courtesy of Matt VanGiesen; 110, Courtesy of Chuck Norris; 112-3, Top Kick Productions/Gena Norris; 120 (LE), Courtesy of Jean Holley Watts; 121, Courtesy of Jean Holley Watts; 124-5, Sollina Images/Getty Images; 128 (LE), West Point Military Academy, courtesy of the Lambka family; 134-5 (both), Ken Grimes; 154 (LE), 155, Gary Sinise Foundation, courtesy of Bryan Forney; 156-7, Dickey Chappelle/National Geographic Creative; 165, Courtesy of Craig Morgan; 168 (LE), Courtesy of Marc Tucker; 180-1, George W. Bush Museum, courtesy of Steve McAlpin; 181, Pablo Delgado, courtesy of Steve McAlpin; 184-5, Harpo, Inc./George Burns, courtesy of Jas Boothe; 186-7, Golaizola/Shutterstock; 190-1, National Archives and Records Administration (NARA), courtesy of Jack Masey; 191, Courtesy of Jack Masey; 202 (both), Robert Barron; 212-3, Stocktrek Images/Getty Images; 218-9, Kathryn Hicks, courtesy of Micala Hicks Siler; 232-3, AP Photo/ferex; 238-9 (both), Courtesy of Joann Puffer Kotcher; 240-1, AP Photo/Aaron Favila; 250 (LE), Courtesy of Greg Gadson; 251, Courtesy of Greg Gadson (with Robert Duvall).

VETERANS VOICES

ROBERT H. MILLER AND ANDREW WAKEFORD

Prepared by the Book Division

Hector Sierra, *Senior Vice President and General Manager*
Lisa Thomas, *Senior Vice President and Editorial Director*
Melissa Farris, *Creative Director*
R. Gary Colbert, *Production Director*
Jennifer A. Thornton, *Director of Managing Editorial*
Susan S. Blair, *Director of Photography*
Meredith C. Wilcox, *Director, Administration and Rights Clearance*

Staff for This Book

Susan Straight, *Editor*
Amy Sklansky, *Text Editor*
Sanaa Akkach, *Art Director*
Laura Lakeway, *Photo Editor*
Marshall Kiker, *Associate Managing Editor*
Judith Klein and Michael O'Connor, *Production Editors*
Mike Horenstein, *Production Manager*
Rock Wheeler, *Rights Clearance Specialist*
Katie Olsen, *Design Production Specialist*
Nicole Miller, *Design Production Assistant*
George Bounelis, *Manager, Production Services*
Rebekah Cain, *Imaging*

Since 1888, the National Geographic Society has funded more than 12,000 research, exploration, and preservation projects around the world. National Geographic Partners distributes a portion of the funds it receives from your purchase to National Geographic Society to support programs including the conservation of animals and their habitats.

For more information, please call 1-800-647-5463 or write to the following address:

National Geographic Partners, LLC
1145 17th Street NW
Washington, DC 20036-4688 USA

Become a member of National Geographic and activate your benefits today at natgeo.com/jointoday.

For information about special discounts for bulk purchases, please contact National Geographic Books Special Sales: ngspecsales@ngs.org

For rights or permissions inquiries, please contact National Geographic Books Subsidiary Rights: ngbookrights@ngs.org

Library of Congress Cataloging-in-Publication Data

Names: Miller, Robert H., 1954- | Wakeford, Andrew, 1949- | National
 Geographic Society (U.S.)
Title: Veterans voices : remarkable stories of heroism, sacrifice, and honor
 / Robert H. Miller & Andrew Wakeford.
Description: Washington, DC : National Geographic, [2016]
Identifiers: LCCN 2015037070 | ISBN 9781426216381 (hardcover : alk. paper)
Subjects: LCSH: Veterans--United States--Biography. | United States--Armed
 Forces--Biography.
Classification: LCC U52 .M57 2016 | DDC 355.0092/273--dc23
LC record available at http://lccn.loc.gov/2015037070

Printed in Hong Kong
16/THK/1

Mayco International treasures freedom and salutes the unselfish sacrifice
of the courageous men and women serving in our armed forces.
Their belief that people should be free from domination and control by others
is ever demonstrated in their dedication and service to our country.
Because of their commitment, America continues to enjoy those freedoms.

That is why we at Mayco International are proud to be the corporate sponsor for *Veterans Voices*.
It is our way to say "Thank You" to all our veterans who served.

"The secret of happiness is freedom, and the secret of freedom is courage."

— THUCYDIDES